T0041288

The Ultimate Guide to Drawing

MANGA ACTION FURRIES

Lessons from 14 Leading Japanese Illustrators

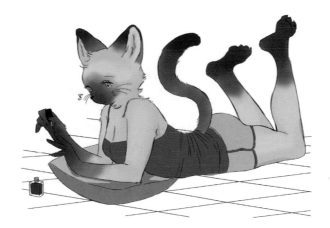

TUTTLE Publishing

Tokyo │ Rutland, Vermont │ Singapore

Contents

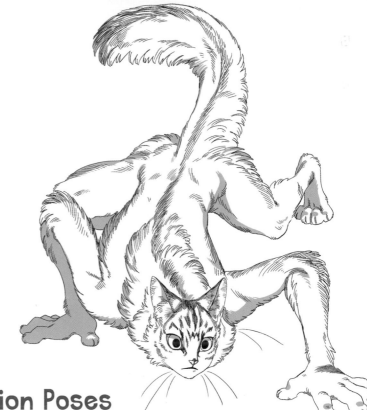

Introduction 8
How to Use This Book 9
A CLOSER LOOK Range of Character Designs 10

Chapter 1 **Furry Fundamentals**

What Is a Furry? 12
The Skeleton & Muscles: Humans vs. Furries 16
Humans: Sketching the Basic Shape 18
Furries: Sketching the Basic Shape 20
Furry Faces 22
A CLOSER LOOK *Focus on Chests and Pectorals* 24

Chapter 2 **Furries in Motion: Action Poses**

Husky 26
Calico Cat 28
Tiger 30
Horse 32
Collie 34
Somali Cat 36
Swallow 38
Hawk 40
Lion 42
Wolf 44
Dragon (young) 46

Dragon (adult) 48
Dolphin 50
Great White Shark 52
Orca 54
Crocodile 56
A CLOSER LOOK *How to Draw Different Faces* 58
Crow 60
Falcon 62
Asian Dragon 64
Beast Dragon 66
Black Panther 68

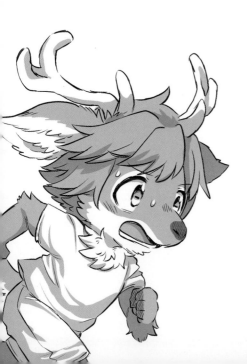

Bald Eagle 70
Red Fox 72
Boar 74
Shiba Inu 76
Spotted Eagle 78
Bear 80
Lizardman 82
Tosa 84
Samoyed 86
Bull 88
Tanuki 90

A CLOSER LOOK *Drawing a Thick Body Type* 92
Red Fox 94
Bunny 96
Mouse 98
Mountain Goat 100
Retriever 102
Siamese Cat 104
Maine Coon Cat 106
Fennec Fox 108
A CLOSER LOOK *Another Look at Breasts & Chests* 110

Chapter 3 Creating Chibi Furries

How to Draw Chibi Furries 112
Degrees of Distortion 114
A CLOSER LOOK *Tips on Drawing Chibi Characters* 116

Chapter 4 Chibi Furries on the Go

Calico Cat 118
Husky 120
Sheep 122
Reindeer 124
Cheetah 126
Squirrel 128

Cow 130
Marine Dragon 132
Bunny 134
Housecat 136
Polar Bear 138
Black-Scaled Dragon 140

Illustrator Profiles 142

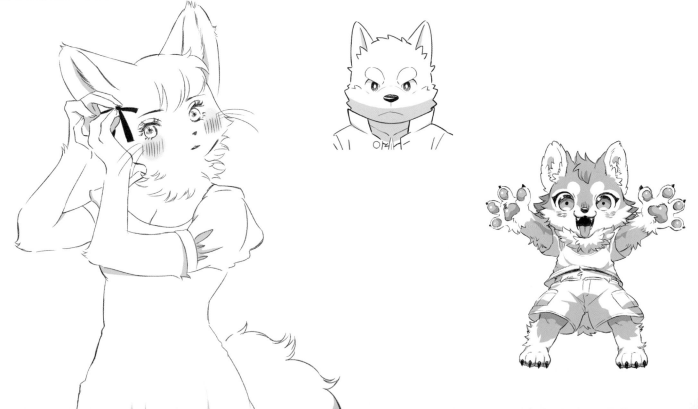

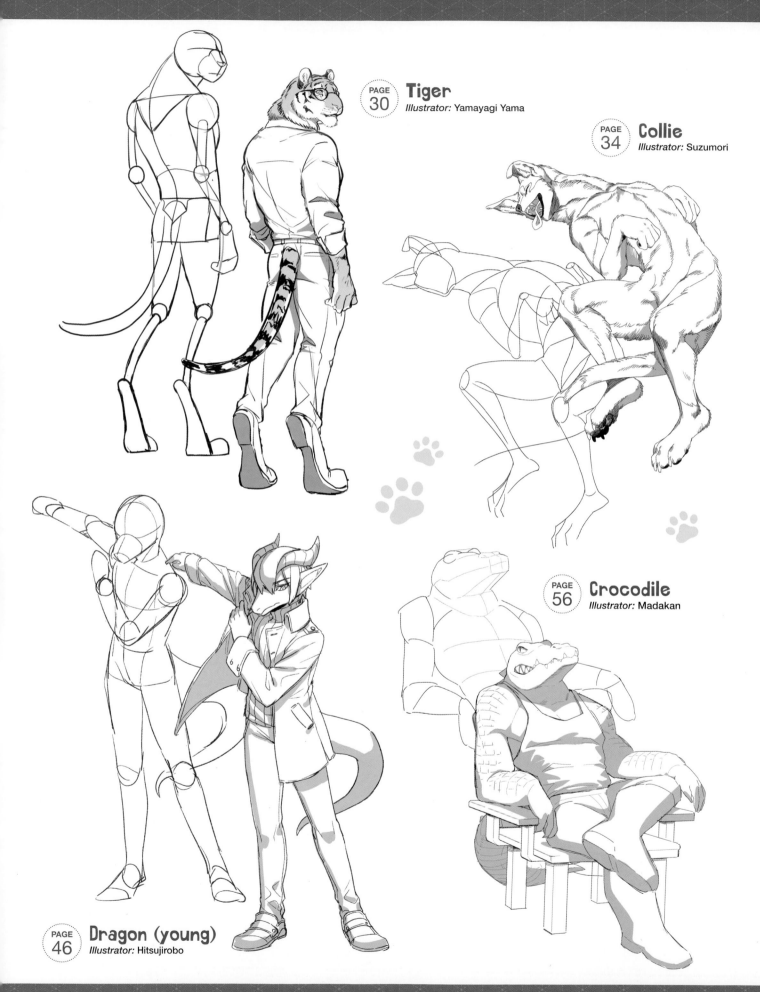

PAGE 30 — **Tiger**
Illustrator: Yamayagi Yama

PAGE 34 — **Collie**
Illustrator: Suzumori

PAGE 56 — **Crocodile**
Illustrator: Madakan

PAGE 46 — **Dragon (young)**
Illustrator: Hitsujirobo

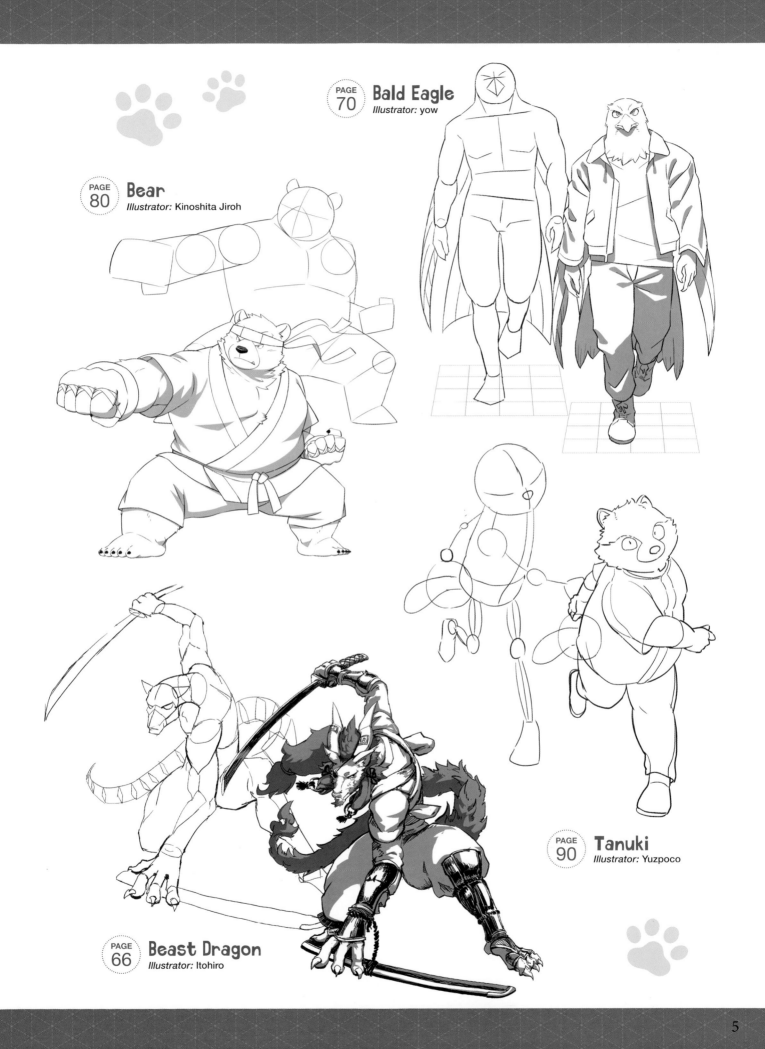

Bald Eagle
PAGE 70
Illustrator: yow

Bear
PAGE 80
Illustrator: Kinoshita Jiroh

Tanuki
PAGE 90
Illustrator: Yuzpoco

Beast Dragon
PAGE 66
Illustrator: Itohiro

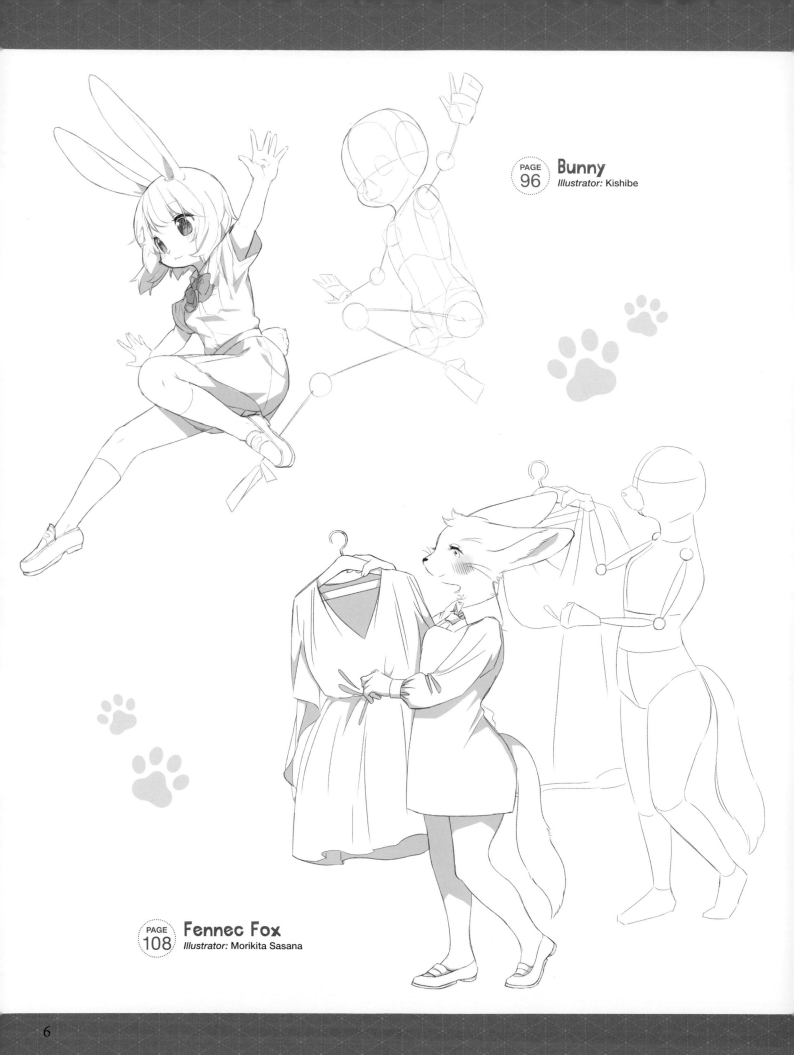

PAGE 96 **Bunny** *Illustrator:* Kishibe

PAGE 108 **Fennec Fox** *Illustrator:* Morikita Sasana

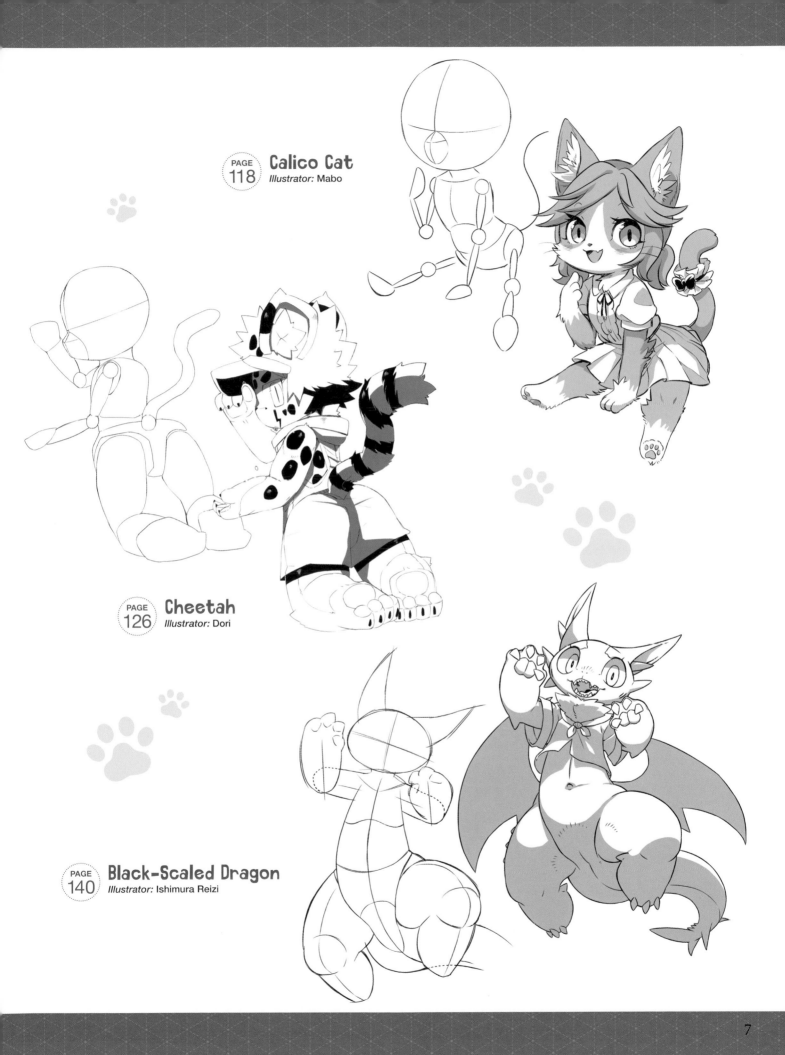

PAGE 118 **Calico Cat**
Illustrator: Mabo

PAGE 126 **Cheetah**
Illustrator: Dori

PAGE 140 **Black-Scaled Dragon**
Illustrator: Ishimura Reizi

Welcome, Friends of Furries!

Thanks for joining us and trying your hand at your own furry characters, either in print or digital form. Legends and folk tales are rife with mythological half-human, half-beast creatures and their exploits, stories that have been passed down and are still with us today. Creatures such as minotaurs, werewolves and mermaids have creeped, crawled and flown through our imaginations for ages.

Drawing Furries

Create your very own furry by adding an animal's charming qualities and features to your character. Many newcomers to furry world hesitate: "I don't know where to start!" Although the concept of a furry is as simple as adding animal characteristics to a human-shaped base or form, if you don't understand the basics of drawing humans and animals, creating a furry can pose some challenges for beginners.

To add to the joys of coming up with your own furry, the design for a character changes depending on the animal species and the illustrator's style.

Most of All: Have Fun!

In this book, we'll introduce various drawing styles and the how-tos in four basic steps: ❶ sketching ❷ fleshing out ❸ rough draft ❹ final touches. Not only will you learn how to draw the usual human poses, you'll also receive pointers on how to draw the animal characteristics to add complexity, dynamism and a greater sense of "realism" to your character. Since you'll be introduced to various drawing styles, you can experiment and adopt the approach that works best for you. You'll also have the opportunity to challenge yourself, trying designs completely different from your usual style.

Illustrator: Muraki

How to Use This Book

To get the most out of the various styles, we'll introduce illustrations done by different artists. Each illustration will be explained in depth, highlighting the particulars of each contributor's unique vision.

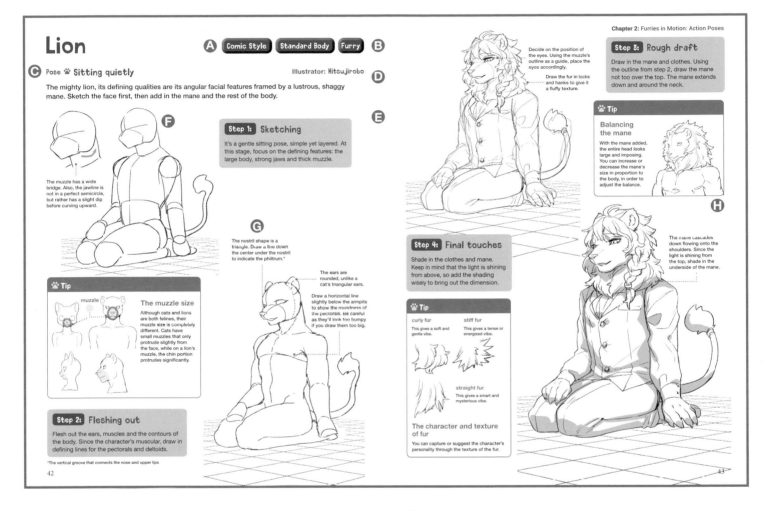

A Here you'll find the type of animal your furry is based on or referencing. Sub-species or specific breeds of each kind of animal are also included.

B The character's attributes are explored here, for example, style, body shape and/or gender.
*In this book "comic style" refers to characters that are cartoonish with significant human traits.

C This section indicates the character's pose. In this book you'll be drawing various positions, from simple standing positions to action poses.

D This section identifies the exercise's illustrator. If you discover a favorite style, you can read more about that illustrator in the ILLUSTRATOR PROFILES (page 142).

E Here is the brief explanation of what you'll be focusing on in each of the four basic steps: ❶ sketching ❷ fleshing out ❸ rough draft ❹ final touches.

F A look at the process used in each of the four steps. The progress of the ears, tails and general shape of the sketch (or blueprint) varies to some extent depending on the illustrator.

G The caption explains important details and how to draw the parts and areas where the leader line extends.

H Design points and how to draw specific furry features. This section presents tips, points of interest and key ideas to consider when working on your illustrations.

1 Range of Character Designs

A character's design varies greatly by illustrator

Depending on the illustrator, a furry character design can vary greatly. Let's look at a bird-based furry as an example. In this case, we're looking at a hawk and a spotted eagle, which are of course both birds of prey. However, they differ here based on the author's worldview.

Both of the bird furries have winglike arms or wings with hands. The A type wings are used for flying and are drawn with a realistic touch, while type B is designed to replace the human arms and hands. From here, you can see the design of the furry changes drastically based on the artist's individual style and vision and what works best.

When using this book, think about how you want to design your furry. When you think about the kind of world you want to create, it makes it easier to come up with the ideal design for your furry.

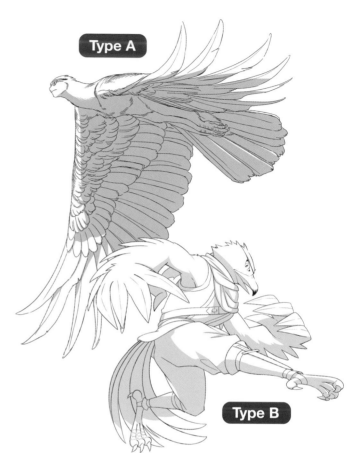

Type A

Type B

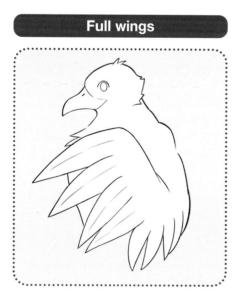

Full wings

Wing arms

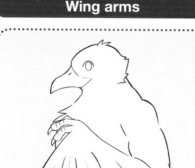

Four arms

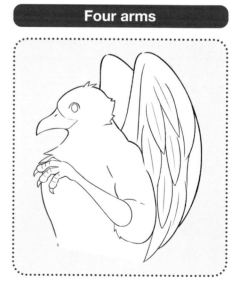

Using different designs

The full wing type is like a realistic wing and is used for flying. The wing type is like a throwback version, a true hybrid. Finally, the four arms type is when the character has armlike limbs as well as wings on the back. There are many possibilities when designing a bird-type furry. You can design your character as you please: whatever fits your world!

Chapter 1
Furry Fundamentals

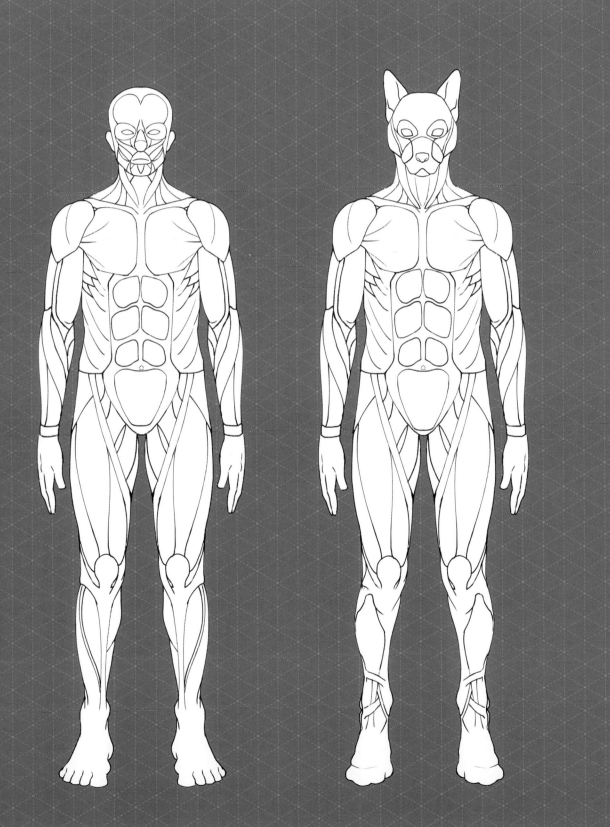

What Is a Furry?

Before we delve into the details and learn how to draw action furries, we should address a key question first: what is a furry? What do you consider a furry? Let's take a look at the range of furry formulations there are and what you can expect in the pages ahead.

Defining a Furry

We all know the minotaur of Greek mythology, or the werewolf, these creatures are mythical, fantastical. They're also furries! They take their place among the range of popular characters that appear in fantasy anime and manga today.

　　For the sake of this book, we'll refer to any characters with partial nonhuman characteristics (such as limbs and features) or animals with any anthropomorphic characters as furries.

But Is It a Furry?

Here we're taking on all kinds of human-creature hybrids: dogs, cats, birds, reptiles and a range of aquatic creatures. We'll also delve into the cuter realms and learn to draw chibi-style furries. So the definition of "furry" is whatever you want it to be: with fins, feathers or fur, with four legs, two or none at all. Whatever fusion, hybrid or mashup you prefer.

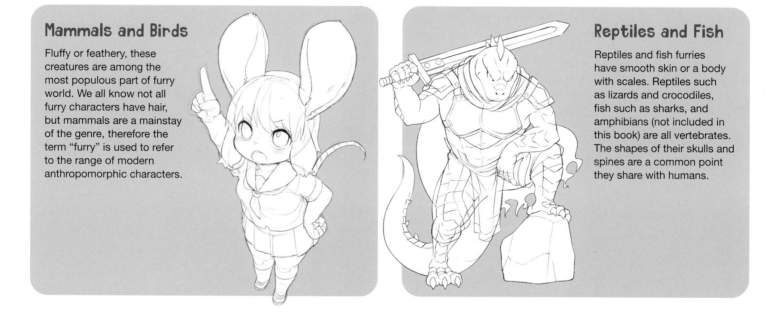

Mammals and Birds

Fluffy or feathery, these creatures are among the most populous part of furry world. We all know not all furry characters have hair, but mammals are a mainstay of the genre, therefore the term "furry" is used to refer to the range of modern anthropomorphic characters.

Reptiles and Fish

Reptiles and fish furries have smooth skin or a body with scales. Reptiles such as lizards and crocodiles, fish such as sharks, and amphibians (not included in this book) are all vertebrates. The shapes of their skulls and spines are a common point they share with humans.

Mythical Creatures

There's no limit to the range of fantasy characters you could consider furries. Hope you like dragons, as that's the focus here! We'll be exploring several types.

Chibis

Chibis are mascot-type furries with small bodies, large heads and cute faces. Like any other furry character, they're based on animals. However, the outsized, cartoonish exaggeration emphasizes part of their physique. There are also cases where the body shape itself differs greatly from that of a human. It's up to you!

Furry Levels

When talking about furries, there are different degrees of transformation a character can undergo, the extent to which the human form assumes and takes on the features of a more feral form. Again, it's all up to you! In this book, we'll be exposing you to a variety of levels of furry transformation.

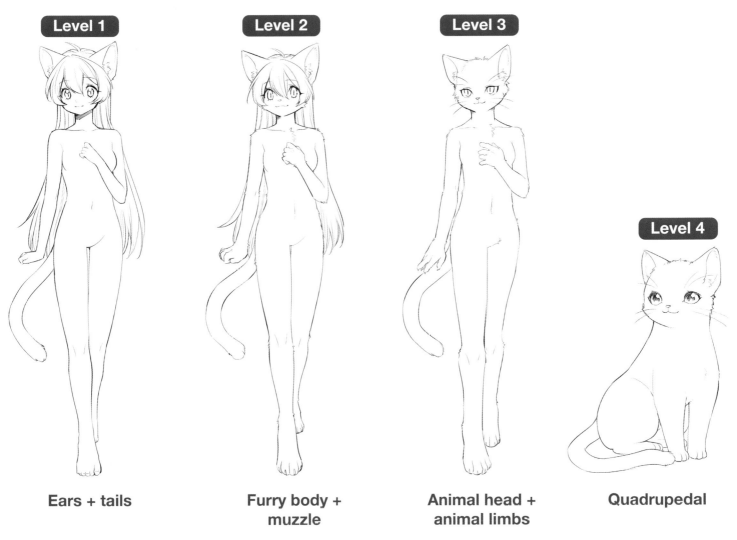

Level 1 — Ears + tails

Level 2 — Furry body + muzzle

Level 3 — Animal head + animal limbs

Level 4 — Quadrupedal

Furry Gradations

Changes in the degree of furriness are not limited to the ones shown above. Gradual changes such as details on the neck and hair can also be included.

Cartoon eyes + neck + hair

Cartoon eyes + neck

Cartoon eyes + animal neck

Animal eyes + animal neck

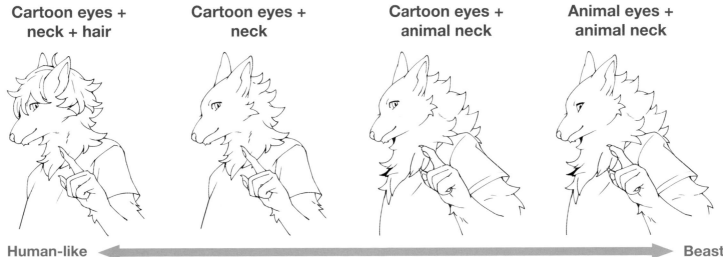

Human-like ⟵⟶ **Beast**

When you can't draw furries well...
Understand What Went Wrong in Your Initial Sketch

> Once I start drawing, it comes out differently from how I envisioned . . .

> Drawn well!

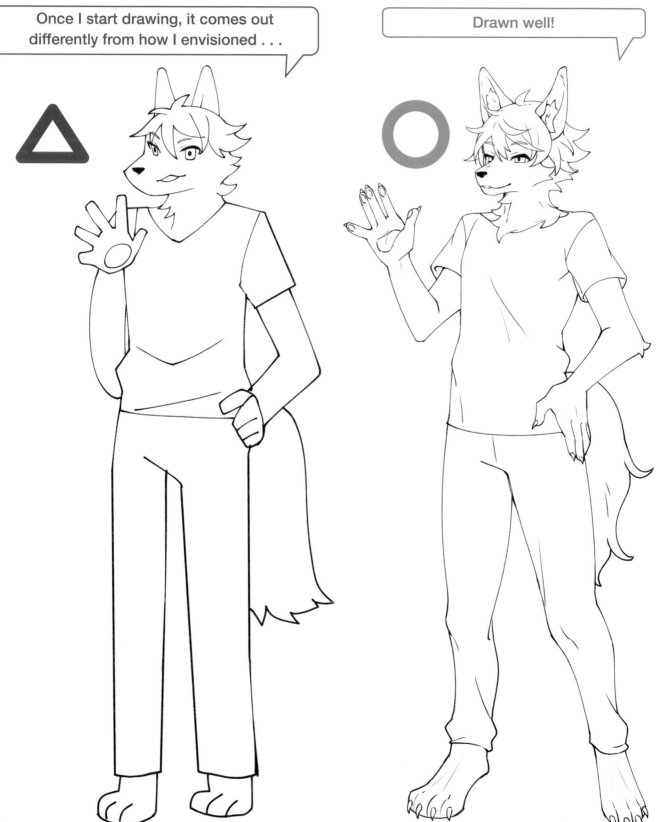

What's the difference?

Add in the details!

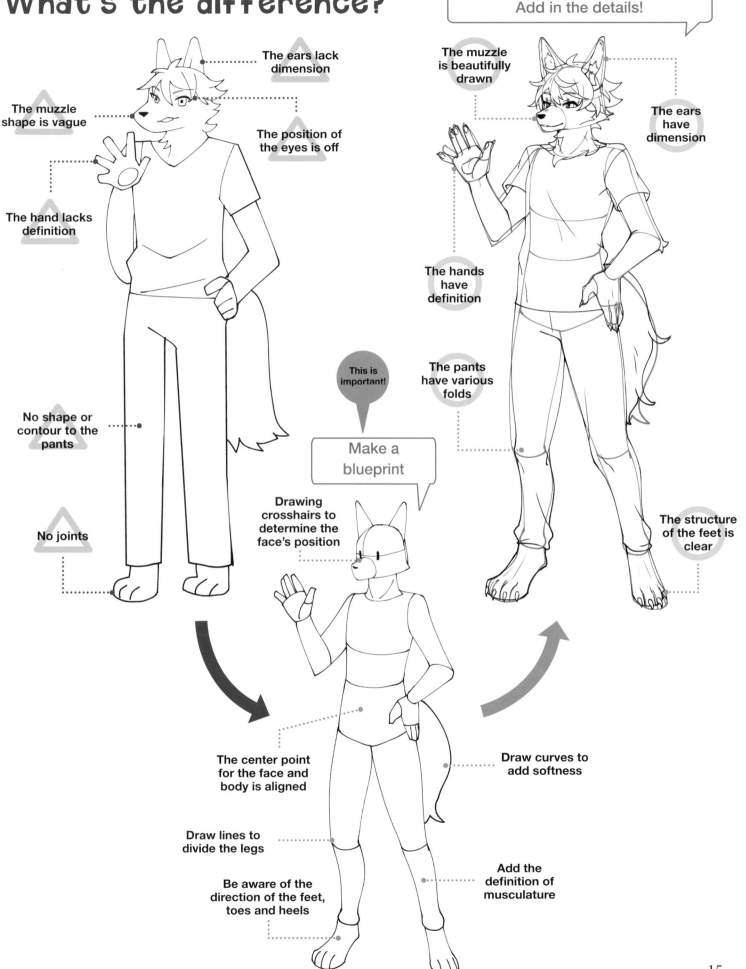

The ears lack dimension

The muzzle shape is vague

The position of the eyes is off

The hand lacks definition

No shape or contour to the pants

No joints

The muzzle is beautifully drawn

The ears have dimension

The hands have definition

The pants have various folds

The structure of the feet is clear

This is important!

Make a blueprint

Drawing crosshairs to determine the face's position

The center point for the face and body is aligned

Draw lines to divide the legs

Be aware of the direction of the feet, toes and heels

Draw curves to add softness

Add the definition of musculature

The Skeleton & Muscles: Humans vs. Furries

Let's take a look at the differences between human and furry anatomy. When we compare the two structures side by side, there isn't a big difference. The main changes are noticeable in the head and legs, but the differences are minimal. Let's compare.

The back side of the human skull is rounded to accommodate the brain, so it's longer in comparison to furry skulls.

The head of the furry has more animal characteristics. The muzzle sticks out so the front of the skull is elongated, while the back is shorter.

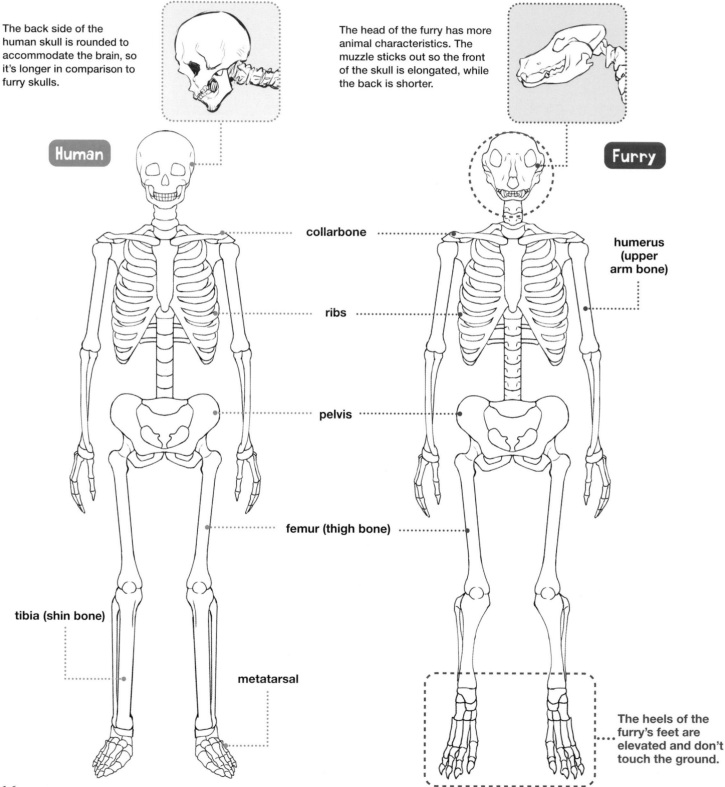

Human

Furry

collarbone

humerus (upper arm bone)

ribs

pelvis

femur (thigh bone)

tibia (shin bone)

metatarsal

The heels of the furry's feet are elevated and don't touch the ground.

Bone structure of an animal

In the skeleton of a quadruped, the bone structure is similar to a human's. Yet unlike humans, it's unable to walk on two legs. The head protrudes forward, the neck is long and the tail contains segmented bones.

The three main parts, the head, ribcage and pelvis, can pose challenges for the furry artist, but a careful study of the anatomy will not only help you understand the bone structure of the actual animals but is invaluble when you need to anthropomorphize an animal character. To set your furries in motion, you need to focus on the feet. But first things first: begin with the basics!

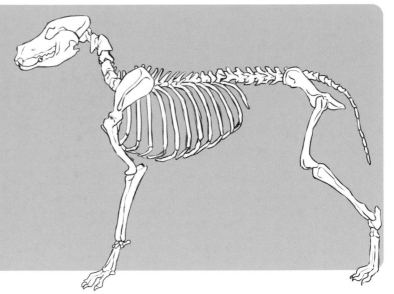

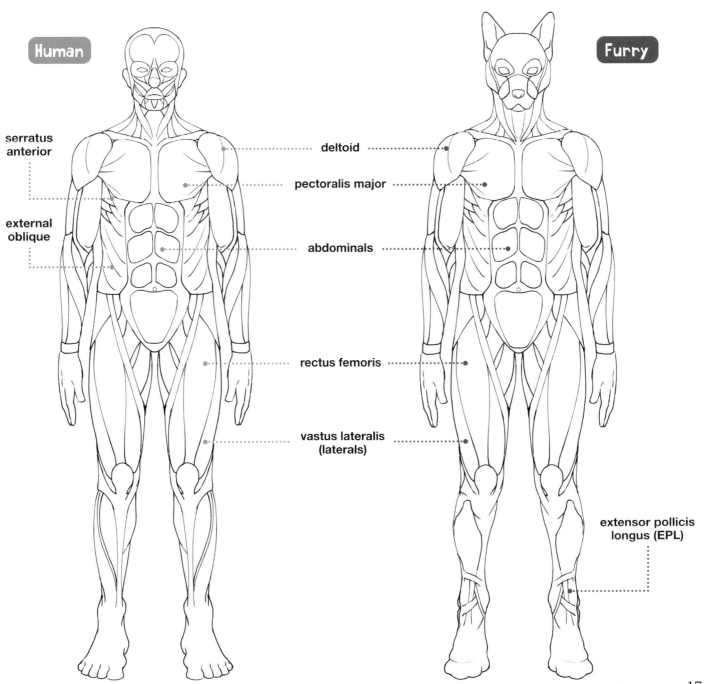

Human

Furry

serratus anterior

external oblique

deltoid

pectoralis major

abdominals

rectus femoris

vastus lateralis (laterals)

extensor pollicis longus (EPL)

Humans: Sketching the Basic Shape

A sketch acts as the basic framework, the simple blueprint for your drawing. It's based on the human skeleton and musculature. Before you start adding furry features, explore basic human form.

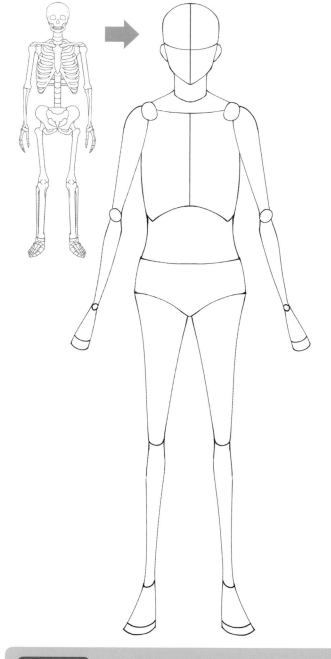

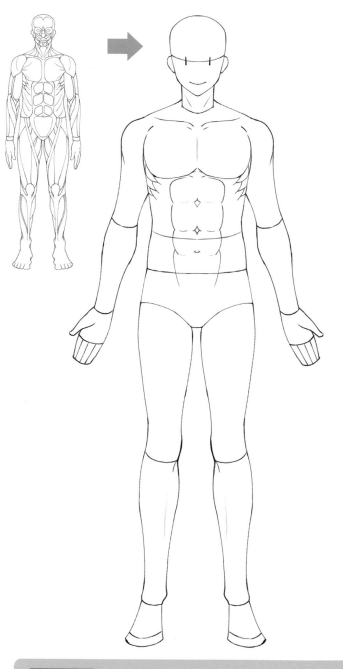

Step 1: Sketching

First, draw the face. Draw a vertical line (center line) in the middle to determine the orientation. Next, draw a vertical line to determine the orientation of the upper body, which is based on the shape of the ribs. Draw joints on the shoulders, elbows and wrists.

Step 2: Fleshing out

Draw muscles all over the body, especially along the limbs, which influences the character's overall silhouette. By fleshing out the shoulders, upper arms, thighs and calves, you'll have a realistic body and well-defined framework to work with.

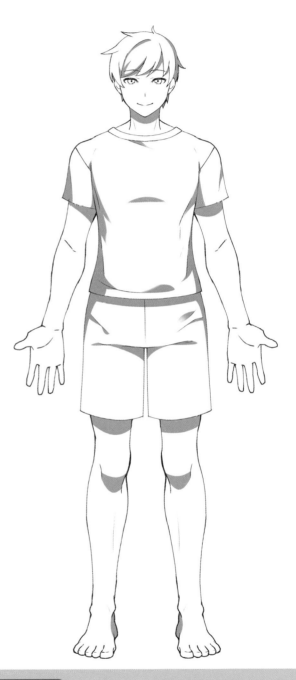

Step 3: Rough draft

Outline the character based on the sketch. Draw clothes to fit the body and add hair. At this step, let's think about the character's personality and draw his, her or its facial expressions.

Step 4: Final touches

Erase the outline and draw wrinkles and shadows on the clothes. Establish the position of the light source. Shadows can be created on areas where parts overlap, such as under the neck and the hem of clothes.

Furries:
Sketching the Basic Shape

Continuing on the next two pages, let's review how to draw the basic outline and form of a furry. It looks roughly the same as the initial sketch of a human character, but there are many key differences, such as the size of the limbs, the shape of the head and the hair.

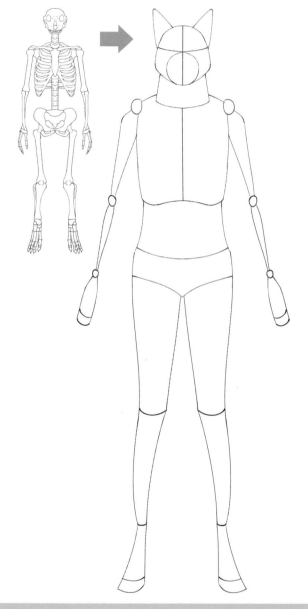

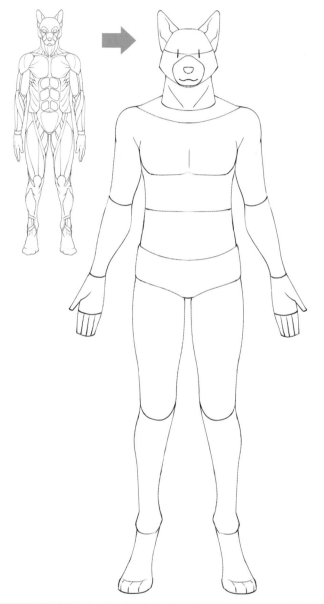

Step 1: Sketching

The neck and limbs are positioned based on the torso, which is similar to a human's. When drawing a furry, make the neck thicker and the head wider than a human's. Draw a circle for the muzzle (page 22) on the lower half of the face. The hand is drawn larger than a human's, and the instep is drawn based on a dog's paw.

Step 2: Fleshing out

Draw in muscles and ears from the top of the outline. For this example, we'll use a dog so draw four toes (resembling a paw). Outline the shape of the feet so the heels are over the ground. Shape the muzzle around the face and draw the tip of the nose and lips.

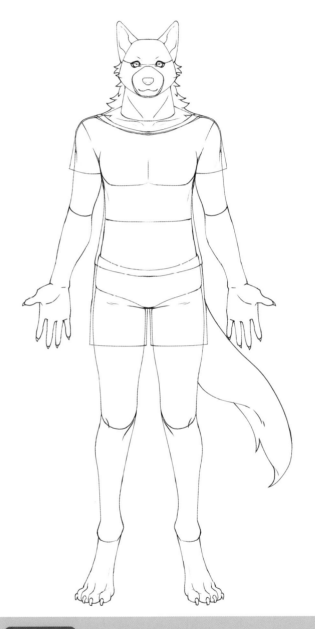

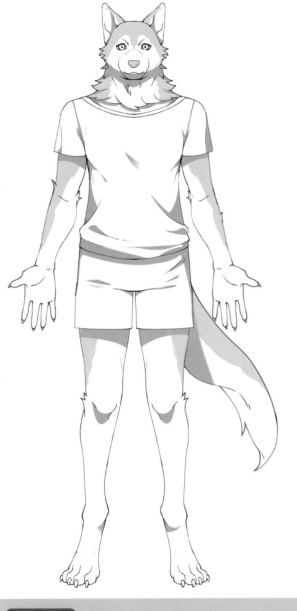

Step 3: Rough draft

Let's add in the fur, which can affect the overall silhouette of the character. If the furry is wearing clothes, add them at this step. For furries with distinct physical features such as tails and fin, make sure to keep that in mind when designing their clothes.

Step 4: Final touches

Erase the outline and finish with the furry's coat pattern, wrinkles on the clothes, shadows and other details. By drawing fur around the joints and other parts you want to highlight, it'll make the fur look shorter for the entire body.

Furry Faces

Faces form the foundation for your furry, its distinctive features and expressions setting your character apart. How does an animal's face, skull and head differ from the human form? Overlaying the silhouettes of some common creatures is a good way of highlighting the key differences.

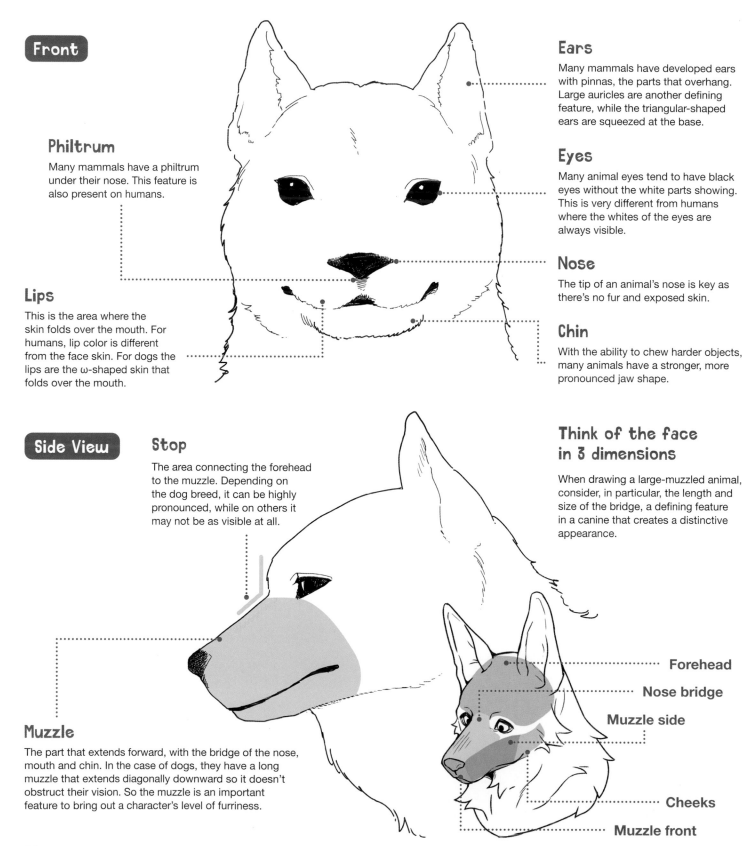

Front

Philtrum

Many mammals have a philtrum under their nose. This feature is also present on humans.

Lips

This is the area where the skin folds over the mouth. For humans, lip color is different from the face skin. For dogs the lips are the ω-shaped skin that folds over the mouth.

Ears

Many mammals have developed ears with pinnas, the parts that overhang. Large auricles are another defining feature, while the triangular-shaped ears are squeezed at the base.

Eyes

Many animal eyes tend to have black eyes without the white parts showing. This is very different from humans where the whites of the eyes are always visible.

Nose

The tip of an animal's nose is key as there's no fur and exposed skin.

Chin

With the ability to chew harder objects, many animals have a stronger, more pronounced jaw shape.

Side View

Stop

The area connecting the forehead to the muzzle. Depending on the dog breed, it can be highly pronounced, while on others it may not be as visible at all.

Think of the face in 3 dimensions

When drawing a large-muzzled animal, consider, in particular, the length and size of the bridge, a defining feature in a canine that creates a distinctive appearance.

Muzzle

The part that extends forward, with the bridge of the nose, mouth and chin. In the case of dogs, they have a long muzzle that extends diagonally downward so it doesn't obstruct their vision. So the muzzle is an important feature to bring out a character's level of furriness.

Forehead

Nose bridge

Muzzle side

Cheeks

Muzzle front

Comparing Animal and Human Silhouettes

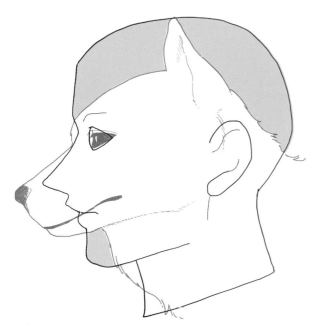

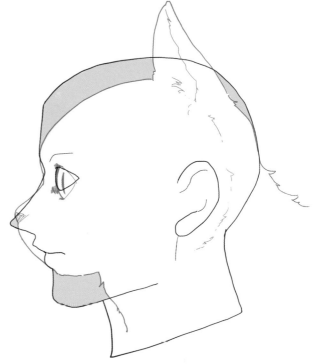

Differences between human and dog faces

If you align the two figures based on the eyes, the human silhouette has a large head and flat eyes and nose. Because they have such different shapes and orientations, if you draw an animal face with the shape of a human skull, it will look disjointed and imbalanced.

Differences between human and cat faces

Cats with short muzzles have silhouettes that looks similar to humans'. However, if you look at the forehead and chin, you can see that the shape of the cat's head is compact and smallish, while the human head extends vertically.

When drawing a furry, the technique is to mix the facial feature with human and animal elements. For example, the length of the head and the direction of the eyes are human-like. Then the muzzle area down to the lower jaw is animal-like, while the neck is as thin as a human's. In this way, you can create a furry with a human-like face. On the other hand, you can increase the degree of furriness by making everything above the neck the face and features of an animal.

Foundations of a furry's face

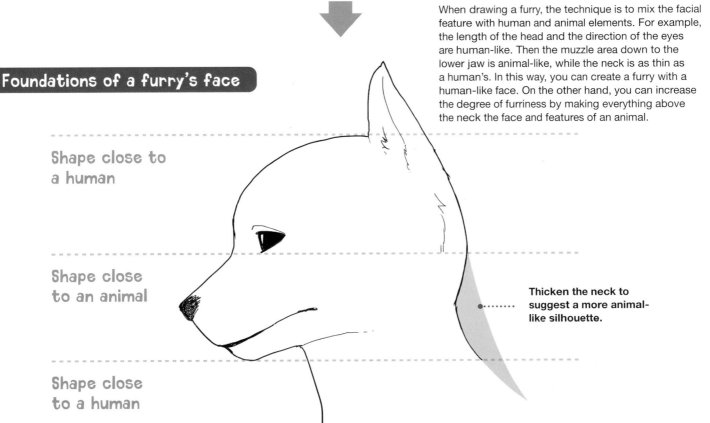

Shape close to a human

Shape close to an animal

Shape close to a human

Thicken the neck to suggest a more animal-like silhouette.

2 Focus on Chests and Pectorals

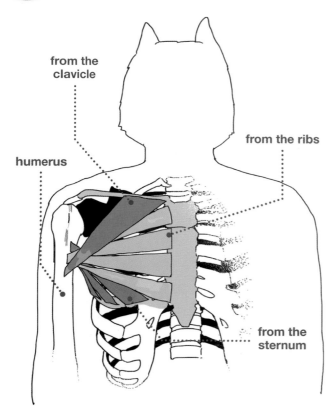

from the clavicle

humerus

from the ribs

from the sternum

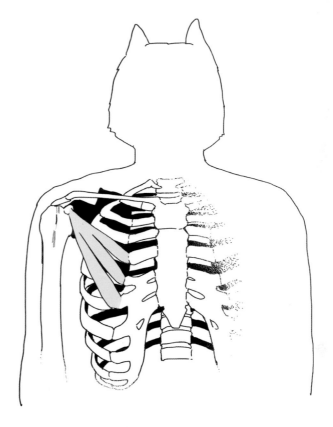

Pectoralis major

The pectoralis major muscle connects the sternum, clavicle (collarbone) and ribs to the humerus, each overlapping the other like a fan.

Pectoralis minor

The pectoralis minor muscle is located under the pectoralis major. Unlike the pectoralis major, the pectoralis minor is concentrated around the shoulder blades. The pectoralis minor appears by bulging in the middle area of the pectoralis major.

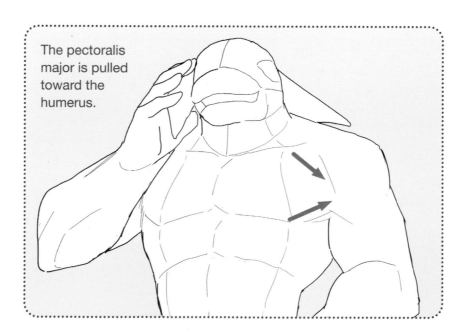

The pectoralis major is pulled toward the humerus.

Furries in Motion: Action Poses

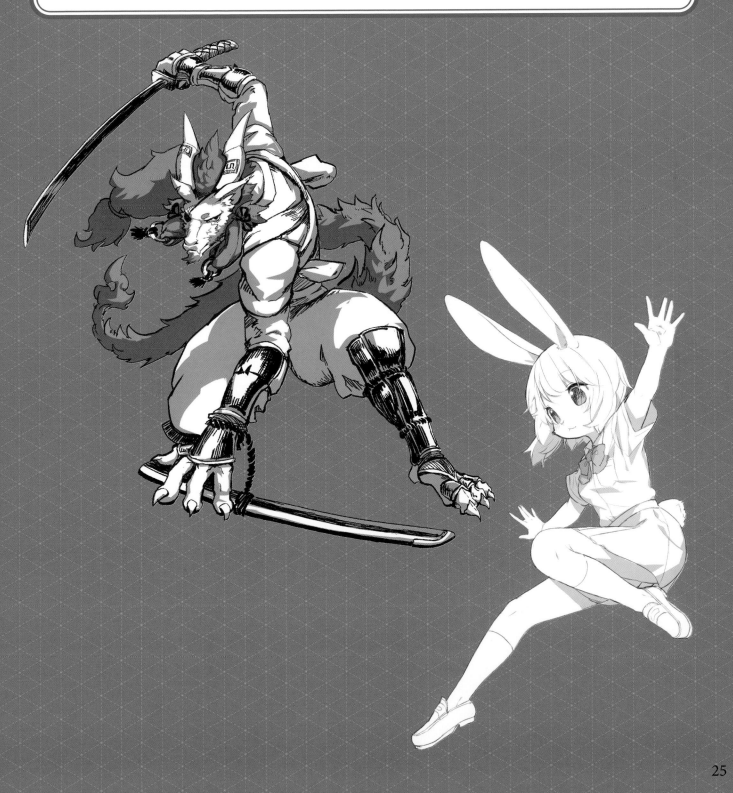

Husky

Pose 🐾 **Standing tall**

Illustrator: **Yamayagi Yama**

A husky with a long muzzle, fearless expression, fluffy coat and a sharp, muscular body can make for a distinctively drawn furry. First, draw the body in a simple frontal pose.

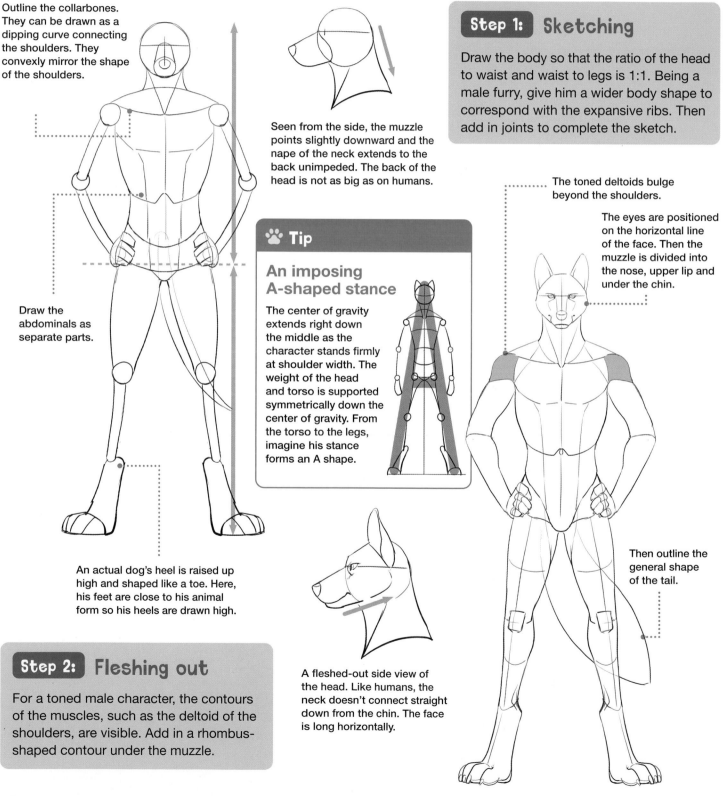

Outline the collarbones. They can be drawn as a dipping curve connecting the shoulders. They convexly mirror the shape of the shoulders.

Seen from the side, the muzzle points slightly downward and the nape of the neck extends to the back unimpeded. The back of the head is not as big as on humans.

Step 1: Sketching

Draw the body so that the ratio of the head to waist and waist to legs is 1:1. Being a male furry, give him a wider body shape to correspond with the expansive ribs. Then add in joints to complete the sketch.

The toned deltoids bulge beyond the shoulders.

The eyes are positioned on the horizontal line of the face. Then the muzzle is divided into the nose, upper lip and under the chin.

Draw the abdominals as separate parts.

🐾 Tip

An imposing A-shaped stance

The center of gravity extends right down the middle as the character stands firmly at shoulder width. The weight of the head and torso is supported symmetrically down the center of gravity. From the torso to the legs, imagine his stance forms an A shape.

An actual dog's heel is raised up high and shaped like a toe. Here, his feet are close to his animal form so his heels are drawn high.

Step 2: Fleshing out

For a toned male character, the contours of the muscles, such as the deltoid of the shoulders, are visible. Add in a rhombus-shaped contour under the muzzle.

A fleshed-out side view of the head. Like humans, the neck doesn't connect straight down from the chin. The face is long horizontally.

Then outline the general shape of the tail.

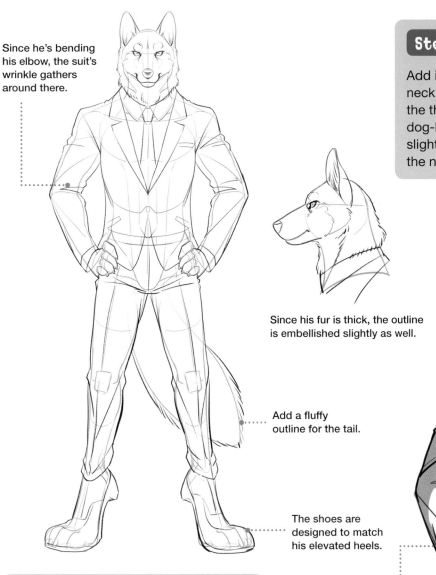

Since he's bending his elbow, the suit's wrinkle gathers around there.

Step 3: Rough draft

Add in his clothes and fur. For the fur around the neck, draw it a little thicker than the outline. Now the thinness of the neck will disappear and a more dog-like silhouette emerges. The collar of the suit is slightly open because of the thick fur. Furthermore, the neck fur can puff up over the collar a little.

Since his fur is thick, the outline is embellished slightly as well.

Add a fluffy outline for the tail.

The shoes are designed to match his elevated heels.

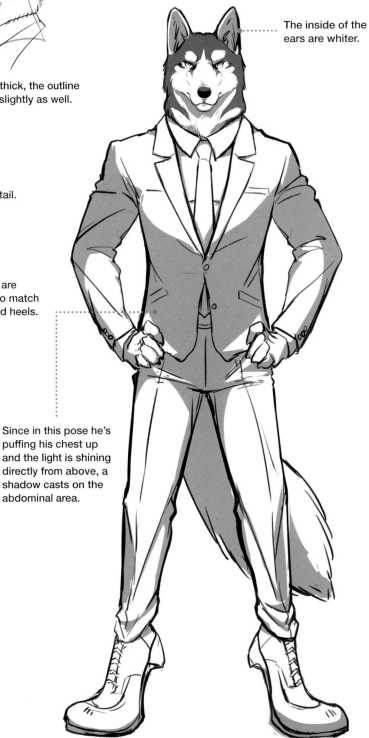

The inside of the ears are whiter.

Since in this pose he's puffing his chest up and the light is shining directly from above, a shadow casts on the abdominal area.

Step 4: Final touches

Now erase the sketch outlines and shade in the character. The pattern of a husky varies but generally the eyes and cheeks are white, especially between the eyebrows. The neck is black and the outside center area is white.

🐾 Tip

Pose from a diagonal view

An imposing stance is not just a character standing upright. You'll get a more imposing presence from the character when you draw him puffing up his chest. If you look from the side, you can see that in this posture the chest is sticking forward. The position of the shoulders doesn't change, but they look like they're pulled back because the chest is sticking out.

Calico Cat

Cartoony　Slim　Furry

Pose 🐾 Waving

Illustrator: Yamayagi Yama

A compactly cute feline, for this character, you can accentuate the slinky, curvy litheness that is associated with cats. This is a good standard pose to master, the front-facing wave.

Using the horizontal face lines as reference, position the bridge of the nose, nose tip, whiskers (the ω of the mouth) and open mouth.

For female characters, draw the ribs with a smaller width. Also, the lower ribs constrict toward the waist.

The width of the pelvis is about the same as the waist.

Step 1: Sketching

In this composition we'll be drawing a cat with a small physique and a cute face. The character will be based on a girl's body and we'll be giving her cat features. The pose is a basic front-view waving pose.

🐾 Tip

Wrist movement

When drawing a waving motion, if you align the forearm and the middle finger in a straight line, the movement will look stiff. The arms have joints so the wrist is flexible. Therefore, if you tilt the wrist and shift the middle finger's position, you'll give the hand a more natural pose.

When you raise your arm, the pectoralis major muscle that connects to your humerus is pulled up with it.

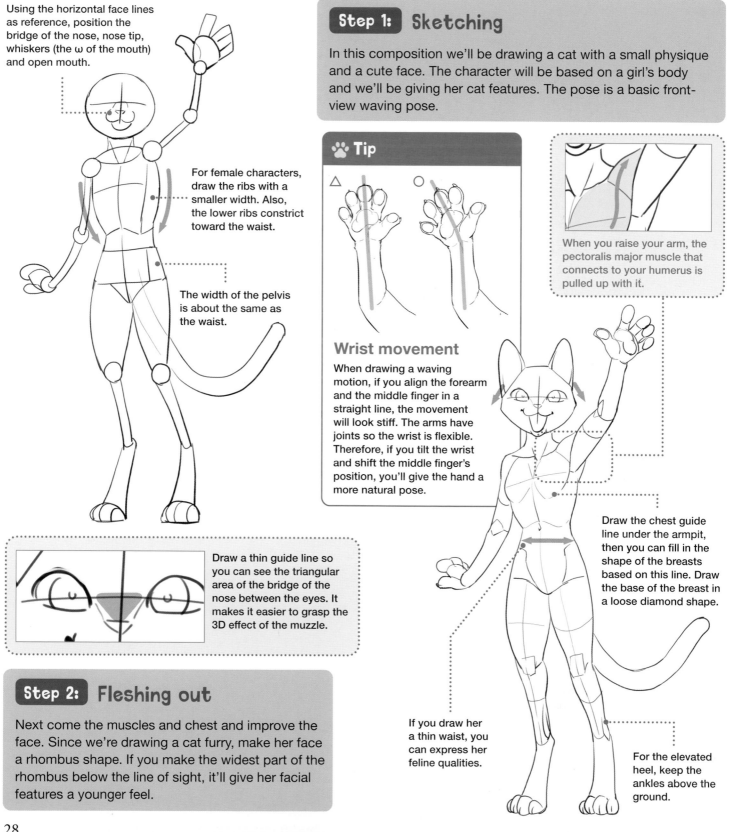

Draw the chest guide line under the armpit, then you can fill in the shape of the breasts based on this line. Draw the base of the breast in a loose diamond shape.

Draw a thin guide line so you can see the triangular area of the bridge of the nose between the eyes. It makes it easier to grasp the 3D effect of the muzzle.

If you draw her a thin waist, you can express her feline qualities.

For the elevated heel, keep the ankles above the ground.

Step 2: Fleshing out

Next come the muscles and chest and improve the face. Since we're drawing a cat furry, make her face a rhombus shape. If you make the widest part of the rhombus below the line of sight, it'll give her facial features a younger feel.

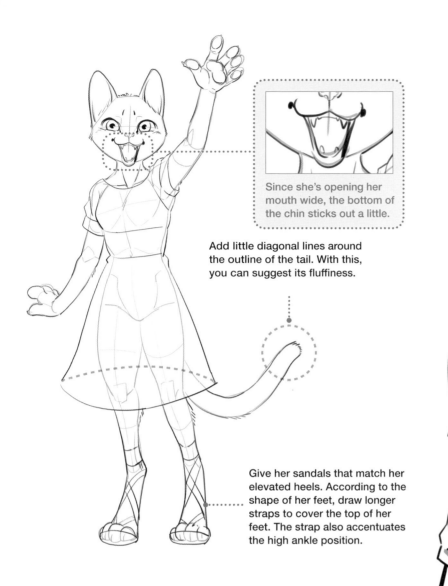

Since she's opening her mouth wide, the bottom of the chin sticks out a little.

Add little diagonal lines around the outline of the tail. With this, you can suggest its fluffiness.

Give her sandals that match her elevated heels. According to the shape of her feet, draw longer straps to cover the top of her feet. The strap also accentuates the high ankle position.

Step 3: Rough draft

Draw the dress, fur, mouth and waist. Since she's wearing a thin and fluttery dress, draw the upper body portion to fit the outline and then spread it in a cylinder shape on the bottom, covering the lower body.

The edge of her fur pattern also covers the outer corner of the eyes up to the cheeks.

Draw the hem of the dress. Imagine a Ω shape of the hem's folds. This makes it easier to express the flare of the dress.

Step 4: Final touches

Draw in her fur pattern, winkles and shadows on the clothes to complete the illustration. The pattern of a calico cat is complex and it differs with each cat. Separate the left and right side of her face with two different colors. If you simplify the pattern, it'll make it easier to convey her uniqueness. Her dress is the kind the hugs the upper body and waist and flares down the waist. Pay close attention to the direction the fabric is pulled in.

A calico cat generally have few patterns on their limbs. Keep the fur pattern on her outer side and avoid the inner parts of the body. By doing this, you'll have a natural looking calico cat fur pattern.

29

Tiger

Pose 🐾 Looking back

Illustrator: Yamayagi Yama

In this composition, we'll be drawing a male tiger looking over his shoulder. The key point here is the twist of the neck and the throat and how the backward glance affects the center of gravity.

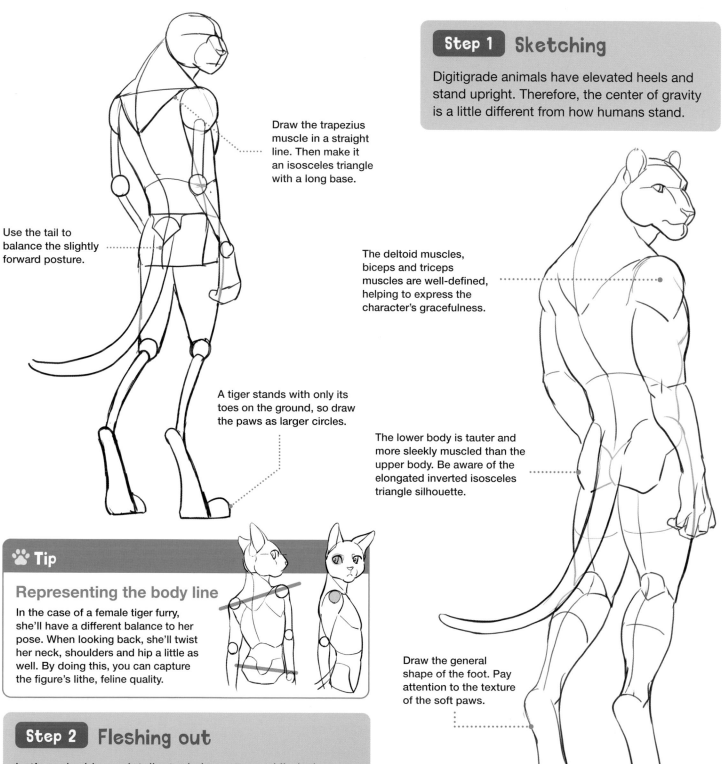

Draw the trapezius muscle in a straight line. Then make it an isosceles triangle with a long base.

Use the tail to balance the slightly forward posture.

A tiger stands with only its toes on the ground, so draw the paws as larger circles.

Step 1 Sketching

Digitigrade animals have elevated heels and stand upright. Therefore, the center of gravity is a little different from how humans stand.

The deltoid muscles, biceps and triceps muscles are well-defined, helping to express the character's gracefulness.

The lower body is tauter and more sleekly muscled than the upper body. Be aware of the elongated inverted isosceles triangle silhouette.

Draw the general shape of the foot. Pay attention to the texture of the soft paws.

🐾 Tip

Representing the body line

In the case of a female tiger furry, she'll have a different balance to her pose. When looking back, she'll twist her neck, shoulders and hip a little as well. By doing this, you can capture the figure's lithe, feline quality.

Step 2 Fleshing out

Let's make him an intellectual character and limit the animal-like features. Yet in order to express his tiger-like features, layer on the necessary muscles.

30

Putting a pair of glasses on a fierce tiger stikes a nice contrast between the brainy and the bestial. This adds to the character.

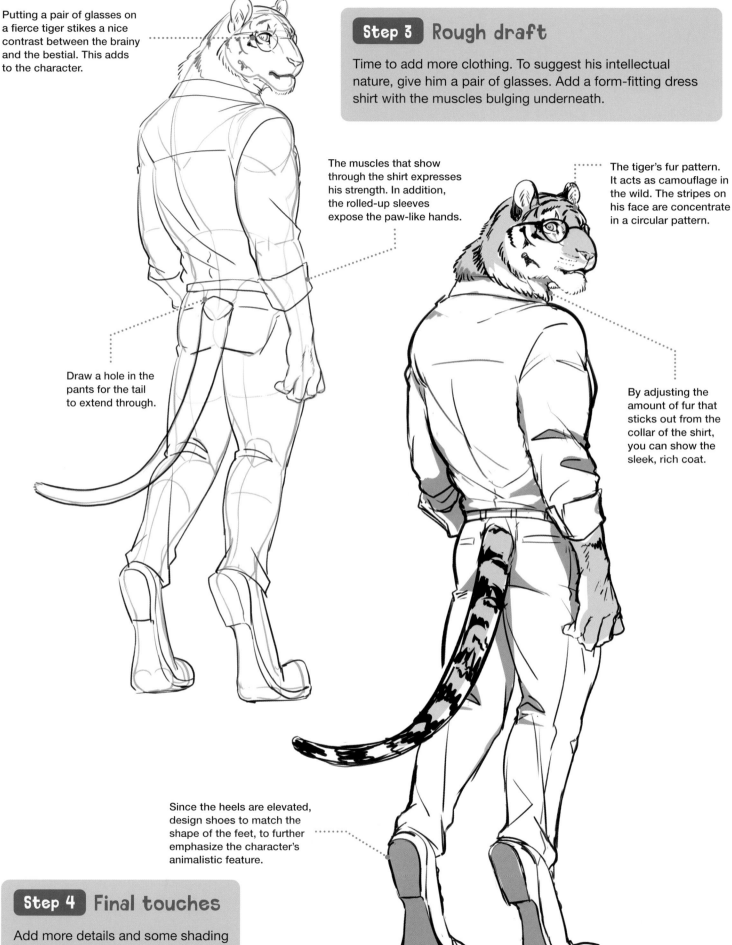

Step 3 Rough draft

Time to add more clothing. To suggest his intellectual nature, give him a pair of glasses. Add a form-fitting dress shirt with the muscles bulging underneath.

The muscles that show through the shirt expresses his strength. In addition, the rolled-up sleeves expose the paw-like hands.

The tiger's fur pattern. It acts as camouflage in the wild. The stripes on his face are concentrate in a circular pattern.

Draw a hole in the pants for the tail to extend through.

By adjusting the amount of fur that sticks out from the collar of the shirt, you can show the sleek, rich coat.

Since the heels are elevated, design shoes to match the shape of the feet, to further emphasize the character's animalistic feature.

Step 4 Final touches

Add more details and some shading and you're done!

31

Horse

Pose 🐾 **Standing at ease**

Illustrator: **Yamayagi Yama**

This one's a snap, right? A female horse strikes a natural standing pose. Focus here on creating a relaxed, natural pose. Pay particular attention to the distance between the left and right eyes.

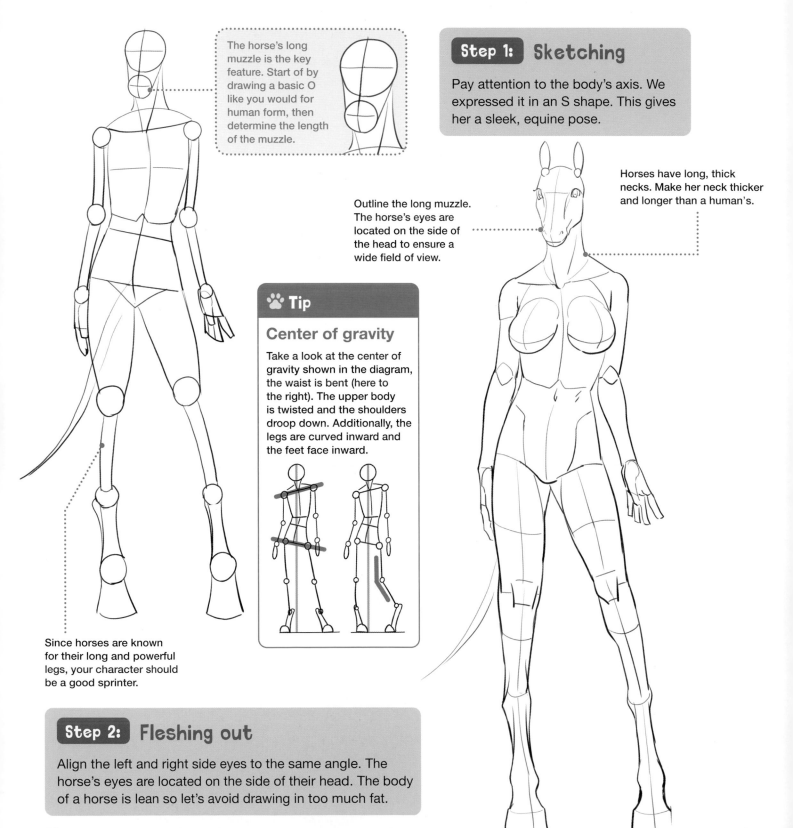

The horse's long muzzle is the key feature. Start of by drawing a basic O like you would for human form, then determine the length of the muzzle.

Step 1: Sketching

Pay attention to the body's axis. We expressed it in an S shape. This gives her a sleek, equine pose.

Outline the long muzzle. The horse's eyes are located on the side of the head to ensure a wide field of view.

Horses have long, thick necks. Make her neck thicker and longer than a human's.

🐾 Tip

Center of gravity

Take a look at the center of gravity shown in the diagram, the waist is bent (here to the right). The upper body is twisted and the shoulders droop down. Additionally, the legs are curved inward and the feet face inward.

Since horses are known for their long and powerful legs, your character should be a good sprinter.

Step 2: Fleshing out

Align the left and right side eyes to the same angle. The horse's eyes are located on the side of their head. The body of a horse is lean so let's avoid drawing in too much fat.

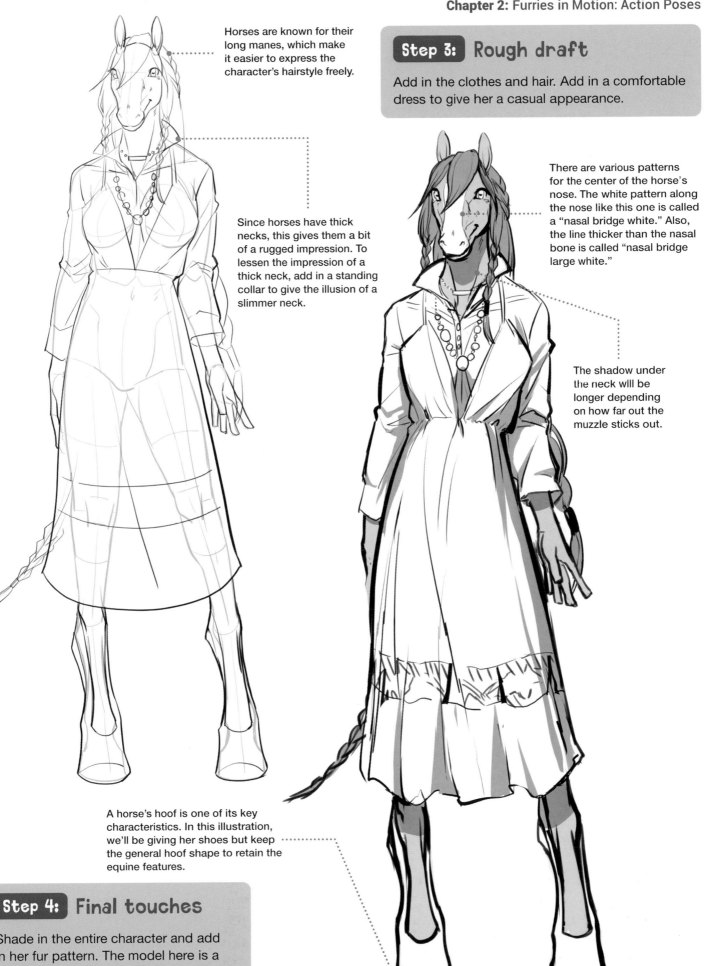

Horses are known for their long manes, which make it easier to express the character's hairstyle freely.

Step 3: Rough draft

Add in the clothes and hair. Add in a comfortable dress to give her a casual appearance.

Since horses have thick necks, this gives them a bit of a rugged impression. To lessen the impression of a thick neck, add in a standing collar to give the illusion of a slimmer neck.

There are various patterns for the center of the horse's nose. The white pattern along the nose like this one is called a "nasal bridge white." Also, the line thicker than the nasal bone is called "nasal bridge large white."

The shadow under the neck will be longer depending on how far out the muzzle sticks out.

A horse's hoof is one of its key characteristics. In this illustration, we'll be giving her shoes but keep the general hoof shape to retain the equine features.

Step 4: Final touches

Shade in the entire character and add in her fur pattern. The model here is a standard brown or chestnut mare.

Collie

Human Head · Slim · Furry

Pose 🐾 Lying down

Illustrator: **Suzumori**

A short-haired dog with long legs and a long body, the skeletal shape is similar to a human's—if only we had short muzzles! Accentuate the character's canine qualities through the posture and sleek coat.

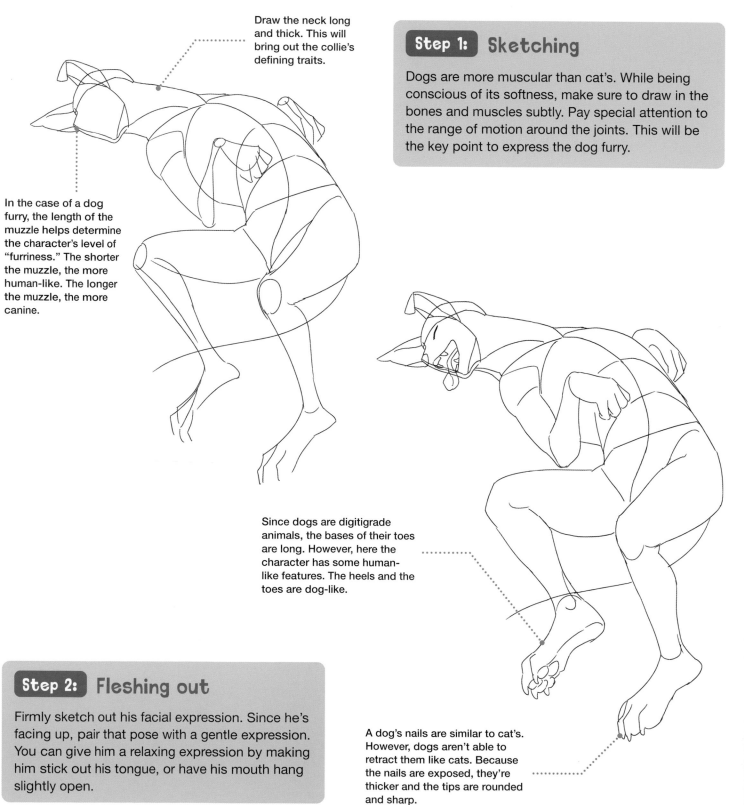

Draw the neck long and thick. This will bring out the collie's defining traits.

In the case of a dog furry, the length of the muzzle helps determine the character's level of "furriness." The shorter the muzzle, the more human-like. The longer the muzzle, the more canine.

Step 1: Sketching

Dogs are more muscular than cat's. While being conscious of its softness, make sure to draw in the bones and muscles subtly. Pay special attention to the range of motion around the joints. This will be the key point to express the dog furry.

Since dogs are digitigrade animals, the bases of their toes are long. However, here the character has some human-like features. The heels and the toes are dog-like.

Step 2: Fleshing out

Firmly sketch out his facial expression. Since he's facing up, pair that pose with a gentle expression. You can give him a relaxing expression by making him stick out his tongue, or have his mouth hang slightly open.

A dog's nails are similar to cat's. However, dogs aren't able to retract them like cats. Because the nails are exposed, they're thicker and the tips are rounded and sharp.

Since the character has his mouth open, you can see his front teeth. You can also add the sagging to hide the front teeth if you like.

Step 3: Rough draft

Decide on the length of the fur and its growth direction. Don't worry about the fur on the chest and abdomen for now. It's easier to control the final appearance if you decide the amount of hair that covers the overall silhouette first.

Determine the amount of fur by putting guide lines on the buttocks and thighs.

Step 4: Final touches

Even with short fur, you can still add some lines to indicate the muscles. The more defined the muscle lines are, the less furry the character appears.

The tongue is more like a dog's, so draw it extra long. To show the body's relaxed state, draw it in a loose S shape.

🐾 Tip

Assume the position!

Even though you're human, if it's a difficult pose to master, take the plunge: twist your body, curl your back, assume the position. It just might greatly improve your illustration.

In this illustration, he has 4 toes on his back legs. You may add wolf claws, or make it more human-like by giving him 5 toes.

Somali Cat

Pose 🐾 Crouching down

Illustrator: **Suzumori**

A Somali cat's notable feature is their large eyes. A curious and muscly type, to highlight these defining characteristics, pose him crouched down, slinking along on all fours.

Step 1: Sketching

The line for the back and the tail are connected in a large curve. With this, you suggest the cat's flexibility. By making the movement of the joints look bigger, for a bolder position, you can give the character suggestions of a human pose.

🐾 Tip

A cat's face

A cat's face is relatively close to a human's, so it's easy to adjust features, such as the face size and the chin length, to make the character more animal-like. If you want it to look more human-like, reduce the bulges around the mouth. To draw a cat's face, make the entire face and forehead a diamond shape. When drawing a cat furry, position the eyes closer to the chin for more animal-like features. If you want the character to be more human-like, position the eyes farther away from the chin.

More weight is being place on the right hand since it's close to his torso.

Use simple lines to express the fingers spreading out.

Use the pupil to determine the line of sight. In this pose, he's aiming for prey so draw the pupils round and large.

Step 2: Fleshing out

Since Somali cats have long fur, there's no need to focus on the muscles as much. For short-fur breeds, you can add the muscle mass at this step. If you make the character slender, it'll be easier to address the final silhouette by adjusting the fur.

Flesh out the fingers, making them round and thick, capturing the softness of a cat's toes.

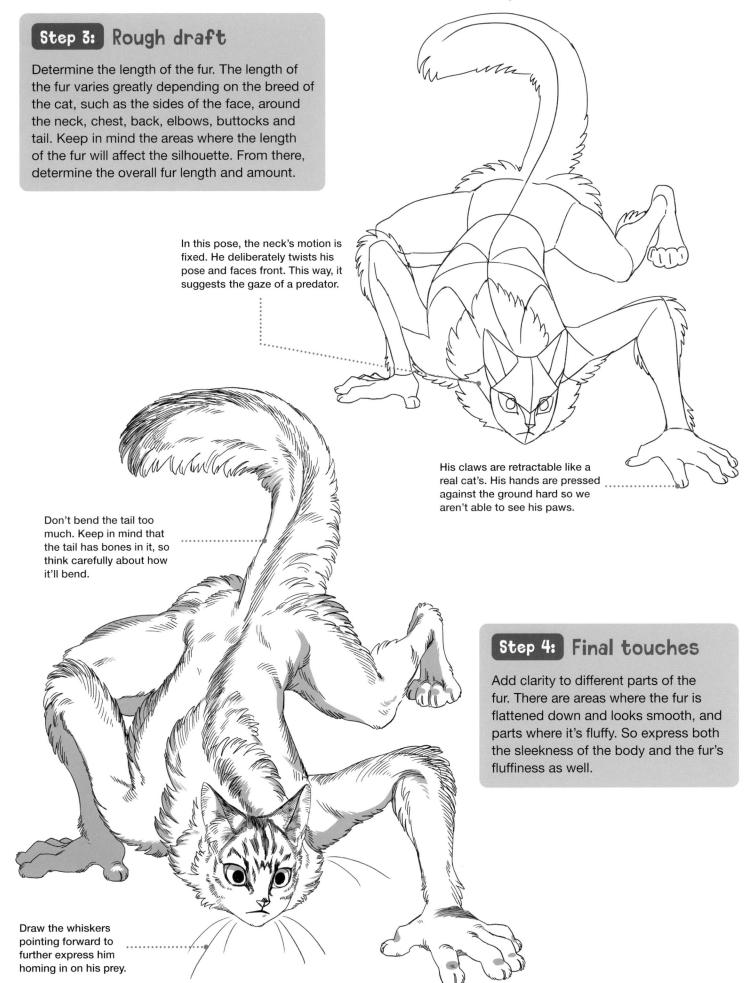

Step 3: Rough draft

Determine the length of the fur. The length of the fur varies greatly depending on the breed of the cat, such as the sides of the face, around the neck, chest, back, elbows, buttocks and tail. Keep in mind the areas where the length of the fur will affect the silhouette. From there, determine the overall fur length and amount.

In this pose, the neck's motion is fixed. He deliberately twists his pose and faces front. This way, it suggests the gaze of a predator.

His claws are retractable like a real cat's. His hands are pressed against the ground hard so we aren't able to see his paws.

Don't bend the tail too much. Keep in mind that the tail has bones in it, so think carefully about how it'll bend.

Step 4: Final touches

Add clarity to different parts of the fur. There are areas where the fur is flattened down and looks smooth, and parts where it's fluffy. So express both the sleekness of the body and the fur's fluffiness as well.

Draw the whiskers pointing forward to further express him homing in on his prey.

Swallow

Pose 🐾 Spreading wings

Illustrator: Suzumori

A swallow's key characteristic is its elongated tail feathers. The wings are divided into two sections. In this illustration, draw the body with emphasis on the cleft tail.

The wings are comprised of three layers coming out of the main body.

Step 1: Sketching

A bird furry with wings on its back and human arms separated from the wings. This type of furry will give you more freedom in posing. You can pose the human body first and then adjust the wings accordingly.

🐾 Tip

Shape of the wings

If you make the wings a little larger than the body, you can express their power. To make the human elements sleek and compact, add muscles to the wings. Balancing realism and fiction is the key to mastering this.

Pay attention to the shape of the tail. Since it's a defining motif of the character, its bold simplicity should be emphasized.

The shape of the wings varies greatly depending on the type of bird. It's a good idea to observe the wings of the modeled bird, then figure out the silhouette of the wings at this step.

Birds are digitigrades. If their feet shape is more bird-like, you can increase their level of furriness.

Step 2: Fleshing out

Determine the size and mass of the ligaments, then you can easily grasp the flow of each feature.

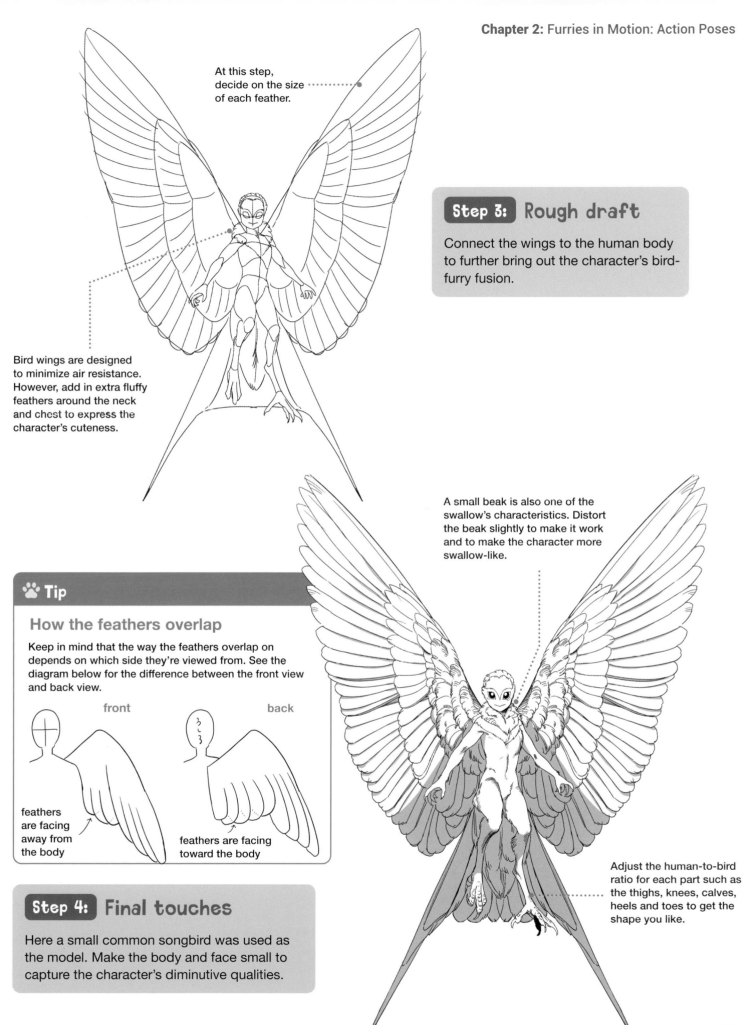

At this step, decide on the size of each feather.

Bird wings are designed to minimize air resistance. However, add in extra fluffy feathers around the neck and chest to express the character's cuteness.

Step 3: Rough draft

Connect the wings to the human body to further bring out the character's bird-furry fusion.

A small beak is also one of the swallow's characteristics. Distort the beak slightly to make it work and to make the character more swallow-like.

🐾 Tip

How the feathers overlap

Keep in mind that the way the feathers overlap on depends on which side they're viewed from. See the diagram below for the difference between the front view and back view.

front back

feathers are facing away from the body

feathers are facing toward the body

Step 4: Final touches

Here a small common songbird was used as the model. Make the body and face small to capture the character's diminutive qualities.

Adjust the human-to-bird ratio for each part such as the thighs, knees, calves, heels and toes to get the shape you like.

Hawk

Pose 🐾 **Flapping wings**

Illustrator: Suzumori

A powerful bird of prey with its signature wings unfurled, draw this flying pose viewed from the side with a slight tilt. By adding a large shadow under the body, it expresses the presence of flying high in the sky.

If you draw the neck thicker and longer, you can get closer to a bird silhouette. Also, you can naturally connect the chest and wings this way.

The legs are tucked back to reduce wind resistance.

Step 1: Sketching

A furry with wings as arms. Perhaps more bird than human, no matter what, it's potentially helpful to observe an actual bird or a nature guide when perfecting this pose.

🐾 Tip

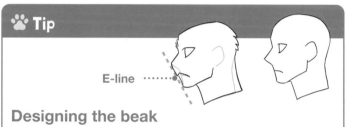

E-line

Designing the beak

You can make the tip of the human's nose the tip of the bird beak. Then use the E-line to create the opening of the beak on a human-like face.

At this step, determine the positions of the eyes and if you want to give him a beak or not.

Add in the pectoral muscles to make the motion of the flapping wings more dynamic.

Step 2: Fleshing out

Roughly determine the overall shape of the wings. Prioritize the general appearance over details and accuracy. You can move on to fill in the feathers later. It'll be easier to check the character's overall silhouette that way.

By making the feathers on the head longer, you can suggest a human's hairstyle. It's also a good way to add individuality to the character's form.

Since feathers look different depending on the angle, determine their thickness at this stage.

🐾 **Tip**

Feather shape

At the beginning, it's hard to draw windblown feathers. First, decide how the wings open in a simple line, adding in the bend, length and angle. This makes it easier to grasp to overall shape.

Step 3: Rough draft

At this step, fill in the details the individual feathers and determine how they overlap.

Step 4: Final touches

Add in the details to finish off the illustration. Carefully drawing each feather one by one will enhance and heighten the presence of the wings.

The thickness of the wings can be expressed by the thickness of the coverts.*

Add a large shadow under the body and wings to indicate the direction of the sunlight.

Draw the feathers more densely for the wing with the stronger perspective. It can look very messy so don't try to draw all the feathers. You can omit some lines so that the dense lines are condensed uniformly.

* Short feathers that cover the base of the bird's wing feathers.

41

Lion

Pose 🐾 Sitting quietly

Illustrator: Hitsujirobo

The mighty lion, its defining qualities are its angular facial features framed by a lustrous, shaggy mane. Sketch the face first, then add in the mane and the rest of the body.

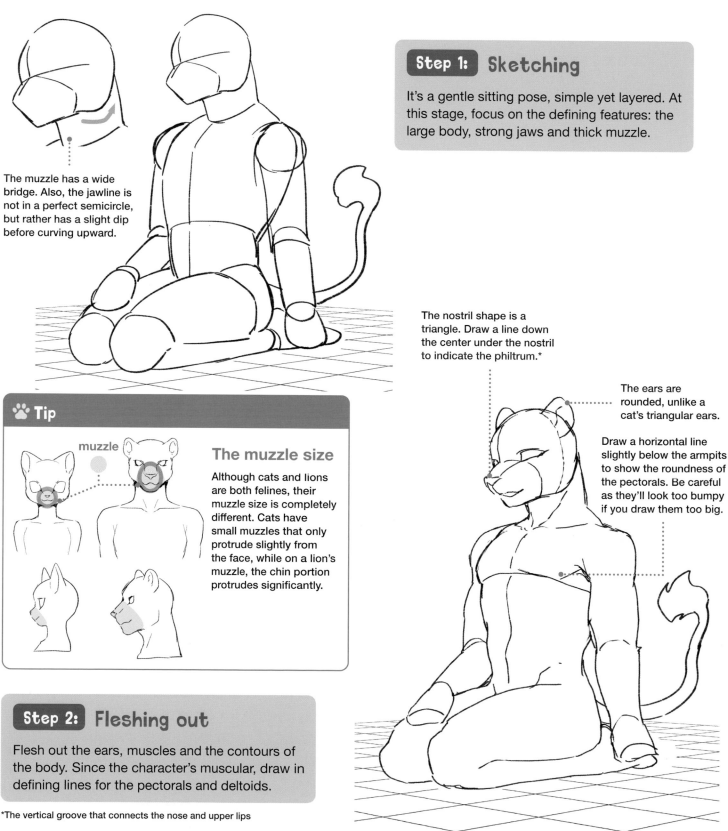

The muzzle has a wide bridge. Also, the jawline is not in a perfect semicircle, but rather has a slight dip before curving upward.

Step 1: Sketching

It's a gentle sitting pose, simple yet layered. At this stage, focus on the defining features: the large body, strong jaws and thick muzzle.

The nostril shape is a triangle. Draw a line down the center under the nostril to indicate the philtrum.*

The ears are rounded, unlike a cat's triangular ears.

Draw a horizontal line slightly below the armpits to show the roundness of the pectorals. Be careful as they'll look too bumpy if you draw them too big.

🐾 Tip

muzzle

The muzzle size

Although cats and lions are both felines, their muzzle size is completely different. Cats have small muzzles that only protrude slightly from the face, while on a lion's muzzle, the chin portion protrudes significantly.

Step 2: Fleshing out

Flesh out the ears, muscles and the contours of the body. Since the character's muscular, draw in defining lines for the pectorals and deltoids.

*The vertical groove that connects the nose and upper lips

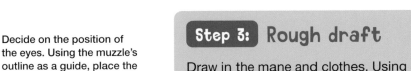

Decide on the position of the eyes. Using the muzzle's outline as a guide, place the eyes accordingly.

Draw the fur in locks and hanks to give it a fluffy texture.

Step 3: Rough draft

Draw in the mane and clothes. Using the outline from step 2, draw the mane not too over the top. The mane extends down and around the neck.

🐾 Tip

Balancing the mane

With the mane added, the entire head looks large and imposing. You can increase or decrease the mane's size in proportion to the body, in order to adjust the balance.

Step 4: Final touches

Shade in the clothes and mane. Keep in mind that the light is shining from above, so add the shading wisely to bring out the dimension.

🐾 Tip

curly fur

This gives a soft and gentle vibe.

stiff fur

This gives a tense or energized vibe.

straight fur

This gives a smart and mysterious vibe.

The character and texture of fur

You can capture or suggest the character's personality through the texture of the fur.

The mane cascades down flowing onto the shoulders. Since the light is shining from the top, shade in the underside of the mane.

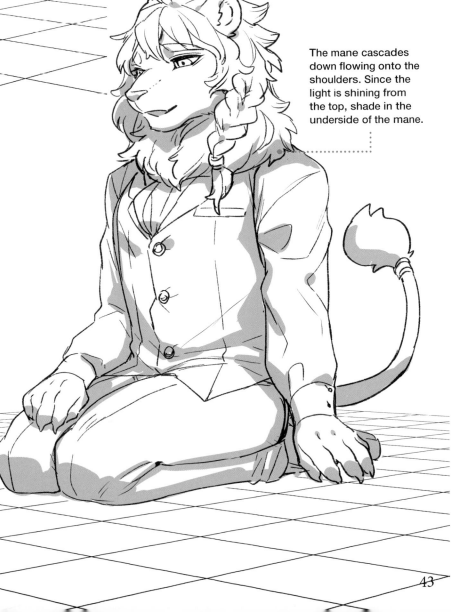

Wolf

Student Comic style Slim Furry

Pose 🐾 **Sitting crosslegged**

Illustrator: **Hitsujirobo**

A relatively simple pose, however, drawing the correct angle and bend of the legs can be complicated. Separate them into different segments, connecting each part until you've created a realistic whole.

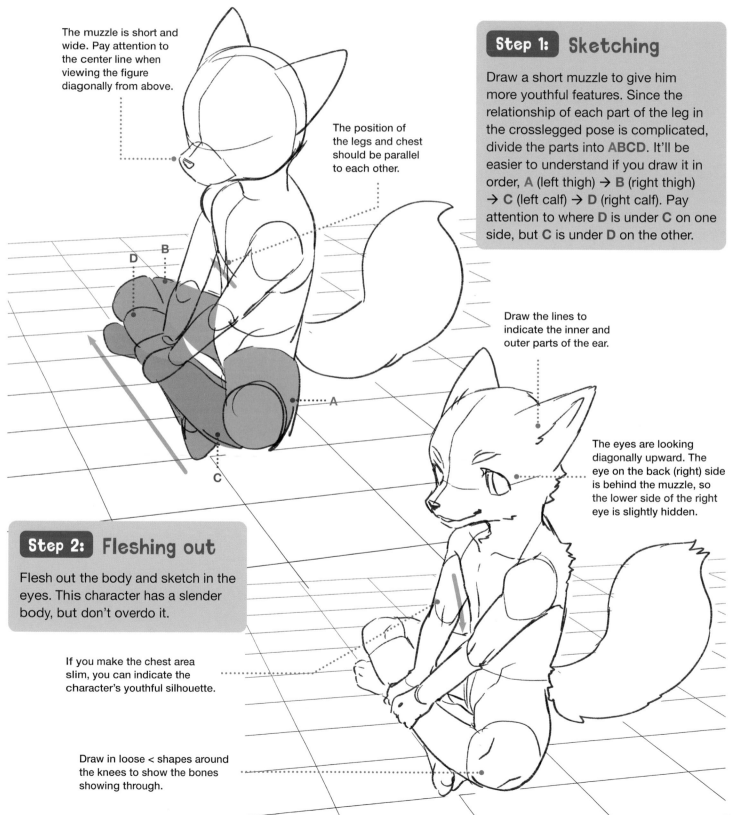

The muzzle is short and wide. Pay attention to the center line when viewing the figure diagonally from above.

The position of the legs and chest should be parallel to each other.

Step 1: Sketching

Draw a short muzzle to give him more youthful features. Since the relationship of each part of the leg in the crosslegged pose is complicated, divide the parts into **ABCD**. It'll be easier to understand if you draw it in order, **A** (left thigh) → **B** (right thigh) → **C** (left calf) → **D** (right calf). Pay attention to where **D** is under **C** on one side, but **C** is under **D** on the other.

Draw the lines to indicate the inner and outer parts of the ear.

The eyes are looking diagonally upward. The eye on the back (right) side is behind the muzzle, so the lower side of the right eye is slightly hidden.

Step 2: Fleshing out

Flesh out the body and sketch in the eyes. This character has a slender body, but don't overdo it.

If you make the chest area slim, you can indicate the character's youthful silhouette.

Draw in loose < shapes around the knees to show the bones showing through.

Draw the fluffy fur coming out from under the ears. Make it pop out from the outline so it looks like the back hair.

Wolves are nocturnal so their pupils are vertically long.

A wolf's tail is large and puffy.

The shirt is pulled by the leg that's being crossed, so can add wrinkles to indicate that tug.

Step 3: Rough draft

Add a hairstyle as well as the fluffy fur. By not drawing fur under the ears, you can create a distinctive hairstyle by referencing his animal features and still giving him a punk-style haircut. Also add more lupine features, to make the figure look less dog-like.

Step 4: Final touches

Shade in the fur along the back side, the stomach and under the tail. Adding a few shadows to the eyebrows will lend depth to the facial features and add a wild impression.

The hair in the back is being blocked by the neck, so it's completely shaded in.

🐾 **Tip**

adult child

Adult vs. child

The difference between an adult and child's muzzle is the length. It'll be easier to draw if you pay attention to the thickness of the neck.

The fingertips and the underparts of the legs are shaded in. This will help indicate the perspective.

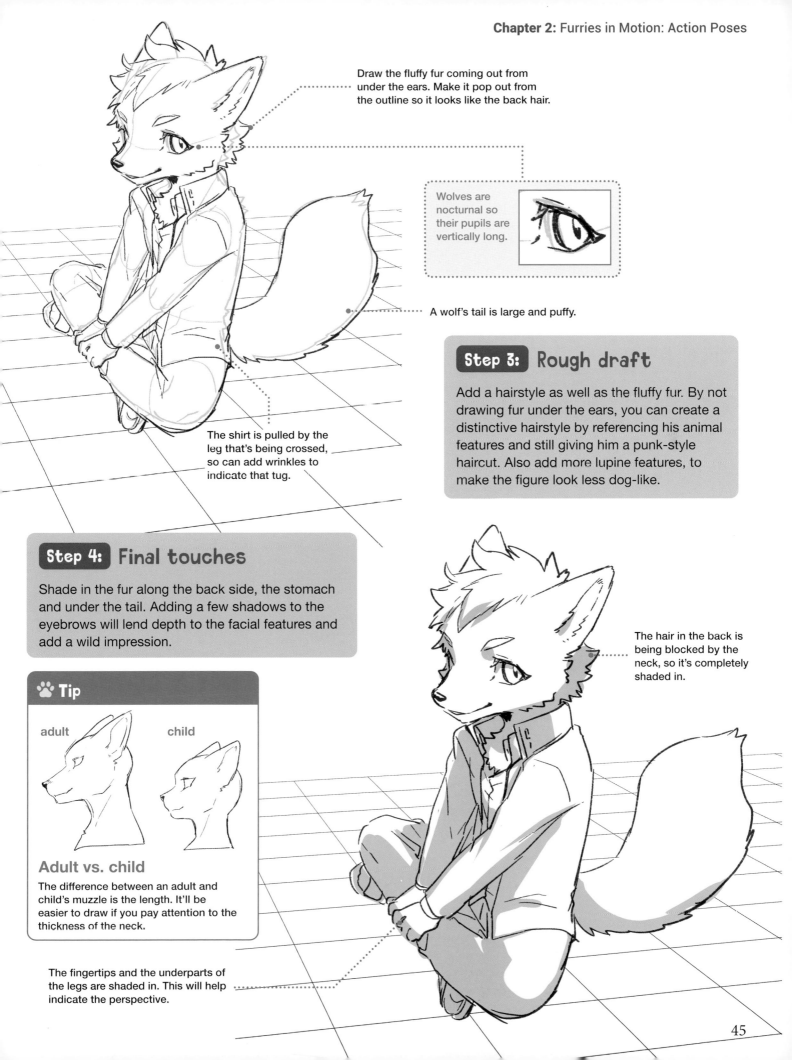

45

Dragon (young)

Pose 🐾 **Putting on a coat**

Illustrator: Hitsujirobo

With his slim physique and smooth skin, this cool young dragon furry is on the go. Unlike a traditional dragon, with its coarse scales and imposing horns, this figure has a slightly sophisticated air.

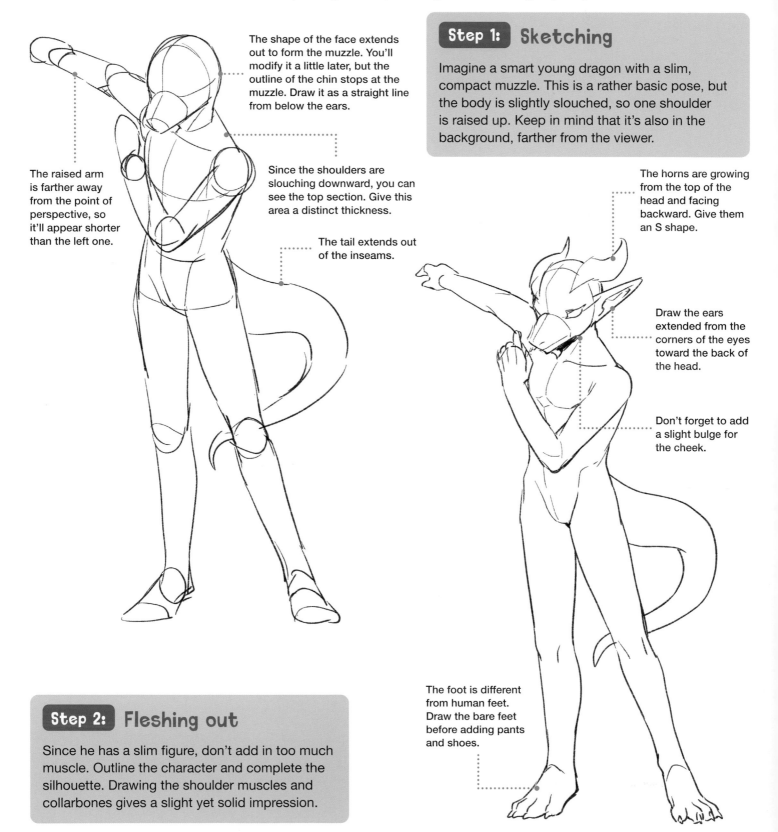

The shape of the face extends out to form the muzzle. You'll modify it a little later, but the outline of the chin stops at the muzzle. Draw it as a straight line from below the ears.

The raised arm is farther away from the point of perspective, so it'll appear shorter than the left one.

Since the shoulders are slouching downward, you can see the top section. Give this area a distinct thickness.

The tail extends out of the inseams.

Step 1: Sketching

Imagine a smart young dragon with a slim, compact muzzle. This is a rather basic pose, but the body is slightly slouched, so one shoulder is raised up. Keep in mind that it's also in the background, farther from the viewer.

The horns are growing from the top of the head and facing backward. Give them an S shape.

Draw the ears extended from the corners of the eyes toward the back of the head.

Don't forget to add a slight bulge for the cheek.

Step 2: Fleshing out

Since he has a slim figure, don't add in too much muscle. Outline the character and complete the silhouette. Drawing the shoulder muscles and collarbones gives a slight yet solid impression.

The foot is different from human feet. Draw the bare feet before adding pants and shoes.

Draw in the hem on the inner part of the coat. This will make it easier to suggest the thickness of the fabric.

Step 3: Rough draft

Draw the inner shirt, coat and pants. The inner shirt is a thinner texture but not too light. You want to give the impression that he's dressing for cold weather. The coat is a thicker material so give it larger wrinkles.

🐾 Tip

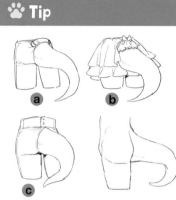

The tail hole design

Where the tail sticks out, you can add an accessory **a** a ribbon **b** or even a belt **c**. Or try coming up with a different design that you like!

The chest has a roundness to it. The lines here capture the contrast between the soft flesh underneath and the more rigidly defined garments.

Step 4: Final touches

Shade in the entire body and add wrinkles to the clothing. By adding shadows along the contours of the corners, the dimensions can be emphasized. You can express the firmness of the compact body through the shadows.

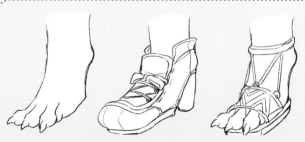

You can design shoes based on the character's feet. Shoe and tail design are two ways of imbuing your character with unique and compelling features.

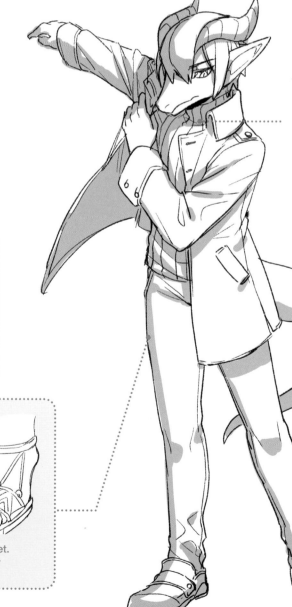

Dragon (adult)

Pose 🐾 **Taking off a shirt** Illustrator: **Hitsujirobo**

Now it's time to take on a wyvern-style dragon. This adult furry strikes a somewhat more traditionally imposing pose, removing his shirt as he almost glares at the viewer.

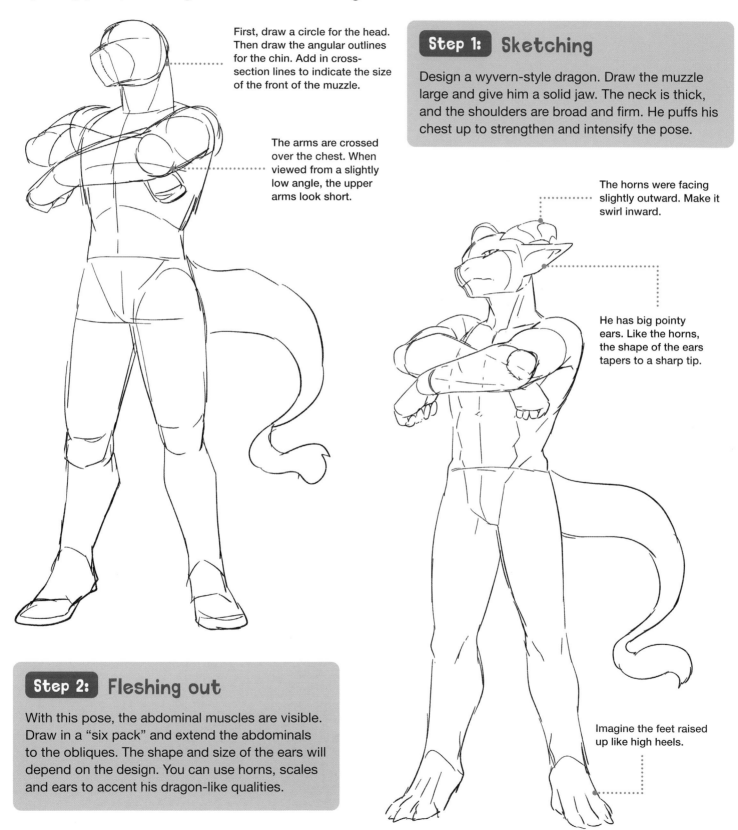

First, draw a circle for the head. Then draw the angular outlines for the chin. Add in cross-section lines to indicate the size of the front of the muzzle.

The arms are crossed over the chest. When viewed from a slightly low angle, the upper arms look short.

Step 1: Sketching

Design a wyvern-style dragon. Draw the muzzle large and give him a solid jaw. The neck is thick, and the shoulders are broad and firm. He puffs his chest up to strengthen and intensify the pose.

The horns were facing slightly outward. Make it swirl inward.

He has big pointy ears. Like the horns, the shape of the ears tapers to a sharp tip.

Step 2: Fleshing out

With this pose, the abdominal muscles are visible. Draw in a "six pack" and extend the abdominals to the obliques. The shape and size of the ears will depend on the design. You can use horns, scales and ears to accent his dragon-like qualities.

Imagine the feet raised up like high heels.

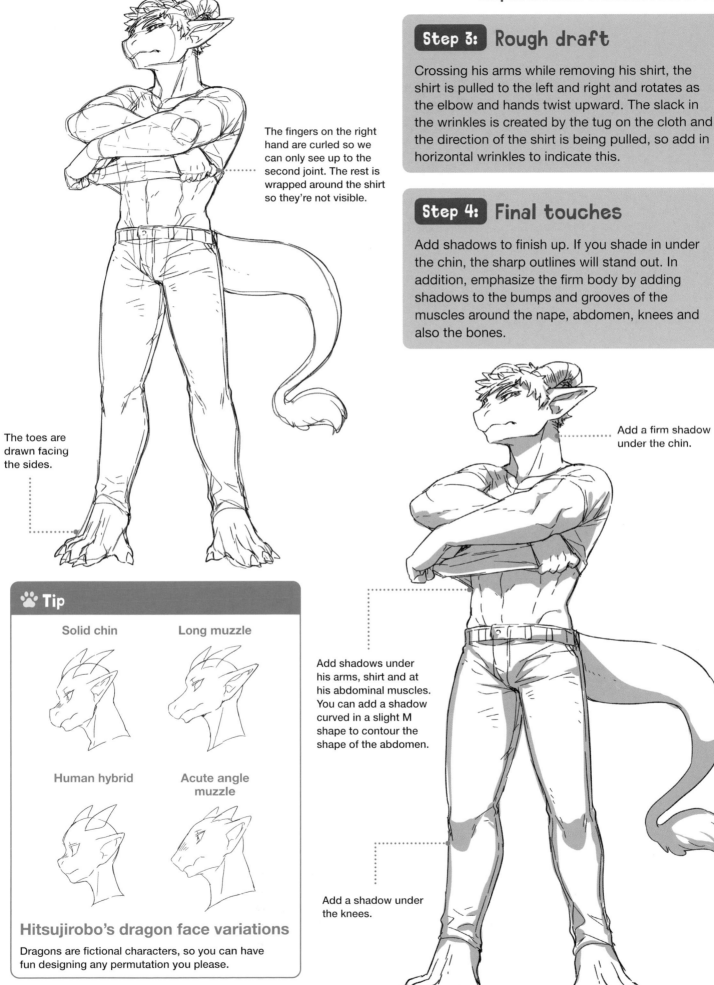

The fingers on the right hand are curled so we can only see up to the second joint. The rest is wrapped around the shirt so they're not visible.

The toes are drawn facing the sides.

Step 3: Rough draft

Crossing his arms while removing his shirt, the shirt is pulled to the left and right and rotates as the elbow and hands twist upward. The slack in the wrinkles is created by the tug on the cloth and the direction of the shirt is being pulled, so add in horizontal wrinkles to indicate this.

Step 4: Final touches

Add shadows to finish up. If you shade in under the chin, the sharp outlines will stand out. In addition, emphasize the firm body by adding shadows to the bumps and grooves of the muscles around the nape, abdomen, knees and also the bones.

Add a firm shadow under the chin.

Add shadows under his arms, shirt and at his abdominal muscles. You can add a shadow curved in a slight M shape to contour the shape of the abdomen.

Add a shadow under the knees.

Tip

Solid chin

Long muzzle

Human hybrid

Acute angle muzzle

Hitsujirobo's dragon face variations

Dragons are fictional characters, so you can have fun designing any permutation you please.

Dolphin

Pose 🐾 Running

Illustrator: Madakan

The smooth and slippery skin of sea creature furries is both challenging and fun to replicate. Aquatic characters really give your imagination the chance to run wild and make the character your own.

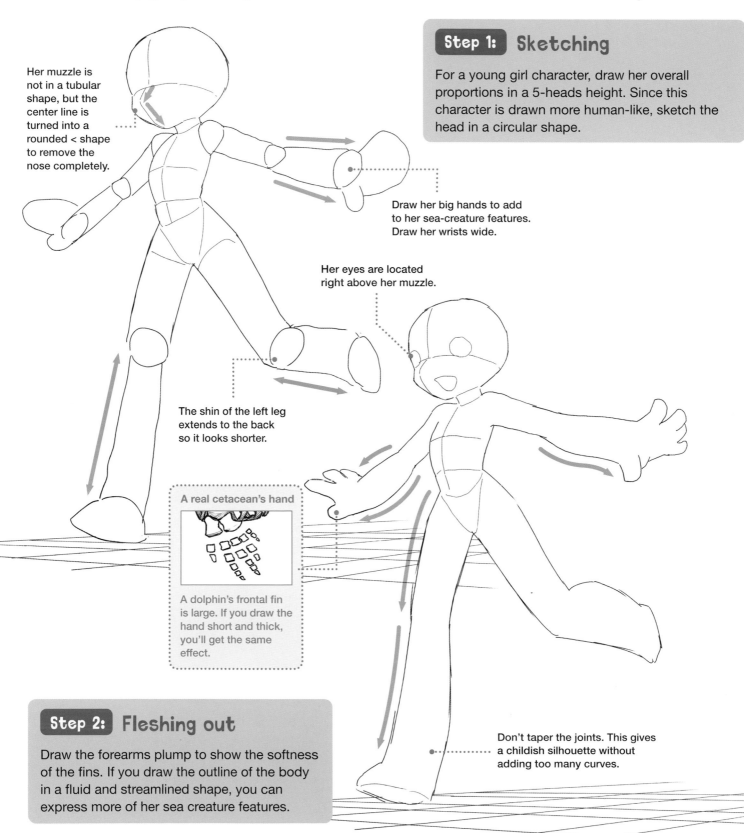

Her muzzle is not in a tubular shape, but the center line is turned into a rounded < shape to remove the nose completely.

Step 1: Sketching

For a young girl character, draw her overall proportions in a 5-heads height. Since this character is drawn more human-like, sketch the head in a circular shape.

Draw her big hands to add to her sea-creature features. Draw her wrists wide.

Her eyes are located right above her muzzle.

The shin of the left leg extends to the back so it looks shorter.

A real cetacean's hand

A dolphin's frontal fin is large. If you draw the hand short and thick, you'll get the same effect.

Step 2: Fleshing out

Draw the forearms plump to show the softness of the fins. If you draw the outline of the body in a fluid and streamlined shape, you can express more of her sea creature features.

Don't taper the joints. This gives a childish silhouette without adding too many curves.

50

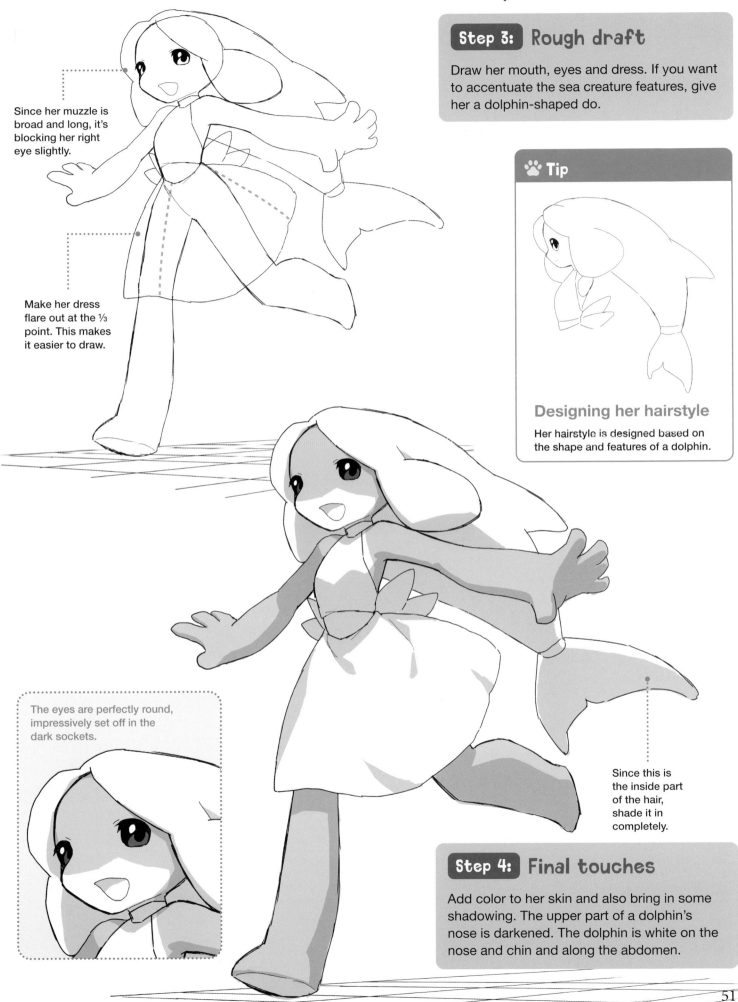

Since her muzzle is broad and long, it's blocking her right eye slightly.

Make her dress flare out at the ⅓ point. This makes it easier to draw.

Step 3: Rough draft

Draw her mouth, eyes and dress. If you want to accentuate the sea creature features, give her a dolphin-shaped do.

🐾 Tip

Designing her hairstyle

Her hairstyle is designed based on the shape and features of a dolphin.

The eyes are perfectly round, impressively set off in the dark sockets.

Since this is the inside part of the hair, shade it in completely.

Step 4: Final touches

Add color to her skin and also bring in some shadowing. The upper part of a dolphin's nose is darkened. The dolphin is white on the nose and chin and along the abdomen.

Great White Shark

Realistic Muscular Furry

Pose 🐾 **Scratching his head**

Illustrator: Madakan

If you shift the angle to a side pose, it'll be more challenging to draw. But it allows for a blend of comedy and menace, a true hybrid! Be sure you show all eight fins.

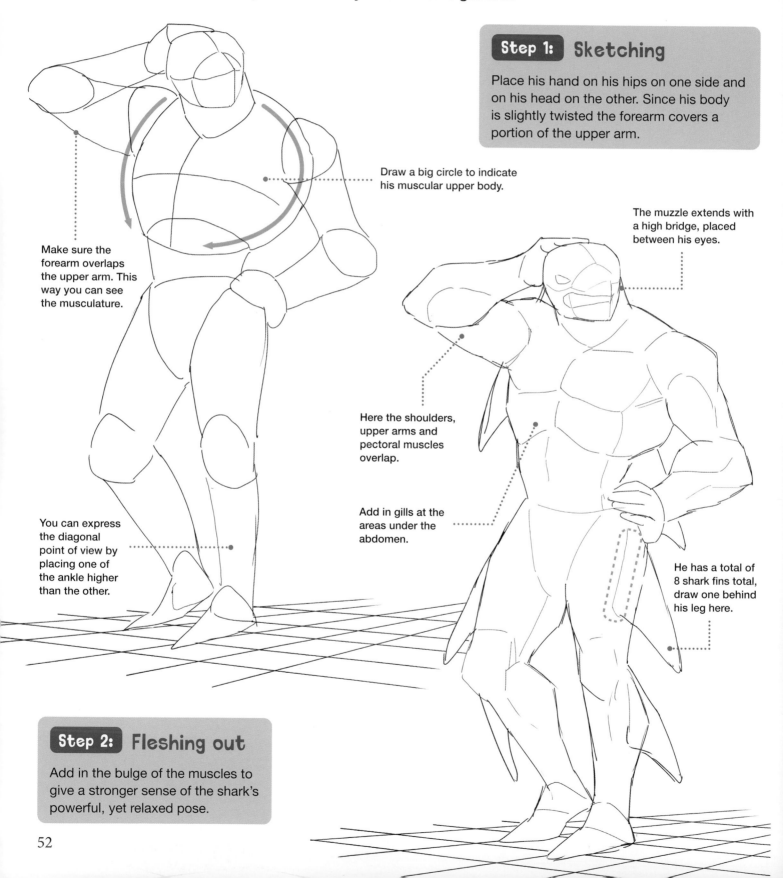

Step 1: Sketching

Place his hand on his hips on one side and on his head on the other. Since his body is slightly twisted the forearm covers a portion of the upper arm.

Draw a big circle to indicate his muscular upper body.

The muzzle extends with a high bridge, placed between his eyes.

Make sure the forearm overlaps the upper arm. This way you can see the musculature.

Here the shoulders, upper arms and pectoral muscles overlap.

Add in gills at the areas under the abdomen.

You can express the diagonal point of view by placing one of the ankle higher than the other.

He has a total of 8 shark fins total, draw one behind his leg here.

Step 2: Fleshing out

Add in the bulge of the muscles to give a stronger sense of the shark's powerful, yet relaxed pose.

Emphasize the muscles by giving him a thin shirt.

His fins slip through the openings in his shorts.

Step 3: Rough draft

Since he has fins along his body, design his outfit accordingly. The sides of the shorts are split so that his fins can show. The shirt is collarless, so it wouldn't get in the way of his dorsal fin.

🐾 Variation

With the shirtless version of the character, you don't have to worry about the dorsal fin's position. Giving him a teeth necklace will give him a more hard-core vibe.

This shark gets its name because of its signature white pattern.

Step 4: Final touches

The great white shark has white ventral sides that move along the face to the tail fin. The gray covers the border of the face, neck and arms.

While this species is white in reality on the ventral side, for the sake of design, move the white pattern to the back of his shin.

For the dorsal fin, add crosshatching to the back of the shirt.

The side fins are gray.

53

Orca

Pose 🐾 **Taking a call**

Illustrator: Madakan

An orca averages around 20 to 25 feet (6–8 meters) long. For this talk-to-me executive, time is money and the face and fins are what sell the sea creature inside the Armani suit.

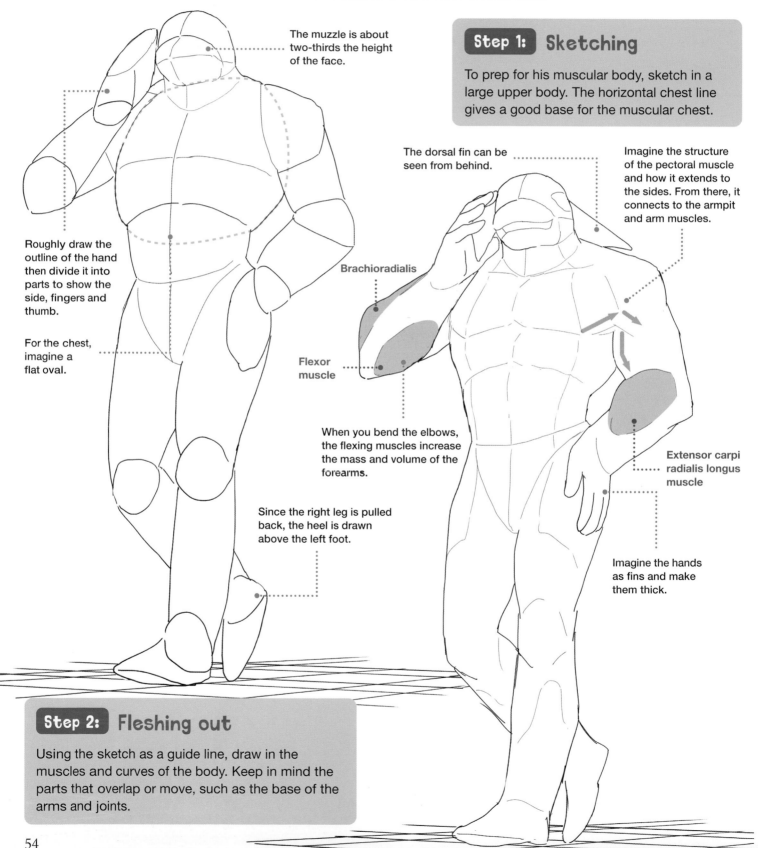

The muzzle is about two-thirds the height of the face.

Step 1: Sketching

To prep for his muscular body, sketch in a large upper body. The horizontal chest line gives a good base for the muscular chest.

The dorsal fin can be seen from behind.

Imagine the structure of the pectoral muscle and how it extends to the sides. From there, it connects to the armpit and arm muscles.

Roughly draw the outline of the hand then divide it into parts to show the side, fingers and thumb.

For the chest, imagine a flat oval.

Brachioradialis

Flexor muscle

When you bend the elbows, the flexing muscles increase the mass and volume of the forearms.

Extensor carpi radialis longus muscle

Since the right leg is pulled back, the heel is drawn above the left foot.

Imagine the hands as fins and make them thick.

Step 2: Fleshing out

Using the sketch as a guide line, draw in the muscles and curves of the body. Keep in mind the parts that overlap or move, such as the base of the arms and joints.

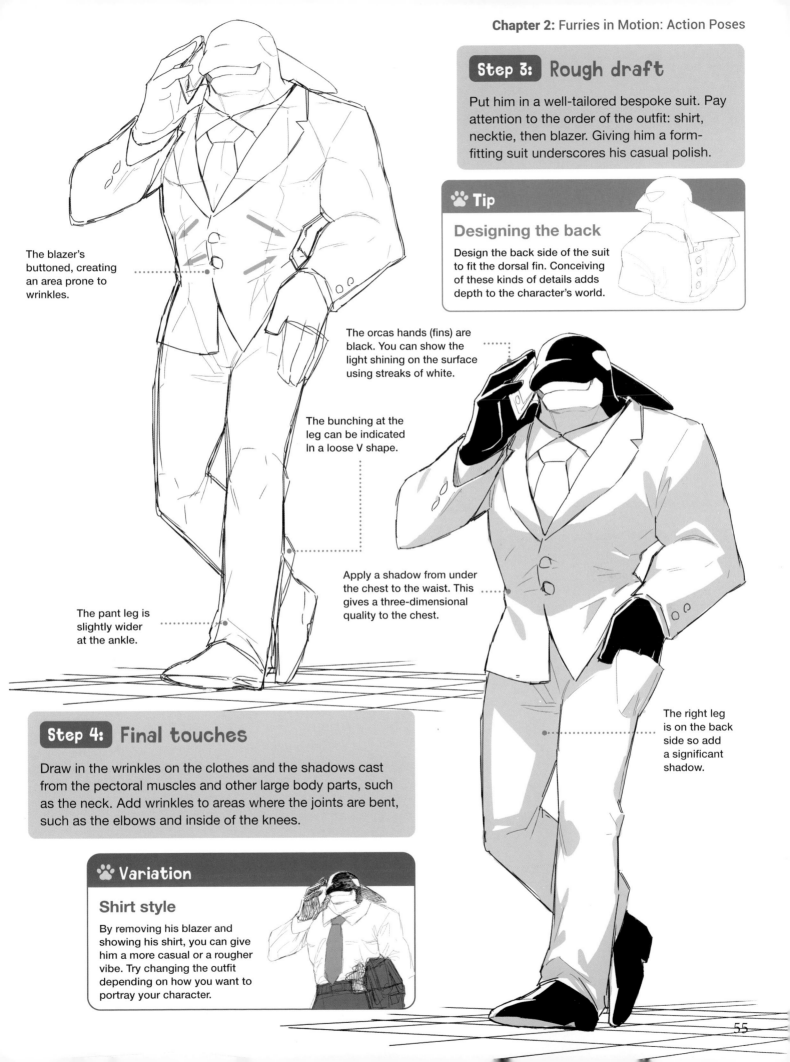

The blazer's buttoned, creating an area prone to wrinkles.

Step 3: Rough draft

Put him in a well-tailored bespoke suit. Pay attention to the order of the outfit: shirt, necktie, then blazer. Giving him a form-fitting suit underscores his casual polish.

🐾 **Tip**

Designing the back

Design the back side of the suit to fit the dorsal fin. Conceiving of these kinds of details adds depth to the character's world.

The orcas hands (fins) are black. You can show the light shining on the surface using streaks of white.

The bunching at the leg can be indicated In a loose V shape.

Apply a shadow from under the chest to the waist. This gives a three-dimensional quality to the chest.

The pant leg is slightly wider at the ankle.

The right leg is on the back side so add a significant shadow.

Step 4: Final touches

Draw in the wrinkles on the clothes and the shadows cast from the pectoral muscles and other large body parts, such as the neck. Add wrinkles to areas where the joints are bent, such as the elbows and inside of the knees.

🐾 **Variation**

Shirt style

By removing his blazer and showing his shirt, you can give him a more casual or a rougher vibe. Try changing the outfit depending on how you want to portray your character.

Crocodile

Realistic Muscular Furry

Pose 🐾 **Sitting on a chair**

Illustrator: Madakan

A strong-jawed, snarling crocodile furry sitting on a chair. Here the main challenge is nailing the relationship between the main body seated in the chair and the position of the tail. Then your focus shifts to the placement of the arms, the armrests and the knees in this cool cross-legged pose.

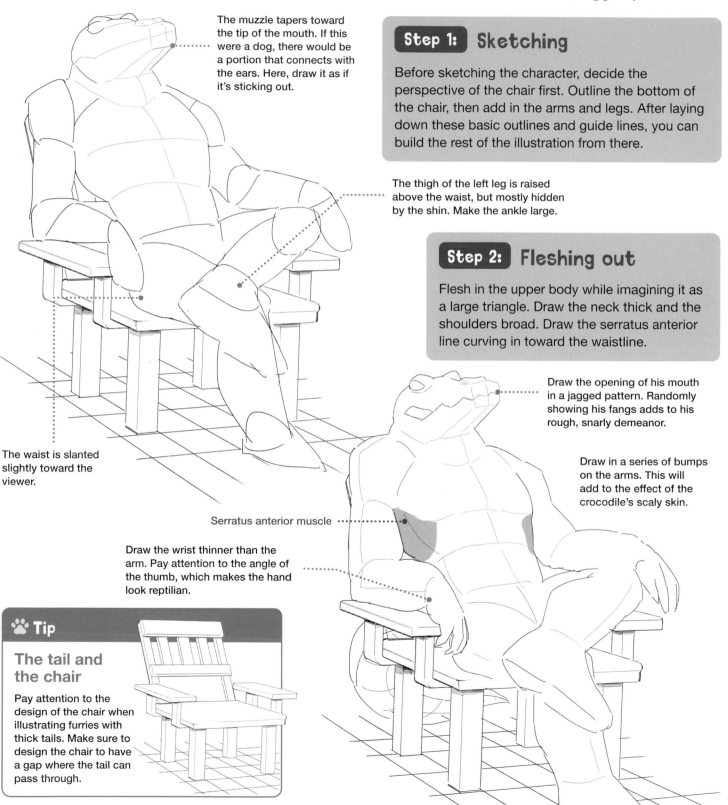

The muzzle tapers toward the tip of the mouth. If this were a dog, there would be a portion that connects with the ears. Here, draw it as if it's sticking out.

The thigh of the left leg is raised above the waist, but mostly hidden by the shin. Make the ankle large.

The waist is slanted slightly toward the viewer.

Serratus anterior muscle

Draw the wrist thinner than the arm. Pay attention to the angle of the thumb, which makes the hand look reptilian.

Step 1: Sketching

Before sketching the character, decide the perspective of the chair first. Outline the bottom of the chair, then add in the arms and legs. After laying down these basic outlines and guide lines, you can build the rest of the illustration from there.

Step 2: Fleshing out

Flesh in the upper body while imagining it as a large triangle. Draw the neck thick and the shoulders broad. Draw the serratus anterior line curving in toward the waistline.

Draw the opening of his mouth in a jagged pattern. Randomly showing his fangs adds to his rough, snarly demeanor.

Draw in a series of bumps on the arms. This will add to the effect of the crocodile's scaly skin.

🐾 Tip

The tail and the chair

Pay attention to the design of the chair when illustrating furries with thick tails. Make sure to design the chair to have a gap where the tail can pass through.

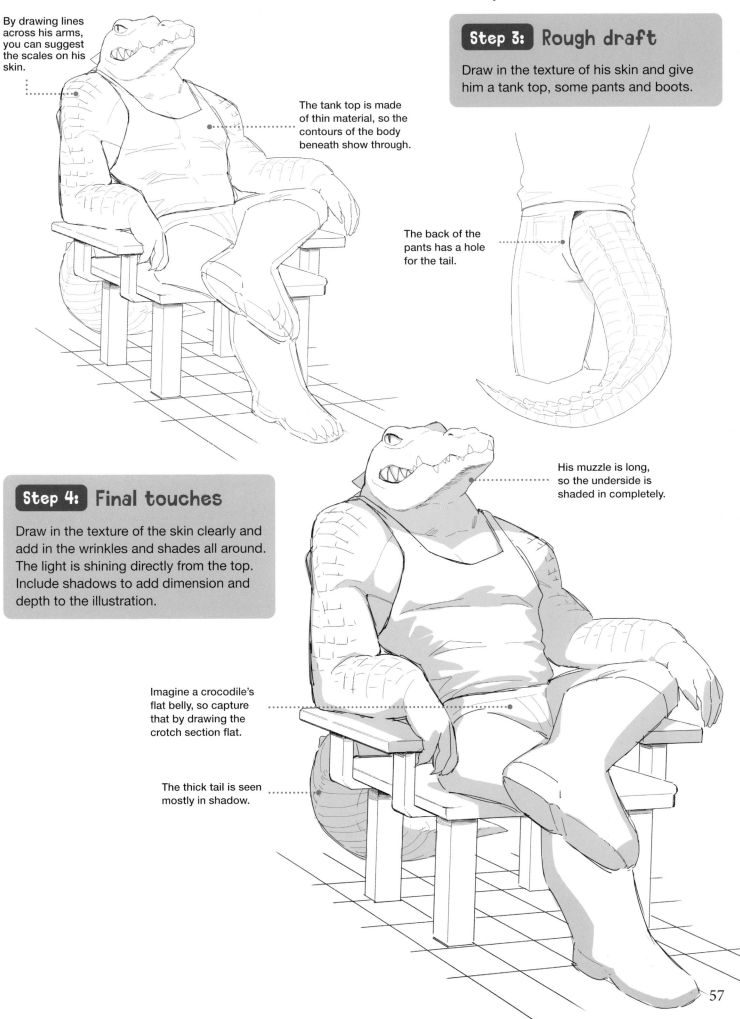

By drawing lines across his arms, you can suggest the scales on his skin.

The tank top is made of thin material, so the contours of the body beneath show through.

Step 3: Rough draft

Draw in the texture of his skin and give him a tank top, some pants and boots.

The back of the pants has a hole for the tail.

Step 4: Final touches

Draw in the texture of the skin clearly and add in the wrinkles and shades all around. The light is shining directly from the top. Include shadows to add dimension and depth to the illustration.

His muzzle is long, so the underside is shaded in completely.

Imagine a crocodile's flat belly, so capture that by drawing the crotch section flat.

The thick tail is seen mostly in shadow.

57

3 How to Draw Different Faces

Difference in the muzzle can greatly change how a character's perceived. The facial features of a furry change greatly depending on the degree of transformation and the direction the illustrator wants to pursue. And that's just the beginning!

Humans vs. animals

When comparing heads from the side, most animals' heads are longer horizontally. In addition to cats with human-like features, monkeys (not shown in this book) also have jaws that protrude forward horizontally, which is different from the human skeleton. To put it simply, humans are animals with an unusual head structure.

Vertical vs. horizontal

The human head's vertically oriented; however most animals have heads that are horizontally aligned. When comparing to human, cats (which have short muzzles and eyes close to each other) have a shorter chin and thicker neck. You can make adjustments to the character's chin and neck to indicate the degree to which your furry has transformed.

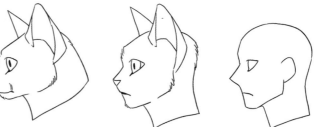

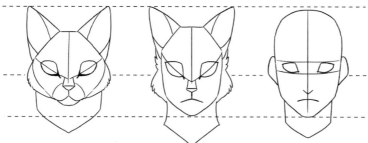

Face shape and eye angle

When looking from the front view, humans have a round head, while cat's heads are more of a diamond shape. Also, just like humans, cats have eyes in front of their face. However, the angle of a cat's eye is lifted at the corners.

Different art styles

The appearance of a furry changes drastically depending on the race, body shape and also the art style. There are various ways to draw a face of a furry, but here are a few styles you can see in this book.

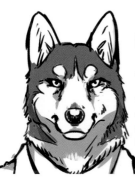

Realistic

Realistic animal eyes, neck, etc. Many features from the base animal making a realistic resemblance.

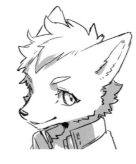

Comic

Thin neck, human eyes and hairstyle. Though the face is animal-based, there are many human elements mixed in to make this comic style.

Thick muzzled

The thick-muzzled face is horizontally oriented. This style adds simplicity to the design and a solid impression.

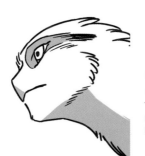

Humanoid

In this style, the human facial features do not modify the animal base significantly.

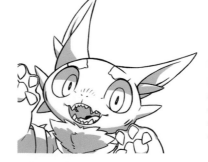

Chibi

Big eyes and a round face like a stuffed animal. Similar to the comic style, but this approach emphasizes the youthfulness and cuteness of the character.

The muzzle changes with age

The longer the bridge of the muzzle is, the more mature the character looks. This also applies to humans. As humans age, the nose bridge grows longer vertically, meanwhile for animals it becomes horizontally longer. By elongating the bridge, you can easily suggest the character's age.

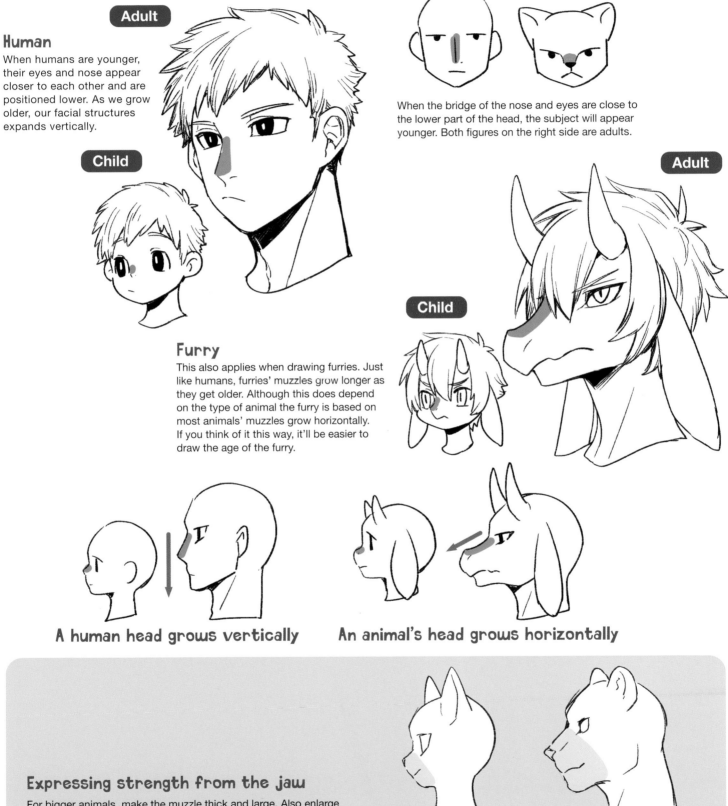

Adult

Human

When humans are younger, their eyes and nose appear closer to each other and are positioned lower. As we grow older, our facial structures expands vertically.

Child

When the bridge of the nose and eyes are close to the lower part of the head, the subject will appear younger. Both figures on the right side are adults.

Adult

Child

Furry

This also applies when drawing furries. Just like humans, furries' muzzles grow longer as they get older. Although this does depend on the type of animal the furry is based on most animals' muzzles grow horizontally. If you think of it this way, it'll be easier to draw the age of the furry.

A human head grows vertically

An animal's head grows horizontally

Expressing strength from the jaw

For bigger animals, make the muzzle thick and large. Also enlarge and deepen the lower jar, finishing it off with a curved line, for a powerfully defined and memorable face.

59

Crow

Pose 🐾 **Tying a necktie** Illustrator: Itohiro

This very humanlike crow is primping before a mirror. The torso and body shape strongly suggest a human's, but the wings are all bird. It's up to you to strike the right balance—or imbalance!

To set up the illustration, start by drawing the mirror first. If you set up the situation, it'll be easier to draw the character interacting with the items naturally.

The wings are folding inward, so they wrap around toward the character's body.

Step 1: Sketching

Sketch the outline of the character tying a necktie in front of a standing mirror. First, draw in the mirror, then align the character's position to face it. The direction of the mirror and the character should be at the same angle.

Since this is a "tying a necktie" pose, think about the orientation of the hands and face. Just by changing the hands and face, you can change the pose and portrayal of the situation in the illustration greatly!

EXPERT TIP:
Brainstorm your concept and reflect it in your character's design. And think ahead! Here we'll starting with a slim suit.

Separate the wings into sections. You'll add in details, such as the feathers, later.

Step 2: Fleshing out

Refine the sketch and add details to the overall shape. Draw the waist a little higher. Since he's a slim character, pay close attention to the size of his buttocks, hips and thighs. Since he's a bird furry, give him thin ankles.

The tail feather spreads out like a fan starting from the buttocks.

Since the mirror is a single flat item, it'll look unnatural if it's standing on its own, so give it a stand.

Design his foot like a bird's foot with three front toes and one back toe. Deciding on the shape of the feet will make it easier to design the shoes. The ankles are quite thin, so make them slim when he's wearing a suit.

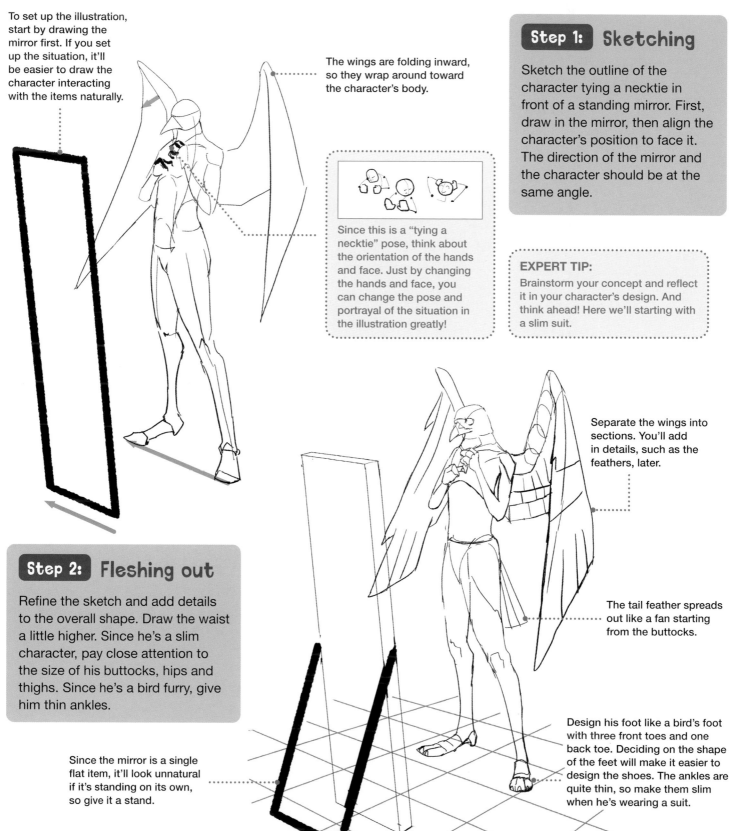

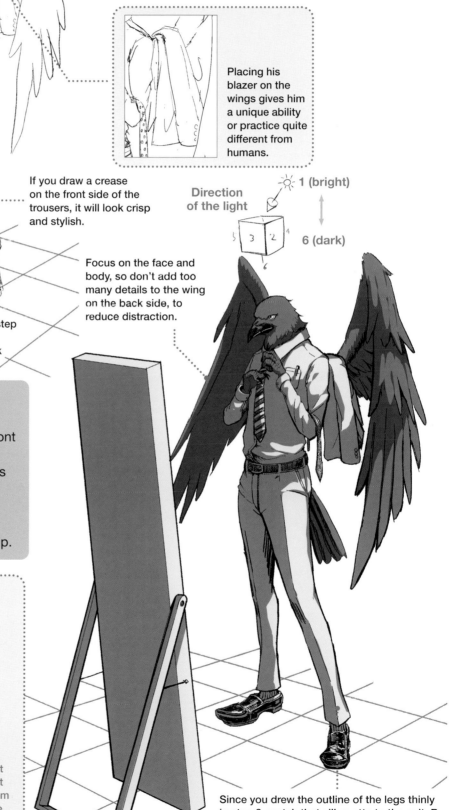

Step 3: Rough draft

Outline his entire body. His features are more bird-like, but his body frame is human. To complete the avian look, wings are an essential addition.

Placing his blazer on the wings gives him a unique ability or practice quite different from humans.

If you draw a crease on the front side of the trousers, it will look crisp and stylish.

Direction of the light

1 (bright)

6 (dark)

Focus on the face and body, so don't add too many details to the wing on the back side, to reduce distraction.

Using the outline you drew in step 2, design the shoes according to the avian shape. They'll look different from human shoes.

Step 4: Final touches

Imagine the light source coming from the front right, then add the shade to the character accordingly. Refer to the outline of the wings you drew in step 2 to understand how the wings were divided into the front and back sections. Using this information, shade the wings to bring out the front-back relationship.

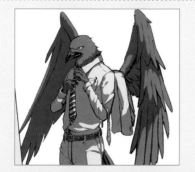

Our eyes tends to seek out areas with more details. These details include colors, shading and the amount of lines drawn at a particular spot. Here we draw a lot of details on the wing in the front, however refrain from adding the same amount of details for the wing in the back. As a result, the line of sight is focused on the wings in front and the character's body.

Since you drew the outline of the legs thinly in step 2, match that silhouette to the suit. By adding shadows along the crease, you can emphasize the smart and stylish look.

Falcon

Pose 🐾 **Reading a newspaper**

Illustrator: **Itohiro**

A peregrine falcon is a small bird of prey that zips through the air. So here the character is designed with the image of a pilot in mind.

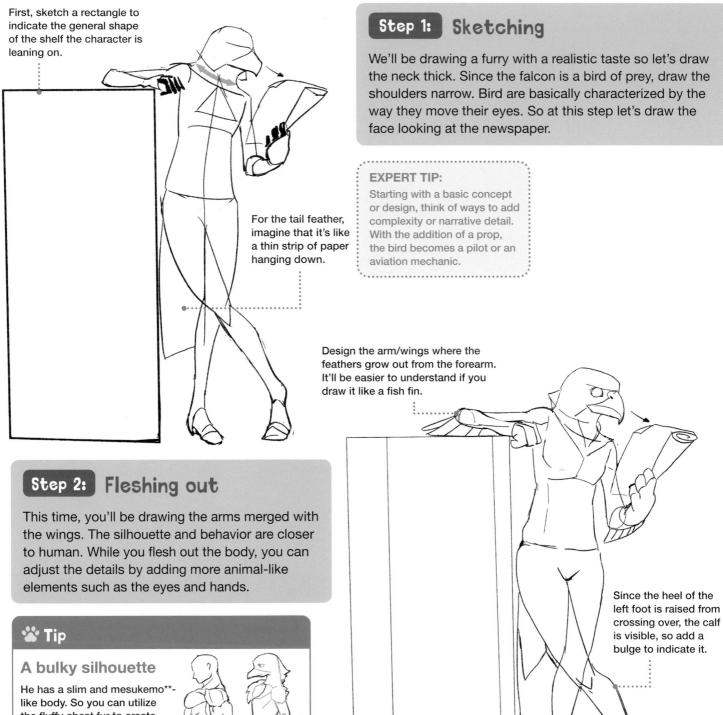

First, sketch a rectangle to indicate the general shape of the shelf the character is leaning on.

For the tail feather, imagine that it's like a thin strip of paper hanging down.

Design the arm/wings where the feathers grow out from the forearm. It'll be easier to understand if you draw it like a fish fin.

Step 1: Sketching

We'll be drawing a furry with a realistic taste so let's draw the neck thick. Since the falcon is a bird of prey, draw the shoulders narrow. Bird are basically characterized by the way they move their eyes. So at this step let's draw the face looking at the newspaper.

EXPERT TIP:
Starting with a basic concept or design, think of ways to add complexity or narrative detail. With the addition of a prop, the bird becomes a pilot or an aviation mechanic.

Since the heel of the left foot is raised from crossing over, the calf is visible, so add a bulge to indicate it.

Step 2: Fleshing out

This time, you'll be drawing the arms merged with the wings. The silhouette and behavior are closer to human. While you flesh out the body, you can adjust the details by adding more animal-like elements such as the eyes and hands.

🐾 Tip

A bulky silhouette

He has a slim and mesukemo**-like body. So you can utilize the fluffy chest fur to create a muscular chest. You can also do this with the arm features for muscular arms.

**Mesukemo are fit male adult furries that are drawn in a high degree of furriness.

62

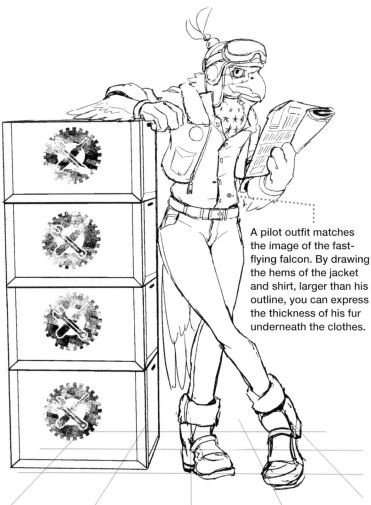

A pilot outfit matches the image of the fast-flying falcon. By drawing the hems of the jacket and shirt, larger than his outline, you can express the thickness of his fur underneath the clothes.

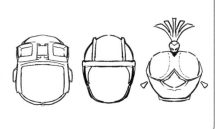

Step 3: Rough draft

Roughly sketch in his clothes and face. On top he wears a flight or bomber jacket, a pair of goggles on his head over his helmet. These accessories add to his character. Make the sleeves of the jacket short so you can show off his wings.

🐾 Tip

Helmet designs

Design a helmet customized to your furry. Think about something that would fit an actual falcon's head. Then mix in helmet elements afterward.

Step 4: Final touches

Imagine the light source coming from the upper left-hand side and add in shadows and details to the sketch. The flat objects such as the cases, newspaper and tail feathers should be covered in shadow. Japanese newspaper are written vertically, so to change the style to him reading an English newspaper, draw the paper horizontally to match how a newspaper is printed.

Up until step 3, you drew the pupils small. Make adjustments to pupil size to finish the stage. If the black eyes remain small, they'll look human. If they're large, they'll look more like a falcon. You can play around and see what works best with your illustration.

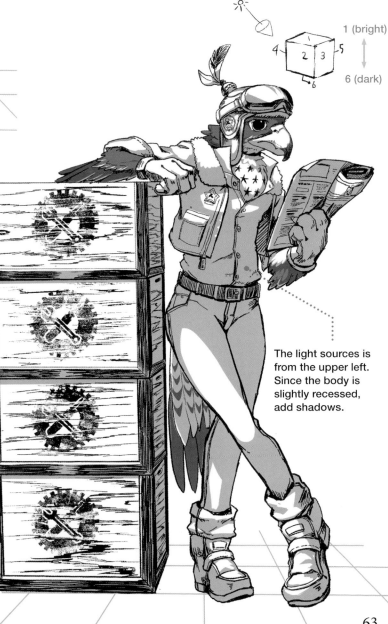

1 (bright)

6 (dark)

The light sources is from the upper left. Since the body is slightly recessed, add shadows.

Asian Dragon

Pose 🐾 **Floating**

Illustrator: **Itohiro**

Ripped right from the realm of fantasy, furry dragons don't always bring winged fury from above. Here a softer side is revealed in a scholar's pose. The character allows for great flexibility and improvisation.

Step 1: Sketching

Before staring, decide on the illustrations concept. You can create a mind map to determine the overall concept. Start by listing the keywords such as, writing, floating in air, old, water dragon, Asian dragon on the left side. Then you can add more and more motifs to expand the keywords.

Extending the tail to below the feet will suggest that the character is floating.

The dragon's face can be drawn with "○ �⊥ ○". "○" is the eye and "⊥" is the tip of the nose. You can change the impression and orientation of the face by playing around with the "○ ⊥ ○" position.

EXPERT TIP:
Determine whether an element is appropriate to your design. Start simple, refining and adding appropriate details as you go.

Point the toes downward to make the character appear to be floating.

Step 2: Fleshing out

The Asian dragon is slim, so keep that in mind when you flesh out the body. Draw the position of the eyes, the shape of the face and the limbs.

Draw the paper of the scroll to flow with the body movement. Add curves to it to give it the floating effect.

Add in lines to separate the tail into sections. This makes it easier to understand the tail's cylinder shape.

Add in long flowing hair to match the image of an old dragon. For the face, add in the ears, gills and other details. Adjust the shape of the horns.

Step 3: Rough draft

The silhouette of the body is mostly hidden by the kimono. If we draw the outline of the body properly in step 2, it'll be easier to add the kimono.

🐾 Tip

Itohiro's dragon head variations

When drawing the dragon's head, you can play around with the thickness and the direction of the arrow to create various designs.

Emphasize the neck's accordion effect. The back side is a combination of scales and hair.

How the light shines

Decorate the tip of the tail. If you place it below, you will create more of a floating effect.

If you don't decide on the order of brightness, the lighting may end up looking unnatural.

Step 4: Final touches

When adding shadows, it's best to imagine the setting and the light source in a cube. If you decide the order of brightness, you will get a better understanding and it'll add cohesiveness to the shadowing and contrast as a whole.

The density of the letters on the scroll helps adds perspective.

🐾 Tip

Using contrast to bring out the focal point

Here the gaps between the fingers are filled in. Although the fingers would normally cast shadows, sometimes too much realism makes the illustration difficult to understand. You can ignore the shadows and lighting rule to bring out the points you want to emphasize by using contrast instead.

65

Beast Dragon

Mid age Realistic Slim Furry

Pose ❧ **Drawing a sword** Illustrator: **Itohiro**

Unlike a dragon with scales, the beast dragon's key feature is its supple coat. In this pose, he'll be on one knee while drawing his sword, so give the illustration a lot of dynamic flow.

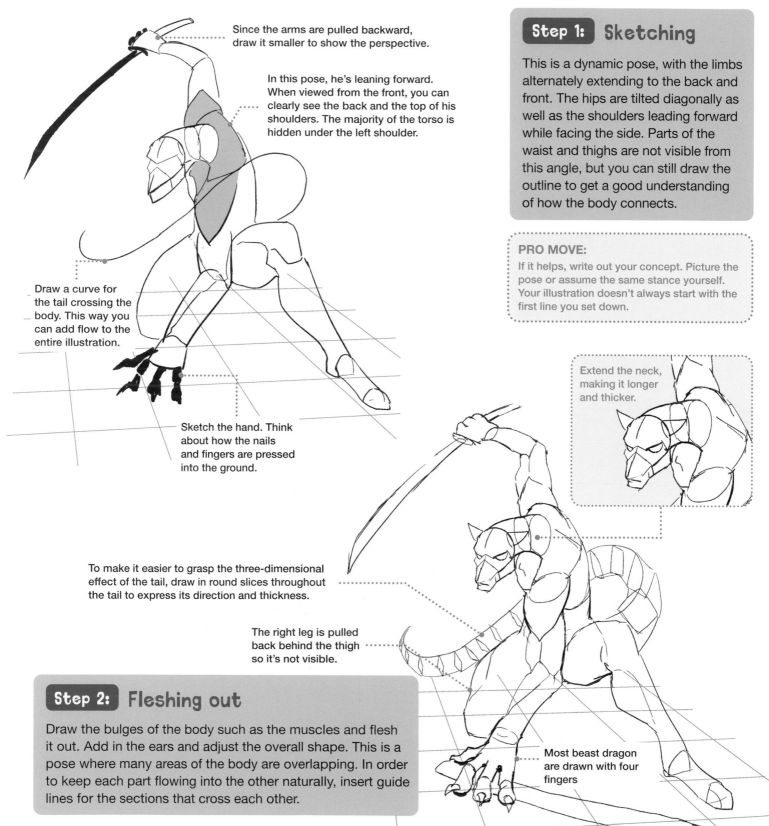

Since the arms are pulled backward, draw it smaller to show the perspective.

In this pose, he's leaning forward. When viewed from the front, you can clearly see the back and the top of his shoulders. The majority of the torso is hidden under the left shoulder.

Draw a curve for the tail crossing the body. This way you can add flow to the entire illustration.

Sketch the hand. Think about how the nails and fingers are pressed into the ground.

Step 1: Sketching

This is a dynamic pose, with the limbs alternately extending to the back and front. The hips are tilted diagonally as well as the shoulders leading forward while facing the side. Parts of the waist and thighs are not visible from this angle, but you can still draw the outline to get a good understanding of how the body connects.

PRO MOVE:
If it helps, write out your concept. Picture the pose or assume the same stance yourself. Your illustration doesn't always start with the first line you set down.

Extend the neck, making it longer and thicker.

To make it easier to grasp the three-dimensional effect of the tail, draw in round slices throughout the tail to express its direction and thickness.

The right leg is pulled back behind the thigh so it's not visible.

Most beast dragon are drawn with four fingers

Step 2: Fleshing out

Draw the bulges of the body such as the muscles and flesh it out. Add in the ears and adjust the overall shape. This is a pose where many areas of the body are overlapping. In order to keep each part flowing into the other naturally, insert guide lines for the sections that cross each other.

Imagine an outfit that's easy to move in, since flexibility is key to performing the slashing motion.

Step 3: Rough draft

If you design a character with large horns and a lot of hair in front of the face, add it at this stage. It'll be easier to match the image of the face and also make it easier to draw the entire body. The beast dragon is furred, so draw hair tufts on the tail, ears and chin.

When designing a beast dragon's hairstyle, you can create a unique character gap by giving them pigtails and other styles. Adding arrangements to the pigtails can bring out their originality. In this illustration, the hair passes through a ring while it wraps around the ears to give it a fluffy impression.

✿ Tip

Designing the eyes

The eyes have a similar shape to human's. The scales under the dragon's eyes look like eyelashes (center). This can give you a little bit of a human touch in the design.

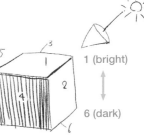

1 (bright)

6 (dark)

The light source is set slightly in front of the upper right.

Since the light source is from the front, the left arm's shadow casts on the thigh.

Step 4: Final touches

The light source is shining from the front. Keep that in mind when adding the finishing touch such as the shadows and wrinkles. The shadow density changes depending on the right and left side of the illustration. Add in the shadows to bring out the front-back relationship in the illustration. If you imagine the front-back relationship during step 2, it'll be easier to bring in the shadows here.

Black Panther

Pose 🐾 Sprinting

Illustrator: you

For this leopard-like big cat, the components of the sleek, lithe, muscular body are key. Focus on capturing and replicating the dynamic feeling of sprinting.

The right arm is swung forward and the left arm is pulled backward. Make sure to draw the right shoulder tilted downward.

Step 1: Sketching

Sketch out a character with a muscular body. Keep the thickness of his body in mind. Imagine a box when sketching the outline and shape of the body. This will make it easier to visualize the depth of the form. The upper body is tilted forward and the right leg located behind the upper body in a diagonal line. Make sure the front line is slanted forward to show the running motion.

Sketch in the tail as well. Make sure the movement of the tail balances with the forward.

Sketch the body parts in cubes. This makes it easier to express the depth of the body.

Draw the muzzle, forehead and ears. The muzzle will be clear if you indicate the width of the nose bridge.

You can express the muscles in straight, well-defined lines.

If you draw the left leg lifted up high, you can suggest the character's sprinting movement. The limbs are staggered so be careful to not draw the left leg and left arm moving forward together.

Draw the details of the muscles. This will be the basis of drawing the wrinkles on the clothing.

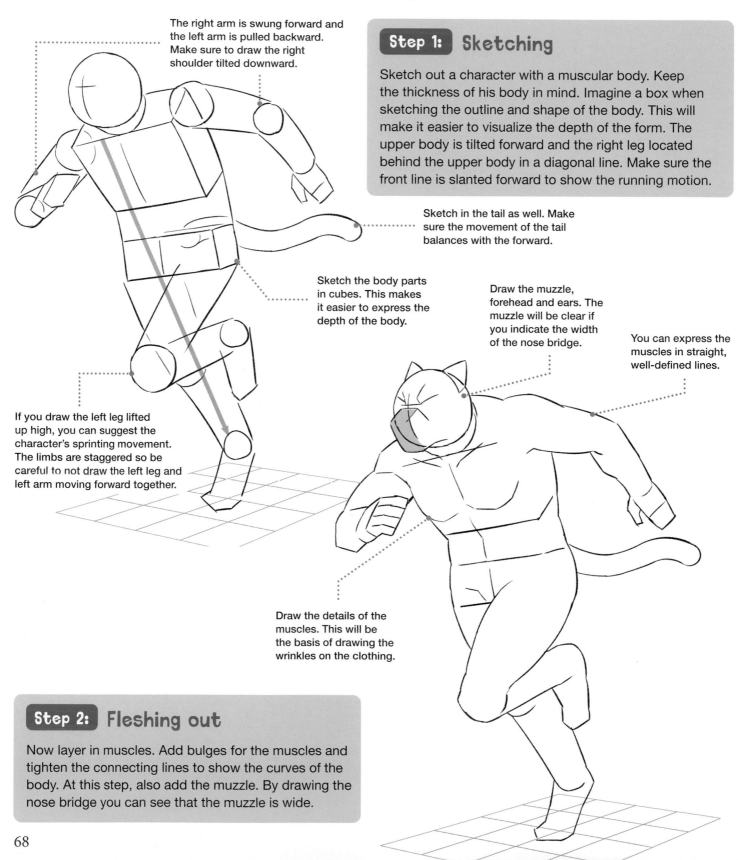

Step 2: Fleshing out

Now layer in muscles. Add bulges for the muscles and tighten the connecting lines to show the curves of the body. At this step, also add the muzzle. By drawing the nose bridge you can see that the muzzle is wide.

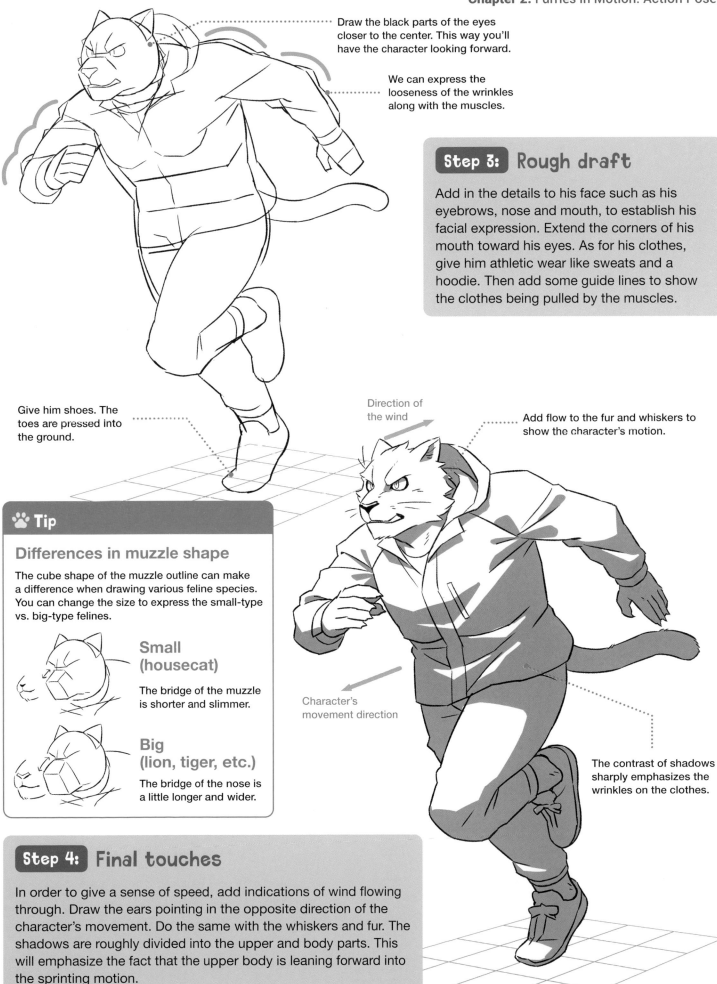

Draw the black parts of the eyes closer to the center. This way you'll have the character looking forward.

We can express the looseness of the wrinkles along with the muscles.

Step 3: Rough draft

Add in the details to his face such as his eyebrows, nose and mouth, to establish his facial expression. Extend the corners of his mouth toward his eyes. As for his clothes, give him athletic wear like sweats and a hoodie. Then add some guide lines to show the clothes being pulled by the muscles.

Give him shoes. The toes are pressed into the ground.

Direction of the wind

Add flow to the fur and whiskers to show the character's motion.

Character's movement direction

🐾 **Tip**

Differences in muzzle shape

The cube shape of the muzzle outline can make a difference when drawing various feline species. You can change the size to express the small-type vs. big-type felines.

Small (housecat)

The bridge of the muzzle is shorter and slimmer.

Big (lion, tiger, etc.)

The bridge of the nose is a little longer and wider.

The contrast of shadows sharply emphasizes the wrinkles on the clothes.

Step 4: Final touches

In order to give a sense of speed, add indications of wind flowing through. Draw the ears pointing in the opposite direction of the character's movement. Do the same with the whiskers and fur. The shadows are roughly divided into the upper and body parts. This will emphasize the fact that the upper body is leaning forward into the sprinting motion.

Bald Eagle

Pose 🐾 **Strolling**

Illustrator: **you**

With its large wings, wide body and sharp eyes, the bald eagle's elegance and power are always on display. Here a casual stroll highlights this flying furry's formidable frame.

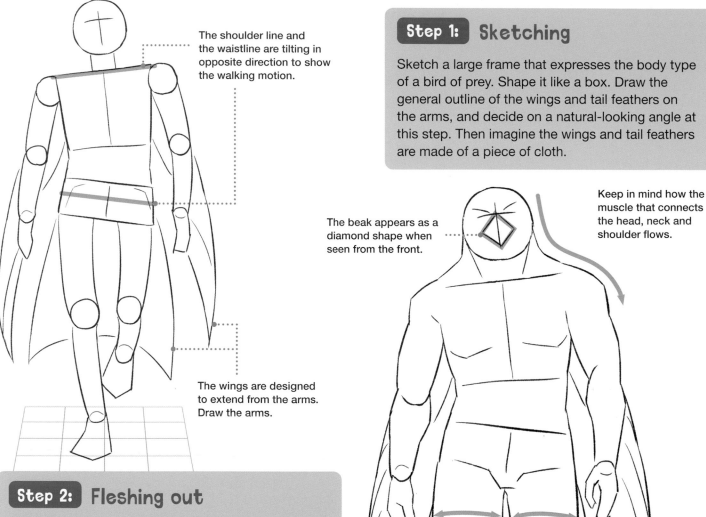

The shoulder line and the waistline are tilting in opposite direction to show the walking motion.

The wings are designed to extend from the arms. Draw the arms.

Step 1: Sketching

Sketch a large frame that expresses the body type of a bird of prey. Shape it like a box. Draw the general outline of the wings and tail feathers on the arms, and decide on a natural-looking angle at this step. Then imagine the wings and tail feathers are made of a piece of cloth.

The beak appears as a diamond shape when seen from the front.

Keep in mind how the muscle that connects the head, neck and shoulder flows.

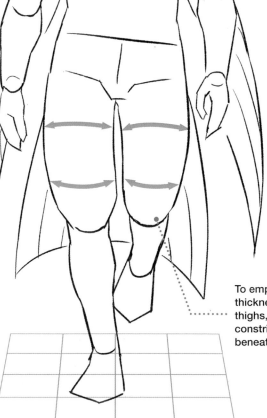

To emphasize the thickness of the thighs, you can constrict the lines beneath the knees.

Step 2: Fleshing out

Now flesh out the neck straight down to the shoulder without creating a constriction line. This way, you'll have a realistic bird-like silhouette for the head section. Be aware of the balance between the head and the shoulders. If you make the thighs thick, you'll be adding more bird-of-prey features.

🐾 Tip

Shoeless characters

When you want to draw a bird foot, first sketch a standard human foot shape. From here, it'll be easier to modify the shape of the foot by spreading the toes to make the foot more avian.

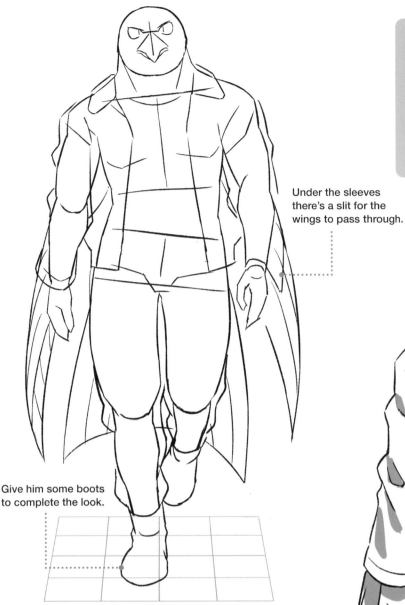

Under the sleeves there's a slit for the wings to pass through.

Give him some boots to complete the look.

Step 3: Rough draft

Divide the beak into the upper and lower parts. The center part of the upper beak extends downward. Therefore, the lower beak is only slightly visible. Imagine how the clothes fit over the character's fluffy feathers. In this illustration you'll give the character an open, flowing jacket.

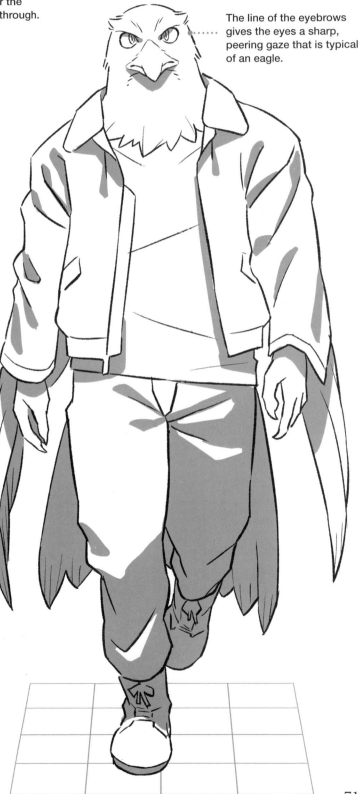

The line of the eyebrows gives the eyes a sharp, peering gaze that is typical of an eagle.

Step 4: Final touches

Finalize the illustration with the details of the feathers and wrinkles on the clothes. Draw the fluffy feathers around the neck and the sharp fingers to add to the character's avian features. The tail feathers and wings are drawn to look much larger than the body. If you draw a tuft of hair around the eyebrows, you can add more eagle-like features.

🐾 **Tip**

Wings as hands

A fantasy bird and furry can have wings that also serve as fingers. In this case, you can widen the wing around the elbow to make it more like a wing. It may be difficult to have characters with these features wear ordinary outfits, but you can also adapt it to make the outfit fit naturally.

Red Fox

Pose 🐾 **Pointing a finger** Illustrator: *you*

The pointed muzzle and long slender limbs are the key characteristics of this dog family animal, the red fox. The pose offers a study in perspective.

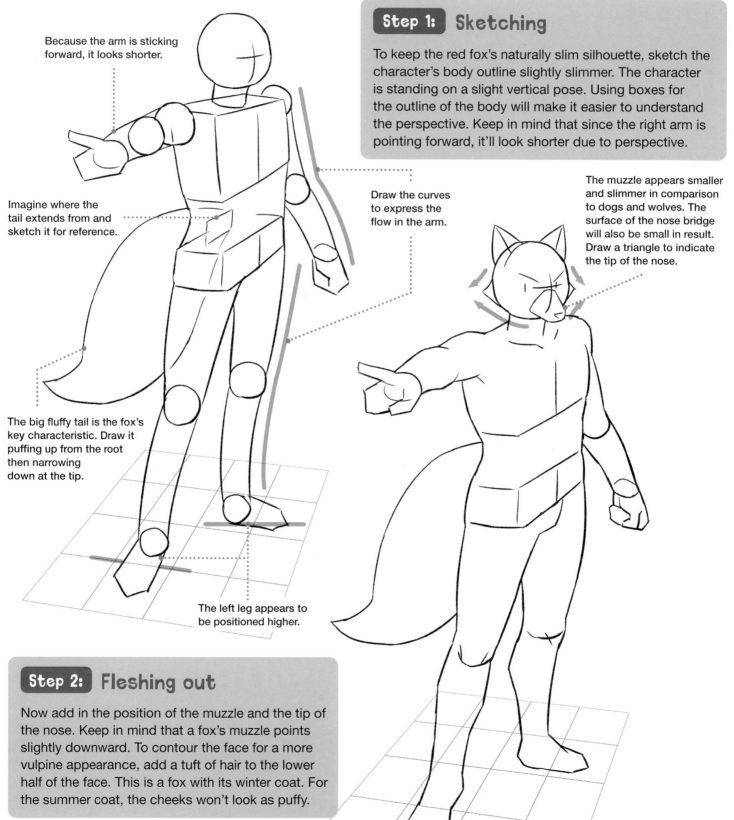

Because the arm is sticking forward, it looks shorter.

Imagine where the tail extends from and sketch it for reference.

The big fluffy tail is the fox's key characteristic. Draw it puffing up from the root then narrowing down at the tip.

The left leg appears to be positioned higher.

Step 1: Sketching

To keep the red fox's naturally slim silhouette, sketch the character's body outline slightly slimmer. The character is standing on a slight vertical pose. Using boxes for the outline of the body will make it easier to understand the perspective. Keep in mind that since the right arm is pointing forward, it'll look shorter due to perspective.

Draw the curves to express the flow in the arm.

The muzzle appears smaller and slimmer in comparison to dogs and wolves. The surface of the nose bridge will also be small in result. Draw a triangle to indicate the tip of the nose.

Step 2: Fleshing out

Now add in the position of the muzzle and the tip of the nose. Keep in mind that a fox's muzzle points slightly downward. To contour the face for a more vulpine appearance, add a tuft of hair to the lower half of the face. This is a fox with its winter coat. For the summer coat, the cheeks won't look as puffy.

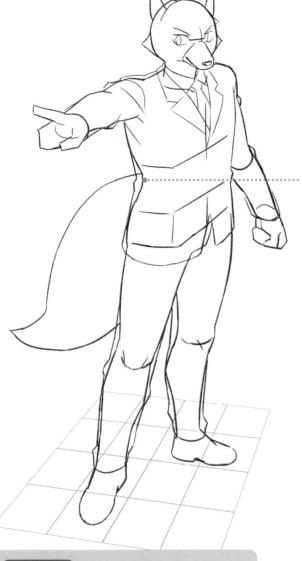

Leave some space at the line in the back.

Step 3: Rough draft

Keep in mind the position of the chin and sketch in the line between the mouth and neck. Since he's a slim creature, you don't need to add extra fur to the neck. Instead he wears a tight-fitting shirt and blazer.

Add fluffy fur at the corner of the eyes and the flaring cheeks.

Step 4: Final touches

His cheeks and tail are fluffy, so add extra fur at this part. Loosely add in large shadows to bring out the character's sharpness with strong contrasts.

🐾 Tip

Drawing different canines

The key aspects of the canine family are the length and thickness of the muzzle and the thickness of the neck.

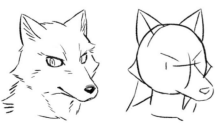

The wolf's muzzle is long and thick. The neck is also thick. If you drop the delicate features and delicate image, you will get closer to a large dog or wolf.

Add shadows along the line of the crease to give him a neat impression.

Boar

Pose 🐾 **Leaning against a wall**

Illustrator: **you**

A wild boar is known for its solidity and amazing strength. Highlight these qualities when drawing this character with a massively muscular, porcine body.

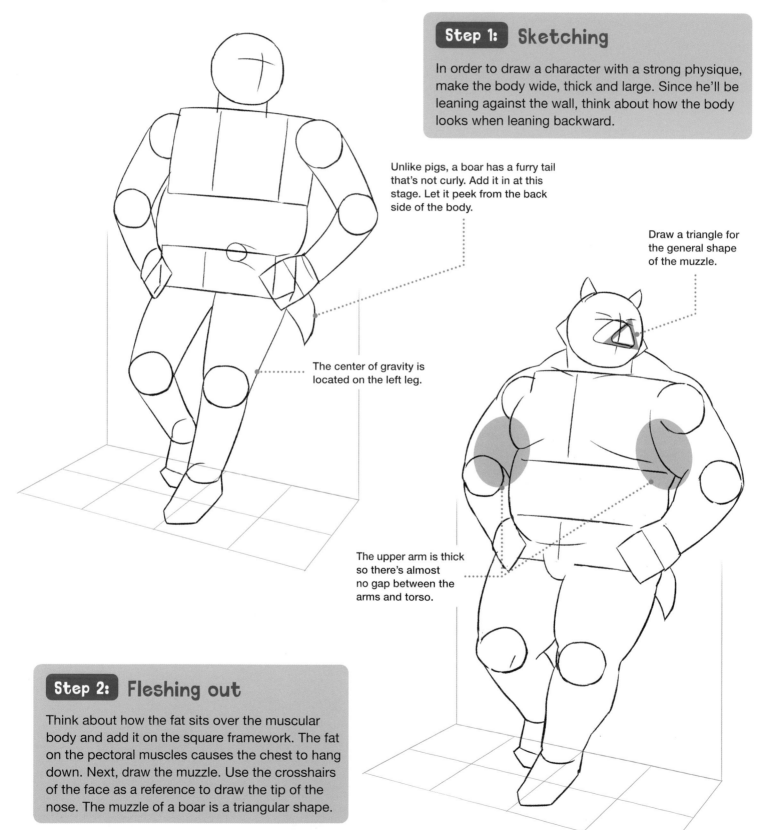

Step 1: Sketching

In order to draw a character with a strong physique, make the body wide, thick and large. Since he'll be leaning against the wall, think about how the body looks when leaning backward.

Unlike pigs, a boar has a furry tail that's not curly. Add it in at this stage. Let it peek from the back side of the body.

Draw a triangle for the general shape of the muzzle.

The center of gravity is located on the left leg.

The upper arm is thick so there's almost no gap between the arms and torso.

Step 2: Fleshing out

Think about how the fat sits over the muscular body and add it on the square framework. The fat on the pectoral muscles causes the chest to hang down. Next, draw the muzzle. Use the crosshairs of the face as a reference to draw the tip of the nose. The muzzle of a boar is a triangular shape.

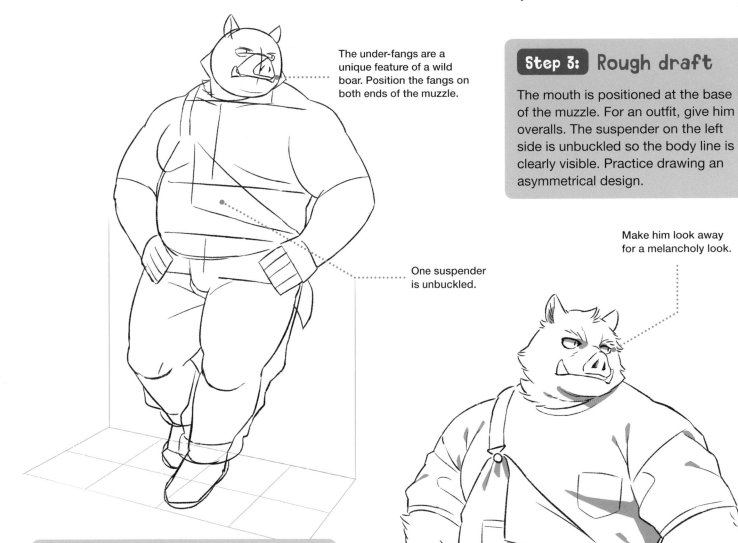

The under-fangs are a unique feature of a wild boar. Position the fangs on both ends of the muzzle.

One suspender is unbuckled.

Step 3: Rough draft

The mouth is positioned at the base of the muzzle. For an outfit, give him overalls. The suspender on the left side is unbuckled so the body line is clearly visible. Practice drawing an asymmetrical design.

Make him look away for a melancholy look.

Step 4: Final touches

To express the stiffness of the boar's bristly hair, let's add in hair around the neck, arms and elbows. By adding little diagonal lines between the eyebrows, you can express the toughness of the boar-like eyes.

🐾 Tip

Drawing a boar muzzle

Imagine a triangular prism with rounded edges for the basic shape of the muzzle. Position the tip of the prism right between the eyebrows and it'll fall into place nicely. The lower jaw is slightly shorter than the upper jaw, so imagine connecting the lower jaw to the face. An actual boar has a longer face, but you can adjust the length of the muzzle of your character according to your design.

Shiba Inu

Pose 🐾 **Holding a sword**

Illustrator: Kinoshita Jiroh

Here a shiba inu holds a sword, looking straight ahead and directly approaching the viewer. For this pose, think about how the character's muscles appear and how to express depth in the illustration.

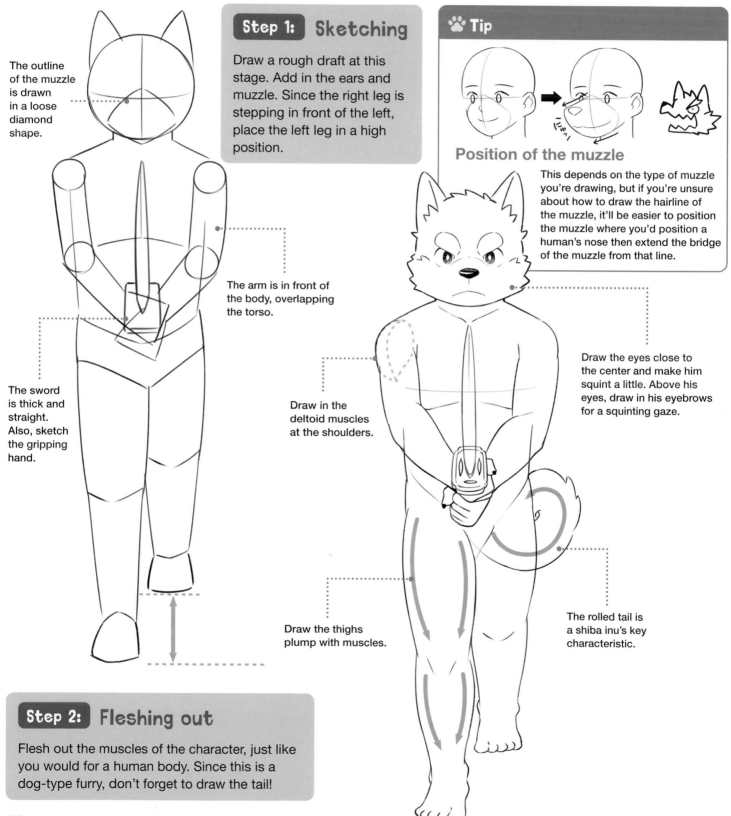

The outline of the muzzle is drawn in a loose diamond shape.

Step 1: Sketching

Draw a rough draft at this stage. Add in the ears and muzzle. Since the right leg is stepping in front of the left, place the left leg in a high position.

🐾 Tip

Position of the muzzle

This depends on the type of muzzle you're drawing, but if you're unsure about how to draw the hairline of the muzzle, it'll be easier to position the muzzle where you'd position a human's nose then extend the bridge of the muzzle from that line.

The arm is in front of the body, overlapping the torso.

The sword is thick and straight. Also, sketch the gripping hand.

Draw in the deltoid muscles at the shoulders.

Draw the eyes close to the center and make him squint a little. Above his eyes, draw in his eyebrows for a squinting gaze.

Draw the thighs plump with muscles.

The rolled tail is a shiba inu's key characteristic.

Step 2: Fleshing out

Flesh out the muscles of the character, just like you would for a human body. Since this is a dog-type furry, don't forget to draw the tail!

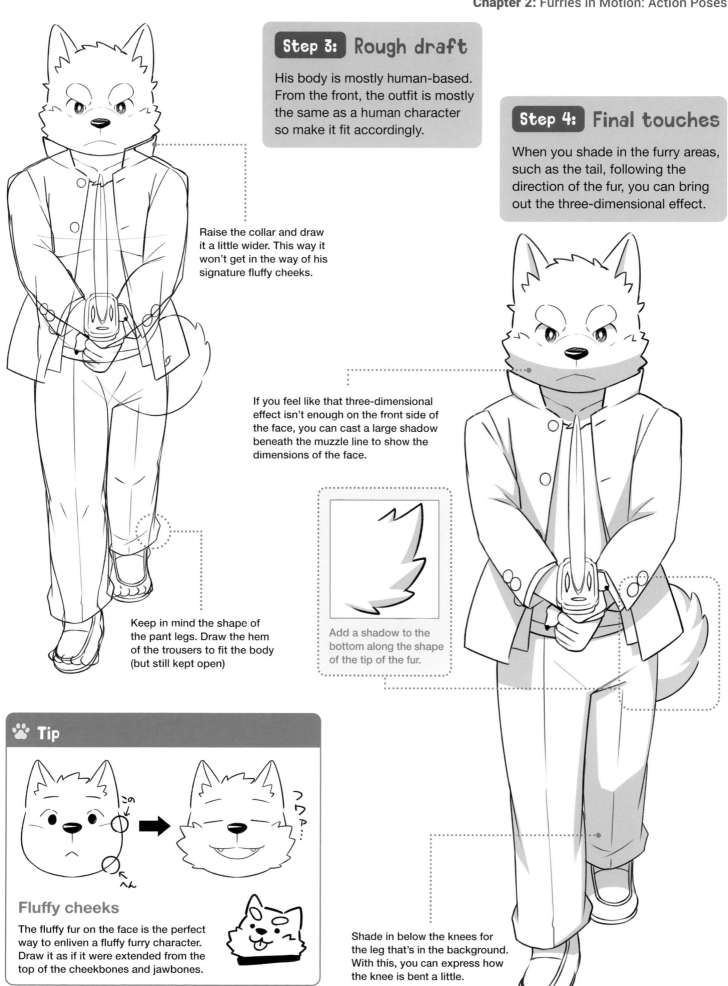

Step 3: Rough draft

His body is mostly human-based. From the front, the outfit is mostly the same as a human character so make it fit accordingly.

Step 4: Final touches

When you shade in the furry areas, such as the tail, following the direction of the fur, you can bring out the three-dimensional effect.

Raise the collar and draw it a little wider. This way it won't get in the way of his signature fluffy cheeks.

If you feel like that three-dimensional effect isn't enough on the front side of the face, you can cast a large shadow beneath the muzzle line to show the dimensions of the face.

Keep in mind the shape of the pant legs. Draw the hem of the trousers to fit the body (but still kept open)

Add a shadow to the bottom along the shape of the tip of the fur.

🐾 Tip

Fluffy cheeks

The fluffy fur on the face is the perfect way to enliven a fluffy furry character. Draw it as if it were extended from the top of the cheekbones and jawbones.

Shade in below the knees for the leg that's in the background. With this, you can express how the knee is bent a little.

Spotted Eagle

Pose 🐾 **Kicking**

Illustrator: **Kinoshita Jiroh**

For this kicking pose, pay attention to the parts that overlap due to the twisting of the body. Also pay attention to the hand-like wings, which is a fundamental design element for bird-human furries.

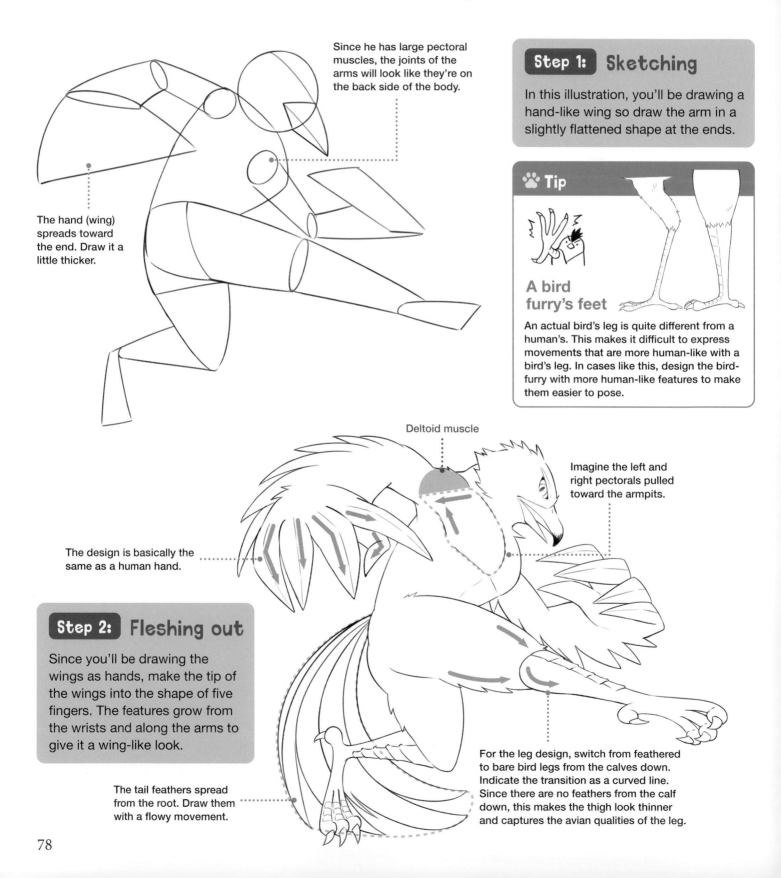

Since he has large pectoral muscles, the joints of the arms will look like they're on the back side of the body.

The hand (wing) spreads toward the end. Draw it a little thicker.

Step 1: Sketching

In this illustration, you'll be drawing a hand-like wing so draw the arm in a slightly flattened shape at the ends.

🐾 Tip

A bird furry's feet

An actual bird's leg is quite different from a human's. This makes it difficult to express movements that are more human-like with a bird's leg. In cases like this, design the bird-furry with more human-like features to make them easier to pose.

Deltoid muscle

Imagine the left and right pectorals pulled toward the armpits.

The design is basically the same as a human hand.

Step 2: Fleshing out

Since you'll be drawing the wings as hands, make the tip of the wings into the shape of five fingers. The features grow from the wrists and along the arms to give it a wing-like look.

The tail feathers spread from the root. Draw them with a flowy movement.

For the leg design, switch from feathered to bare bird legs from the calves down. Indicate the transition as a curved line. Since there are no feathers from the calf down, this makes the thigh look thinner and captures the avian qualities of the leg.

78

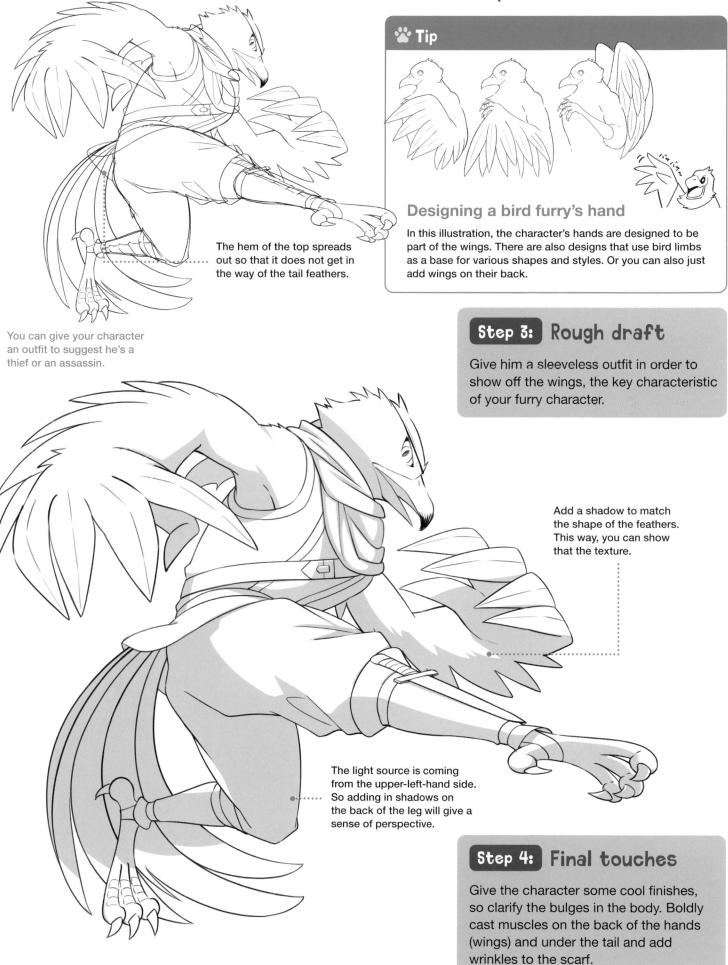

Tip

Designing a bird furry's hand

In this illustration, the character's hands are designed to be part of the wings. There are also designs that use bird limbs as a base for various shapes and styles. Or you can also just add wings on their back.

The hem of the top spreads out so that it does not get in the way of the tail feathers.

You can give your character an outfit to suggest he's a thief or an assassin.

Step 3: Rough draft

Give him a sleeveless outfit in order to show off the wings, the key characteristic of your furry character.

Add a shadow to match the shape of the feathers. This way, you can show that the texture.

The light source is coming from the upper-left-hand side. So adding in shadows on the back of the leg will give a sense of perspective.

Step 4: Final touches

Give the character some cool finishes, so clarify the bulges in the body. Boldly cast muscles on the back of the hands (wings) and under the tail and add wrinkles to the scarf.

Bear

Fat muzzle **Muscular** **Big body** **Furry**

Pose 🐾 Punching **Illustrator: Kinoshita Jiroh**

Pay close attention to the perspective of the pose and the fist sticking out. Bears have a bone structure similar to human's so take advantage of that commonality when developing your furry.

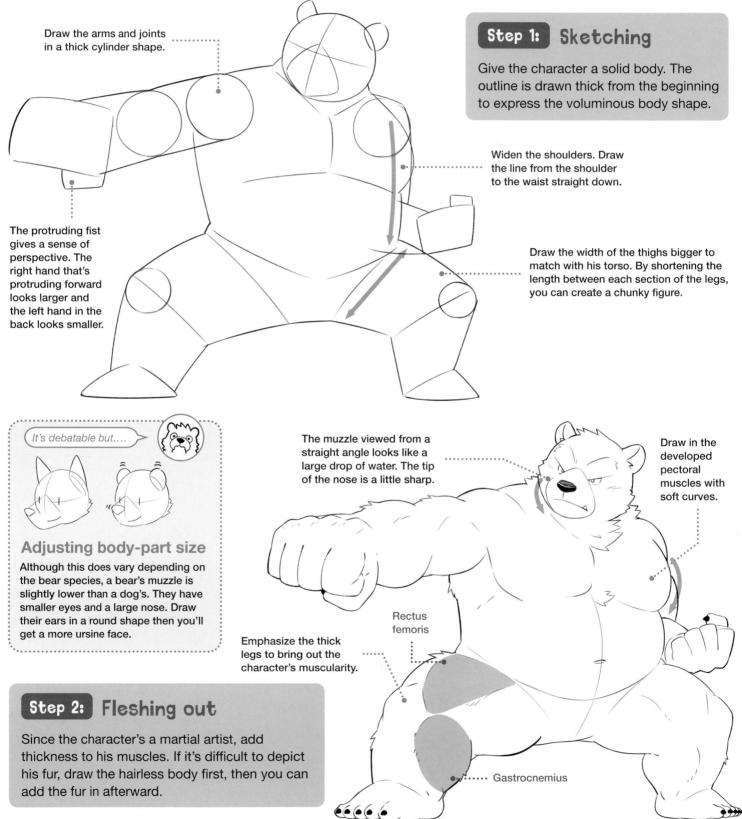

Draw the arms and joints in a thick cylinder shape.

Step 1: Sketching

Give the character a solid body. The outline is drawn thick from the beginning to express the voluminous body shape.

Widen the shoulders. Draw the line from the shoulder to the waist straight down.

The protruding fist gives a sense of perspective. The right hand that's protruding forward looks larger and the left hand in the back looks smaller.

Draw the width of the thighs bigger to match with his torso. By shortening the length between each section of the legs, you can create a chunky figure.

It's debatable but....

Adjusting body-part size

Although this does vary depending on the bear species, a bear's muzzle is slightly lower than a dog's. They have smaller eyes and a large nose. Draw their ears in a round shape then you'll get a more ursine face.

The muzzle viewed from a straight angle looks like a large drop of water. The tip of the nose is a little sharp.

Draw in the developed pectoral muscles with soft curves.

Emphasize the thick legs to bring out the character's muscularity.

Rectus femoris

Gastrocnemius

Step 2: Fleshing out

Since the character's a martial artist, add thickness to his muscles. If it's difficult to depict his fur, draw the hairless body first, then you can add the fur in afterward.

80

Step 3: Rough draft

To accentuate his martial arts vibe, give him a karate outfit, loosely flowing, especially around the pelvis area. You can also add details such as the obi.

🐾 Tip

Save it for later!

Some people might say "I can draw humans but, when it comes to furries, and I can't seem to draw them right." In that case, you can draw a human body first, then you can add the animal-like features such as the nails, fur and paws later.

Step 4: Final touches

Now add in shadows to match the muscles and wrinkles on the clothes. Show the fur that sticks out along the folds of the robe, such as the chest and neck.

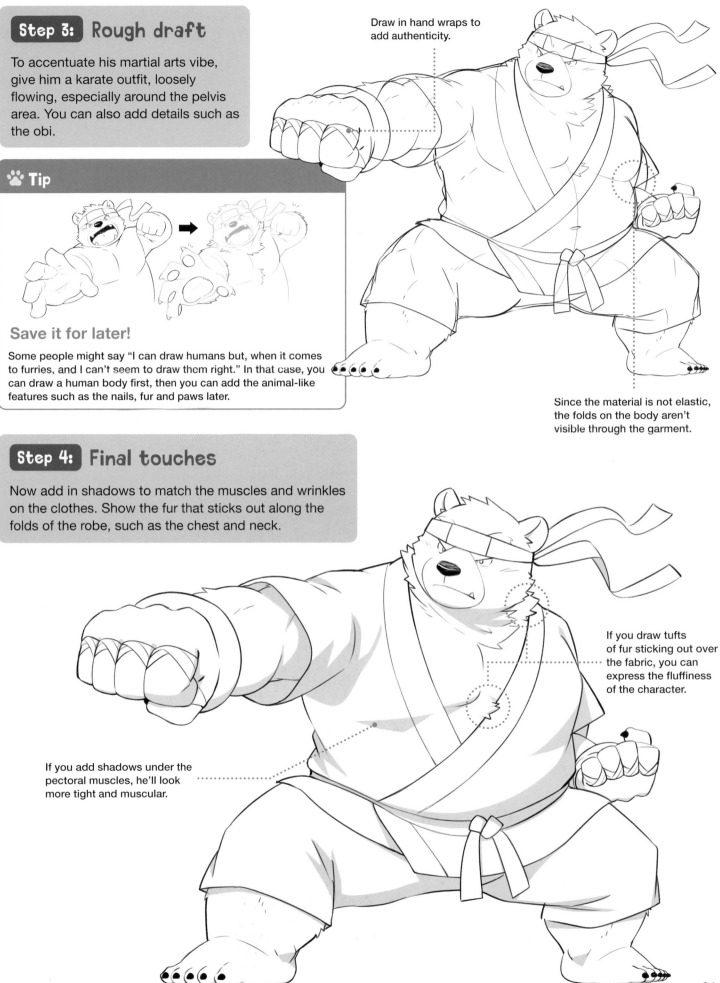

Draw in hand wraps to add authenticity.

Since the material is not elastic, the folds on the body aren't visible through the garment.

If you draw tufts of fur sticking out over the fabric, you can express the fluffiness of the character.

If you add shadows under the pectoral muscles, he'll look more tight and muscular.

Lizardman

Pose 🐾 **Leaning on one knee**

Illustrator: **Kinoshita Jiroh**

Straight out of fantasy stories, this character can leap fully formed from your imagination, ready for action. The reptilian body poses a fun challenge.

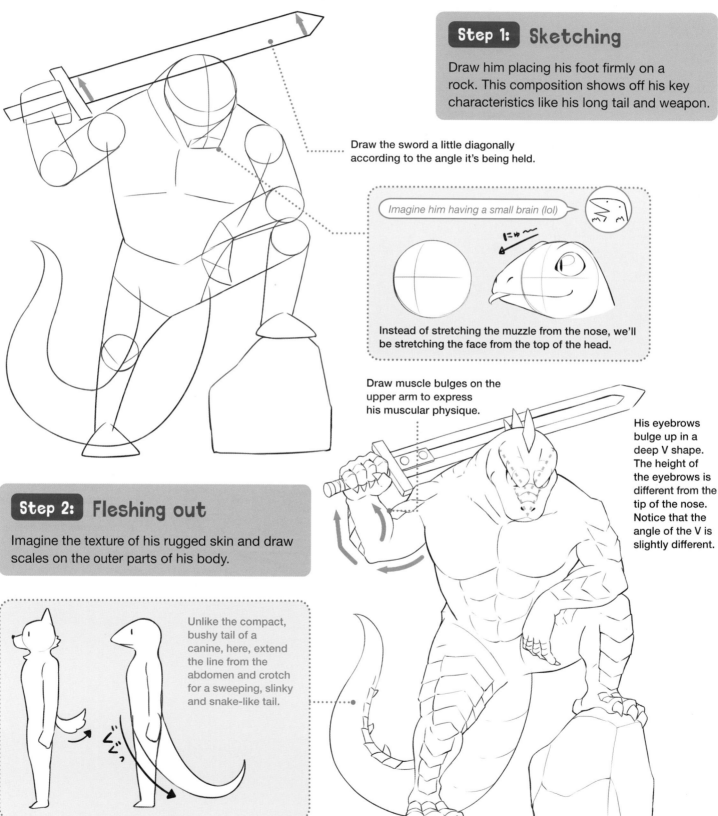

Step 1: Sketching

Draw him placing his foot firmly on a rock. This composition shows off his key characteristics like his long tail and weapon.

Draw the sword a little diagonally according to the angle it's being held.

Imagine him having a small brain (lol)

Instead of stretching the muzzle from the nose, we'll be stretching the face from the top of the head.

Draw muscle bulges on the upper arm to express his muscular physique.

His eyebrows bulge up in a deep V shape. The height of the eyebrows is different from the tip of the nose. Notice that the angle of the V is slightly different.

Step 2: Fleshing out

Imagine the texture of his rugged skin and draw scales on the outer parts of his body.

Unlike the compact, bushy tail of a canine, here, extend the line from the abdomen and crotch for a sweeping, slinky and snake-like tail.

Step 3: Rough draft

Give him a light suit of armor to showcase the scaly skin. Armor is hard and bulky, so its outline should be slightly larger than the body line.

The scales on the arms are shaped like arrows. Draw them uniformly.

Draw three toes in front. The sharp claws look like a rhombus when viewed from the front.

Draw the inner thigh spread out so that it doesn't get in the way of the tail. Then design a cloth codpiece to cover the thighs.

The sword is shaded on the lower half. This will bring out its dimensions.

Step 4: Final touches

Since the armor has many contours, add in shadows to bring out the details. The light source is shining form the upper-right-hand side so shade in the under sides of the breastplate, sword and other objects.

Shade in the entire cloak.

The cylindrical tail tapers to the tip. The shadow curves in toward the front.

Tosa

Comic style Big body Muscular Furry

Pose 🐾 Walking with a sword

Illustrator: Yuzpoco

Seen from a low, diagonal angle, the tosa's powerful physique is portrayed through the large solidly muscled frame.

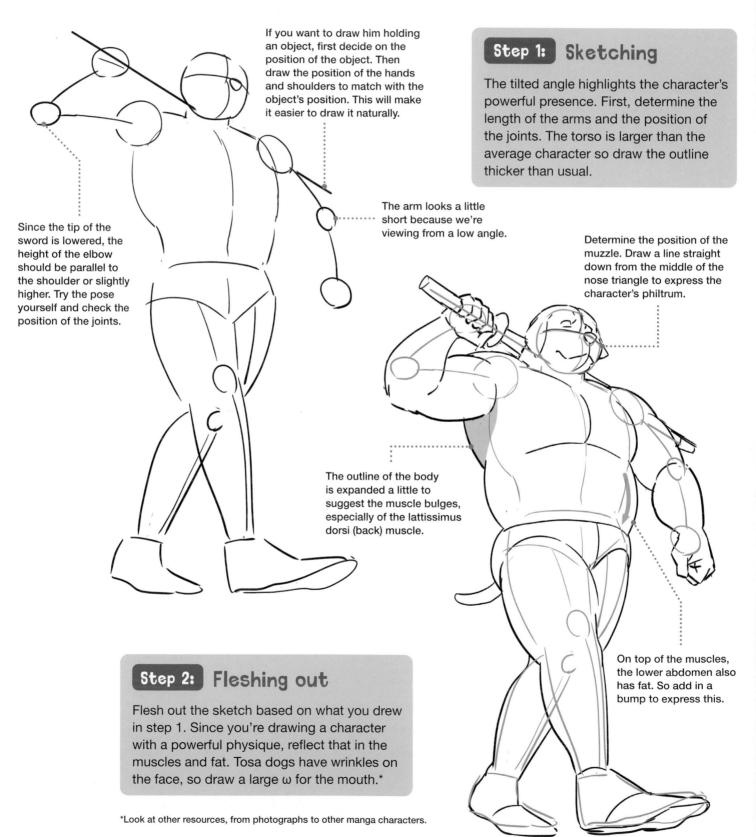

If you want to draw him holding an object, first decide on the position of the object. Then draw the position of the hands and shoulders to match with the object's position. This will make it easier to draw it naturally.

Step 1: Sketching

The tilted angle highlights the character's powerful presence. First, determine the length of the arms and the position of the joints. The torso is larger than the average character so draw the outline thicker than usual.

The arm looks a little short because we're viewing from a low angle.

Since the tip of the sword is lowered, the height of the elbow should be parallel to the shoulder or slightly higher. Try the pose yourself and check the position of the joints.

Determine the position of the muzzle. Draw a line straight down from the middle of the nose triangle to express the character's philtrum.

The outline of the body is expanded a little to suggest the muscle bulges, especially of the lattissimus dorsi (back) muscle.

On top of the muscles, the lower abdomen also has fat. So add in a bump to express this.

Step 2: Fleshing out

Flesh out the sketch based on what you drew in step 1. Since you're drawing a character with a powerful physique, reflect that in the muscles and fat. Tosa dogs have wrinkles on the face, so draw a large ω for the mouth.*

*Look at other resources, from photographs to other manga characters.

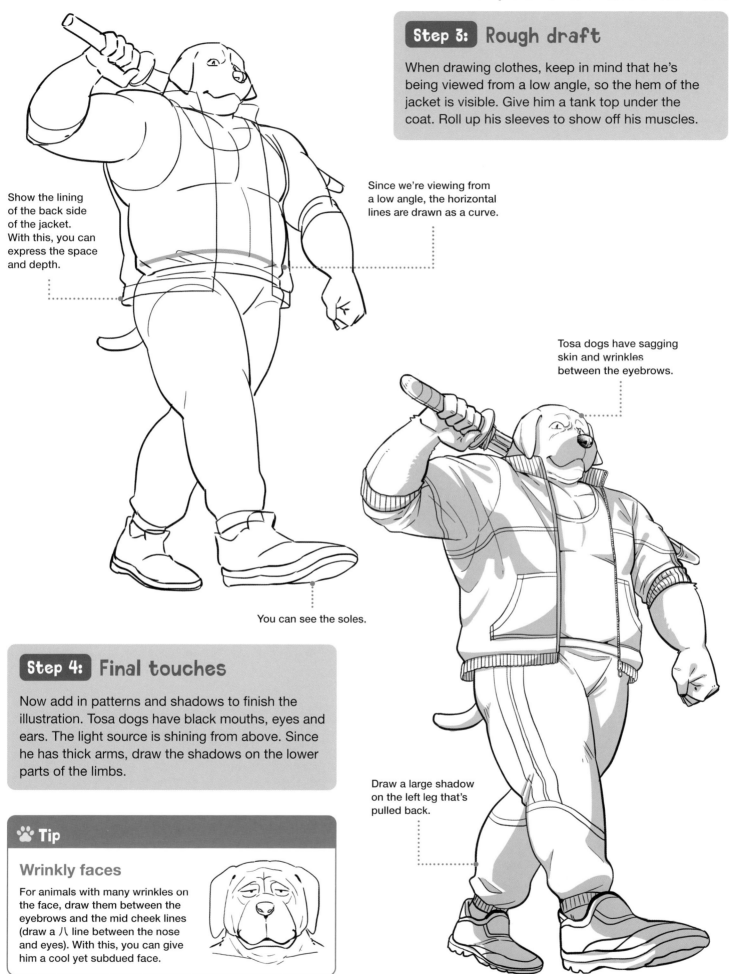

Show the lining of the back side of the jacket. With this, you can express the space and depth.

Step 3: Rough draft

When drawing clothes, keep in mind that he's being viewed from a low angle, so the hem of the jacket is visible. Give him a tank top under the coat. Roll up his sleeves to show off his muscles.

Since we're viewing from a low angle, the horizontal lines are drawn as a curve.

Tosa dogs have sagging skin and wrinkles between the eyebrows.

You can see the soles.

Step 4: Final touches

Now add in patterns and shadows to finish the illustration. Tosa dogs have black mouths, eyes and ears. The light source is shining from above. Since he has thick arms, draw the shadows on the lower parts of the limbs.

Draw a large shadow on the left leg that's pulled back.

🐾 Tip

Wrinkly faces

For animals with many wrinkles on the face, draw them between the eyebrows and the mid cheek lines (draw a 八 line between the nose and eyes). With this, you can give him a cool yet subdued face.

Samoyed

Pose 🐾 **Relaxing on a sofa**

Illustrator: Yuzpoco

With its curly tail and fluffy body, this chubby furry samoyed is kicking back, providing the perfect opportunity for you to tackle this particular pose.

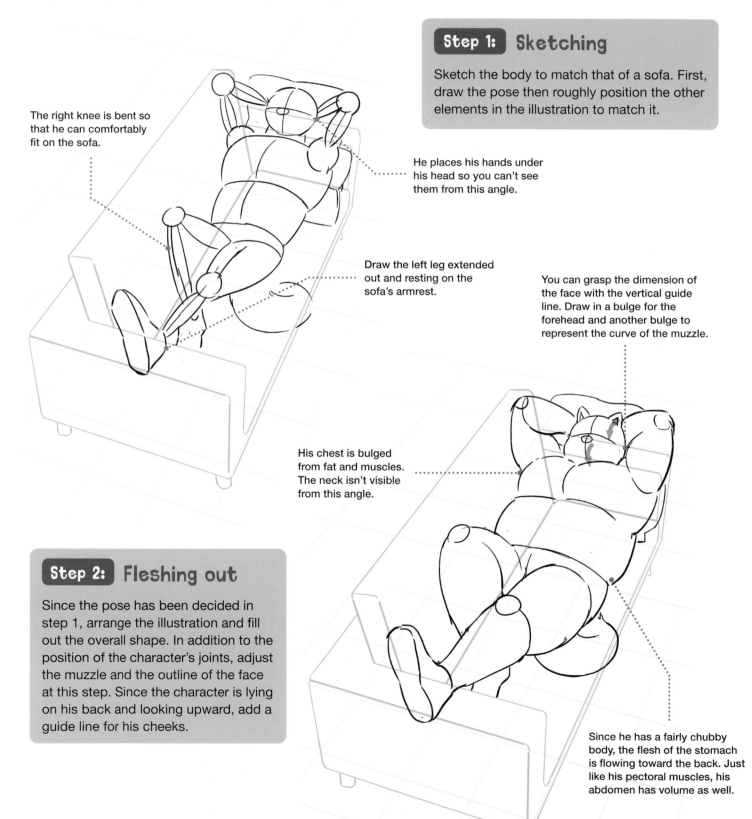

Step 1: Sketching

Sketch the body to match that of a sofa. First, draw the pose then roughly position the other elements in the illustration to match it.

The right knee is bent so that he can comfortably fit on the sofa.

He places his hands under his head so you can't see them from this angle.

Draw the left leg extended out and resting on the sofa's armrest.

You can grasp the dimension of the face with the vertical guide line. Draw in a bulge for the forehead and another bulge to represent the curve of the muzzle.

His chest is bulged from fat and muscles. The neck isn't visible from this angle.

Step 2: Fleshing out

Since the pose has been decided in step 1, arrange the illustration and fill out the overall shape. In addition to the position of the character's joints, adjust the muzzle and the outline of the face at this step. Since the character is lying on his back and looking upward, add a guide line for his cheeks.

Since he has a fairly chubby body, the flesh of the stomach is flowing toward the back. Just like his pectoral muscles, his abdomen has volume as well.

Samoyeds are a breed with a large amount of fur. Draw fur tufts of a < shape throughout his body outline to express his fluffy body. He sticks his tongue out to add to the relaxed expression.

Add to the character's personality by keeping his slippers on.

The hem of the shirt falls off the edge of the sofa.

Fat is soft. As a result, when the pants are tight, the fat on the stomach will bulge out from being squeezed.

Step 3: Rough draft

Put him in a loose-fitting pair of pajamas. His shirt is unbuttoned, fully open, and he still has his slippers on. With this, you can express his slightly sloppy and laid-back personality.

🐾 Tip

Change the impression

If you leave out details such as teeth and lips on the front muzzle, you can draw more comic-style facial features. On the other add, if you add more details, you'll create a more realistic animal-like appearance.

Draw tufts of fur around the body outline to add to his fluffiness.

Step 4: Final touches

Add shadows and fur to finish off. Draw a tuft of fur on the stomach to give him a fluffy feel. Shadows are added to the sides to bring out the three-dimensional effect.

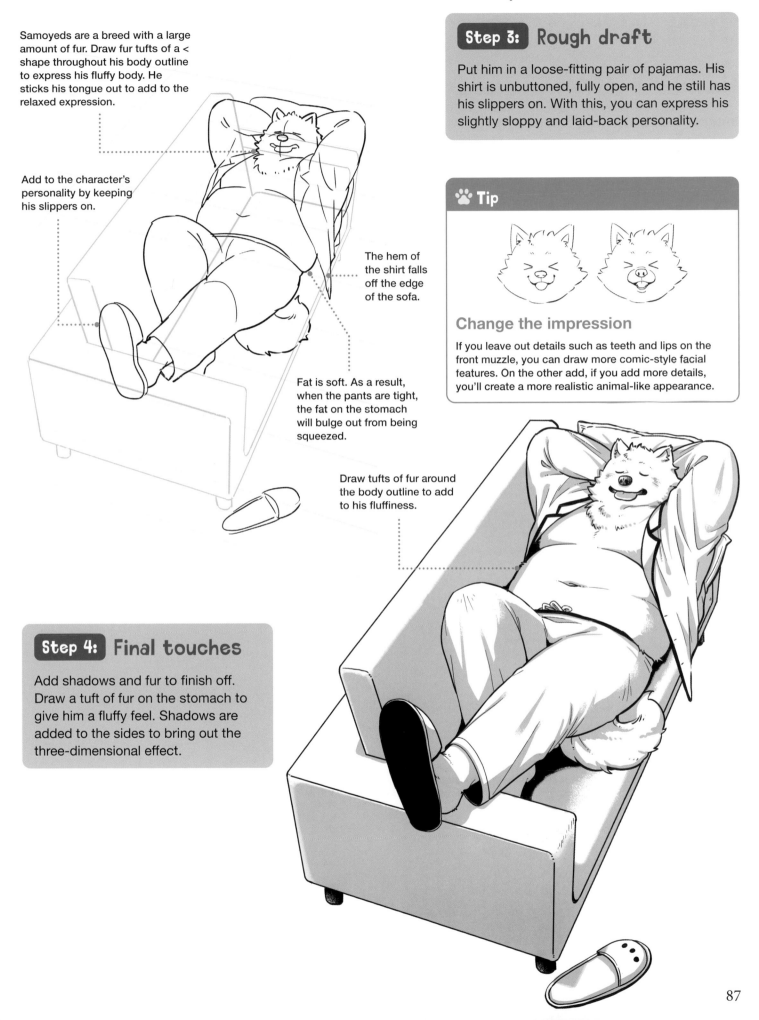

Bull

Comic style　Big body　Muscular　Furry

Pose 🐾 Lifting a heavy object

Illustrator: Yuzpoco

Imagine a Murcian bull* snorting and pawing the ground, about to charge. The large and muscular body physique suggests a professional wrestler. Pay close attention to the shape of the bull's muzzle.

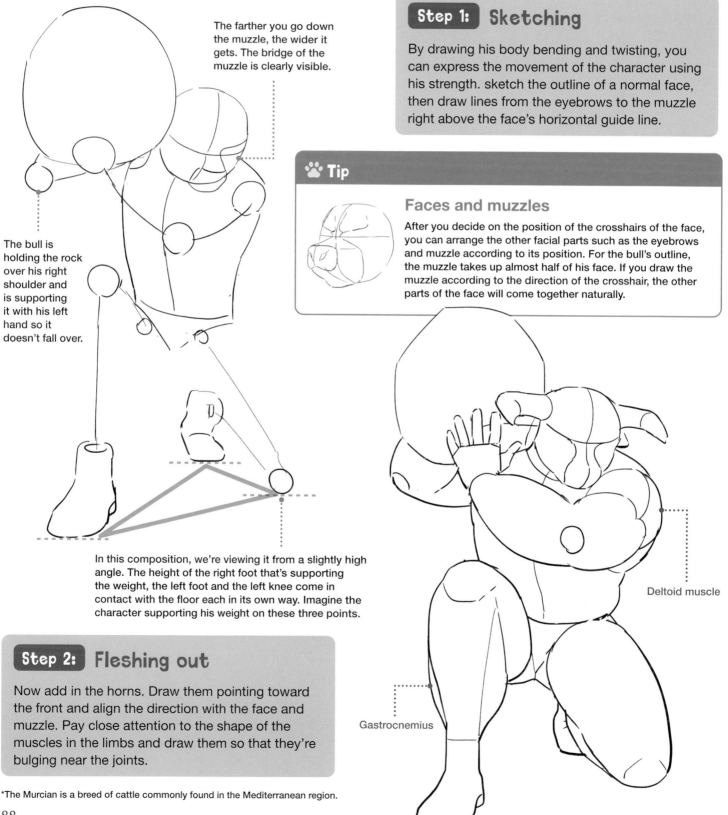

The farther you go down the muzzle, the wider it gets. The bridge of the muzzle is clearly visible.

The bull is holding the rock over his right shoulder and is supporting it with his left hand so it doesn't fall over.

In this composition, we're viewing it from a slightly high angle. The height of the right foot that's supporting the weight, the left foot and the left knee come in contact with the floor each in its own way. Imagine the character supporting his weight on these three points.

Step 1: Sketching

By drawing his body bending and twisting, you can express the movement of the character using his strength. sketch the outline of a normal face, then draw lines from the eyebrows to the muzzle right above the face's horizontal guide line.

🐾 Tip

Faces and muzzles

After you decide on the position of the crosshairs of the face, you can arrange the other facial parts such as the eyebrows and muzzle according to its position. For the bull's outline, the muzzle takes up almost half of his face. If you draw the muzzle according to the direction of the crosshair, the other parts of the face will come together naturally.

Deltoid muscle

Gastrocnemius

Step 2: Fleshing out

Now add in the horns. Draw them pointing toward the front and align the direction with the face and muzzle. Pay close attention to the shape of the muscles in the limbs and draw them so that they're bulging near the joints.

*The Murcian is a breed of cattle commonly found in the Mediterranean region.

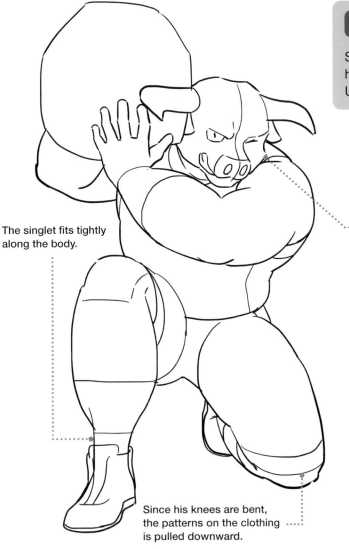

The singlet fits tightly along the body.

Since his knees are bent, the patterns on the clothing is pulled downward.

Sometimes it's hard to find reference for the type of muscle that suits your character. Cases like this may be challenging, but you can have fun if you imagine your own style of musclature.

Step 3: Rough draft

Since the outfit is stretchy, it hugs the body perfectly. The hem and edges of the tight outfit curve along with the body. Using the muzzle as reference, draw in the chin.

Using the muzzle as reference, add in the lower jaw to make the outline stronger.

The ears are a little hidden under the horns. Add shadows around the ears to make them stand out.

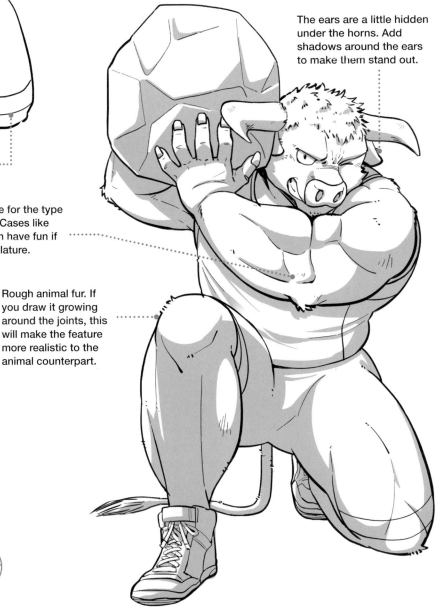

Rough animal fur. If you draw it growing around the joints, this will make the feature more realistic to the animal counterpart.

Step 4: Final touches

Add in shadows and give the bull fluffy short hair. Draw only a few tufts of fur to show the characters furry texture. The shadows are added to the torso and at the sections where the legs overlap. This way you'll get a better sense of depth and dimension.

The body is difficult to draw! So even if there's something that's still bothering you after you completed the illustration, you still get full points for completing it!!

Tanuki

Pose 🐾 **Throwing a ball** Illustrator: Yuzpoco

Charmingly chubby, with a unique horizontally elongated face, this tanuki's pose is attention-grabbing, the ball headed straight toward the viewer.

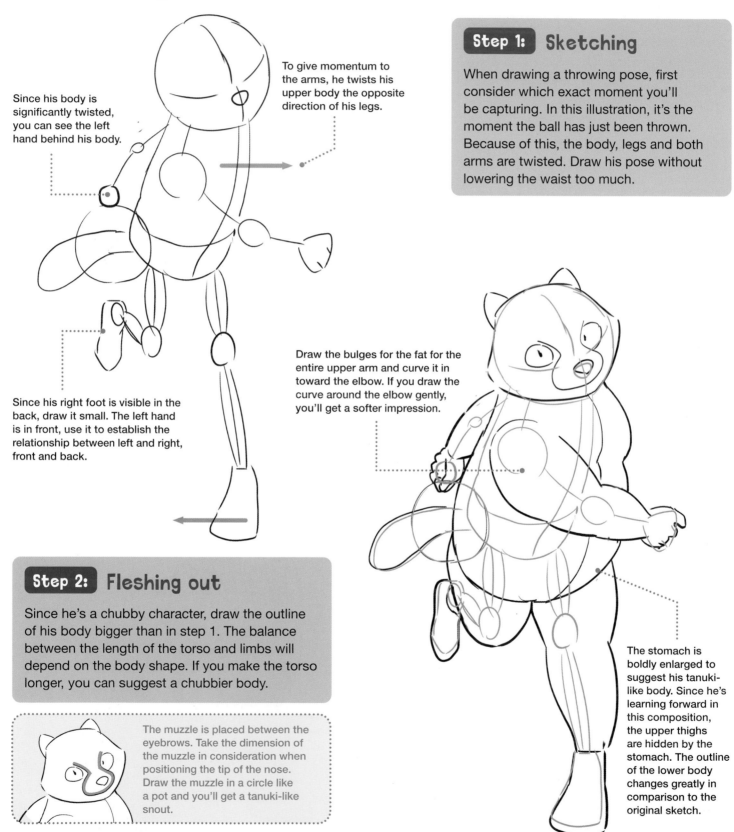

Since his body is significantly twisted, you can see the left hand behind his body.

To give momentum to the arms, he twists his upper body the opposite direction of his legs.

Step 1: Sketching

When drawing a throwing pose, first consider which exact moment you'll be capturing. In this illustration, it's the moment the ball has just been thrown. Because of this, the body, legs and both arms are twisted. Draw his pose without lowering the waist too much.

Draw the bulges for the fat for the entire upper arm and curve it in toward the elbow. If you draw the curve around the elbow gently, you'll get a softer impression.

Since his right foot is visible in the back, draw it small. The left hand is in front, use it to establish the relationship between left and right, front and back.

Step 2: Fleshing out

Since he's a chubby character, draw the outline of his body bigger than in step 1. The balance between the length of the torso and limbs will depend on the body shape. If you make the torso longer, you can suggest a chubbier body.

The muzzle is placed between the eyebrows. Take the dimension of the muzzle in consideration when positioning the tip of the nose. Draw the muzzle in a circle like a pot and you'll get a tanuki-like snout.

The stomach is boldly enlarged to suggest his tanuki-like body. Since he's learning forward in this composition, the upper thighs are hidden by the stomach. The outline of the lower body changes greatly in comparison to the original sketch.

Step 3: Rough draft

Give him a baseball uniform. Using the center line from step 1, add in the center line of his shirt to show where the buttons are located. For his face, connect the lines from the muzzle to show his fur pattern.

Draw a face pattern that connects his eyebrows and muzzle line.

You can express the momentum of throwing by having the sleeve fluttering a little. You can also express the soft fabric of the shirt and the depth and dimension of the sleeve.

Since his stomach is rounded, the waistline of the pants is covered and cannot be seen from this angle.

Step 4: Final touches

Finish off by adding the details of the pattern and shadows. A regular raccoon would usually have vertical lines between its eyebrows and a striped tail, however, tanukis are different. Be careful and keep this in mind when searching for reference photos.

🐾 Tip

Drawing characters with short limbs

When drawing furries of short-limbed animals such as tanukis and corgis, it's easy to grasp their compact characteristics. However, when drawing their limbs short in their furry form, it may be difficult to pose them.

The light source is from the upper left-hand side. The parts of the leg that are visible in the back are shaded. Since he's leaning forward significantly, the light hits the upper portion of it.

4 Drawing a Thick Body Type

A furry with an overall bigger silhouette has a strong presence. Because of the extra padding present, it's actually more difficult to pose larger body types. Still there are various ways of highlighting the features of a larger-scaled body.

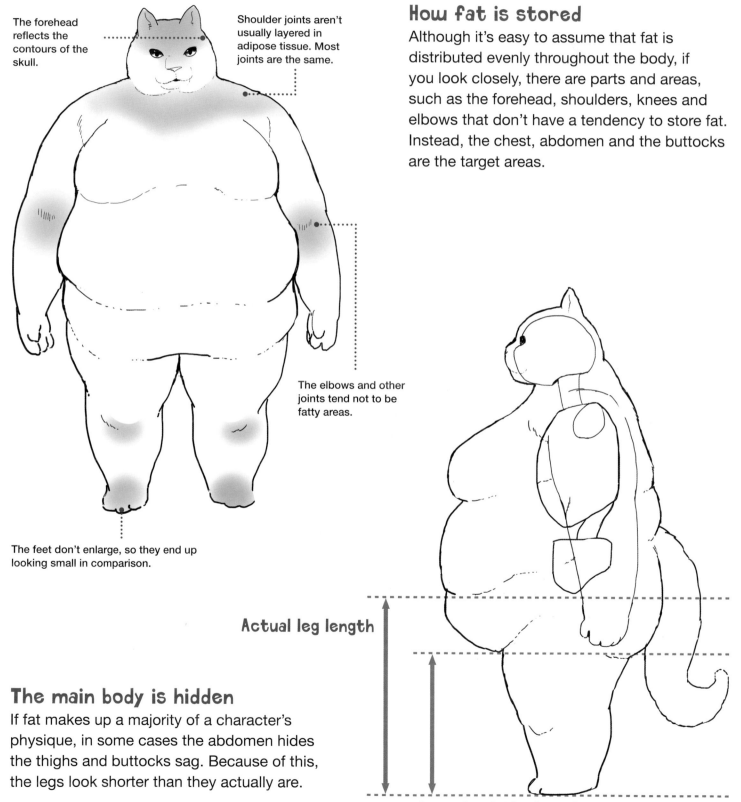

The forehead reflects the contours of the skull.

Shoulder joints aren't usually layered in adipose tissue. Most joints are the same.

The elbows and other joints tend not to be fatty areas.

The feet don't enlarge, so they end up looking small in comparison.

How fat is stored

Although it's easy to assume that fat is distributed evenly throughout the body, if you look closely, there are parts and areas, such as the forehead, shoulders, knees and elbows that don't have a tendency to store fat. Instead, the chest, abdomen and the buttocks are the target areas.

Actual leg length

The main body is hidden

If fat makes up a majority of a character's physique, in some cases the abdomen hides the thighs and buttocks sag. Because of this, the legs look shorter than they actually are.

Length of the leg that we can see

Different kinds of thick body types

Chubby

This is the type with a lot of padding that makes up the overall body shape. The bulging belly or sagging abdomen are key features to practice and get right.

Thick + Muscular

For broad-shouldered, large-bodied characters, muscle and adipose tissue combine to create a bulkier frame and a more hulking presence. Despite the larger size, the overall silhouette appears tighter, more defined because of the muscles.

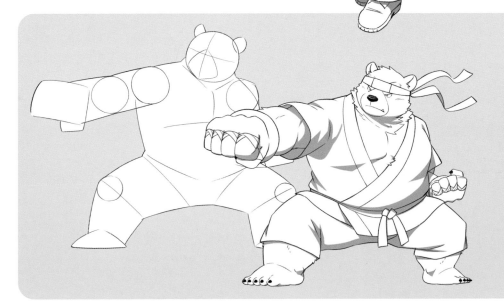

Powerful

The whole body is muscular and is very large to emphasize the powerful body type. This body type is similar to sumo wrestlers. So emphasize the thick joints and bones when sketching.

Red Fox

Pose ❀ **Bending forward** Illustrator: Kishibe

This furry female character is also known as a mesukemo. Among mesukemos, the red fox is especially popular. The long limbs and fluffy body and tail make this an appealing character.

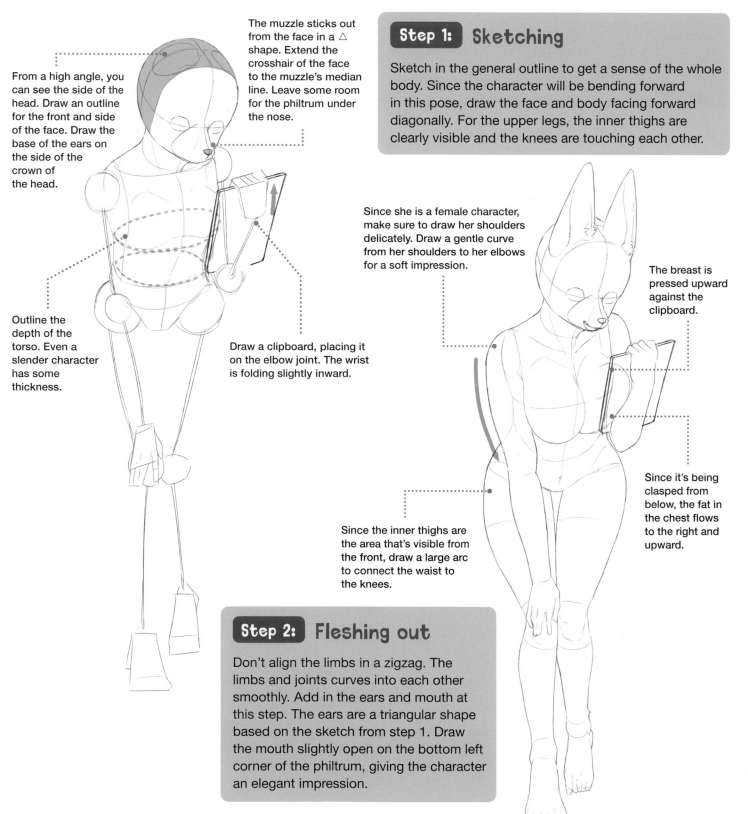

From a high angle, you can see the side of the head. Draw an outline for the front and side of the face. Draw the base of the ears on the side of the crown of the head.

The muzzle sticks out from the face in a △ shape. Extend the crosshair of the face to the muzzle's median line. Leave some room for the philtrum under the nose.

Outline the depth of the torso. Even a slender character has some thickness.

Draw a clipboard, placing it on the elbow joint. The wrist is folding slightly inward.

Step 1: Sketching

Sketch in the general outline to get a sense of the whole body. Since the character will be bending forward in this pose, draw the face and body facing forward diagonally. For the upper legs, the inner thighs are clearly visible and the knees are touching each other.

Since she is a female character, make sure to draw her shoulders delicately. Draw a gentle curve from her shoulders to her elbows for a soft impression.

The breast is pressed upward against the clipboard.

Since it's being clasped from below, the fat in the chest flows to the right and upward.

Since the inner thighs are the area that's visible from the front, draw a large arc to connect the waist to the knees.

Step 2: Fleshing out

Don't align the limbs in a zigzag. The limbs and joints curves into each other smoothly. Add in the ears and mouth at this step. The ears are a triangular shape based on the sketch from step 1. Draw the mouth slightly open on the bottom left corner of the philtrum, giving the character an elegant impression.

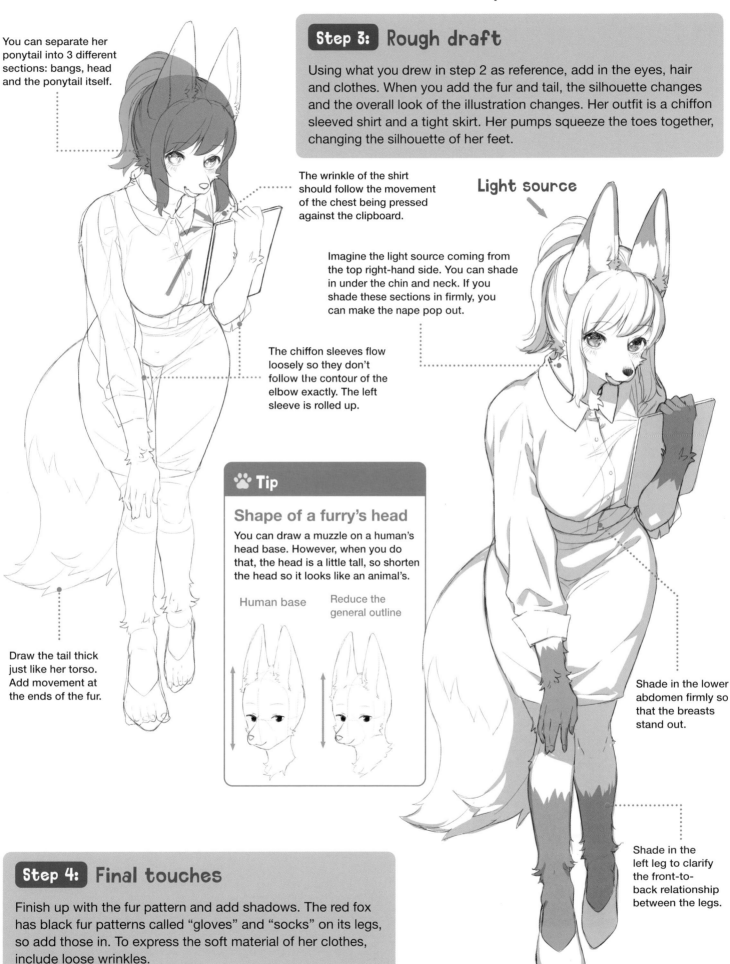

You can separate her ponytail into 3 different sections: bangs, head and the ponytail itself.

Step 3: Rough draft

Using what you drew in step 2 as reference, add in the eyes, hair and clothes. When you add the fur and tail, the silhouette changes and the overall look of the illustration changes. Her outfit is a chiffon sleeved shirt and a tight skirt. Her pumps squeeze the toes together, changing the silhouette of her feet.

The wrinkle of the shirt should follow the movement of the chest being pressed against the clipboard.

Light source

Imagine the light source coming from the top right-hand side. You can shade in under the chin and neck. If you shade these sections in firmly, you can make the nape pop out.

The chiffon sleeves flow loosely so they don't follow the contour of the elbow exactly. The left sleeve is rolled up.

🐾 Tip

Shape of a furry's head

You can draw a muzzle on a human's head base. However, when you do that, the head is a little tall, so shorten the head so it looks like an animal's.

Human base

Reduce the general outline

Draw the tail thick just like her torso. Add movement at the ends of the fur.

Shade in the lower abdomen firmly so that the breasts stand out.

Step 4: Final touches

Finish up with the fur pattern and add shadows. The red fox has black fur patterns called "gloves" and "socks" on its legs, so add those in. To express the soft material of her clothes, include loose wrinkles.

Shade in the left leg to clarify the front-to-back relationship between the legs.

Bunny

Pose 🐾 Leaping

Illustrator: Kishibe

With round eyes and long ears, this fuzzy furry is ready to spring into action. This action pose is a good one to master and adapt to other characters you create.

If you enlarge her eyes and position them lower, you'll give her a more youthful appearance.

Since you want to show her youthfulness, draw her plumpy cheeks.

The arms in the back side look short.

Draw the hand in 3 sections, the thumb, fingers and palm.

Step 1: Sketching

Let's draw in a little muzzle for our bunny girl. Spread her arms to the left and right to give her a bigger movement. Her right leg extends out and the right leg folded in with her knees to give her pose dynamic.

🐾 Tip

Drawing a short muzzle from a low angle

Draw a loose line to connect the muzzle, chin and the neck. Drawing the muzzle small will give her a cute impression.

The ears are vertically long and semi-circular.

The knee is a stiff plate connected by an elastic ligament above the joints.

In this pose, the buttocks and the thigh connect as one part.

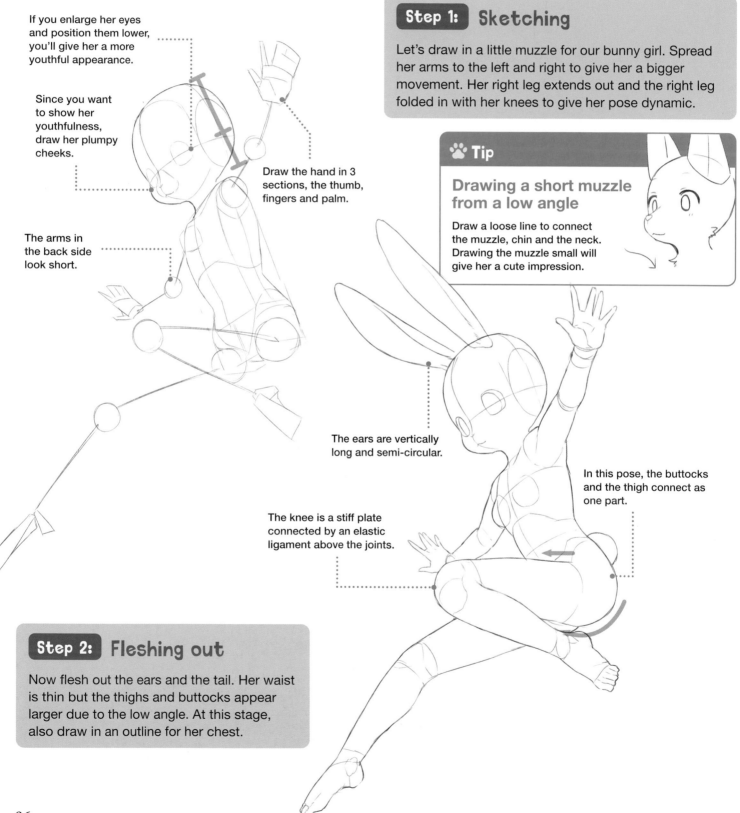

Step 2: Fleshing out

Now flesh out the ears and the tail. Her waist is thin but the thighs and buttocks appear larger due to the low angle. At this stage, also draw in an outline for her chest.

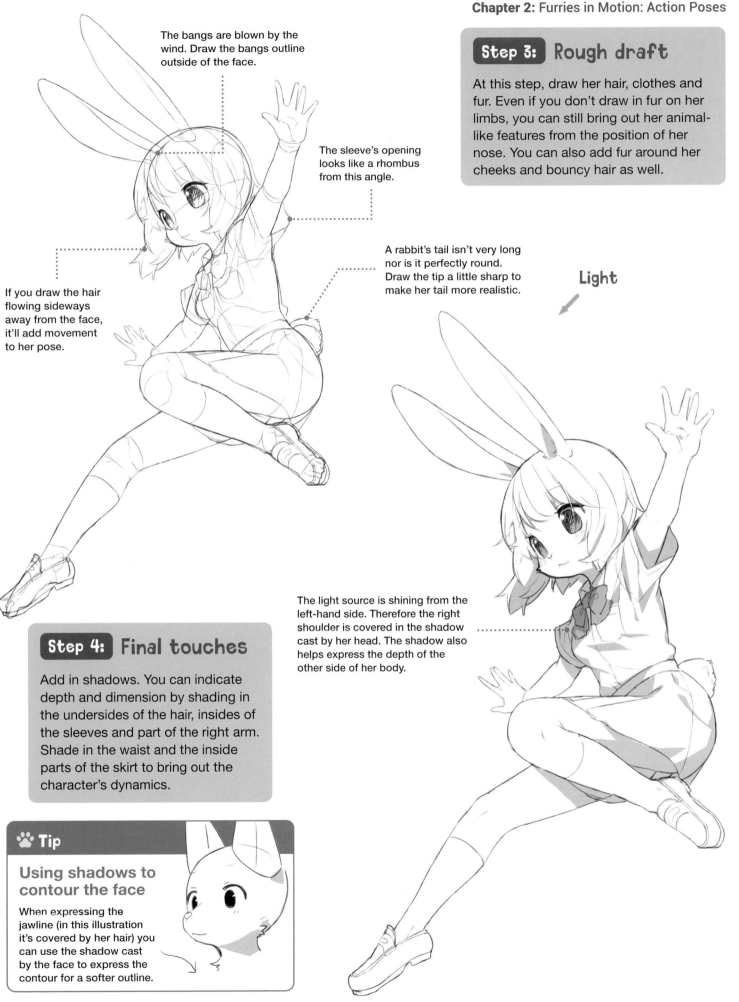

The bangs are blown by the wind. Draw the bangs outline outside of the face.

The sleeve's opening looks like a rhombus from this angle.

If you draw the hair flowing sideways away from the face, it'll add movement to her pose.

Step 3: Rough draft

At this step, draw her hair, clothes and fur. Even if you don't draw in fur on her limbs, you can still bring out her animal-like features from the position of her nose. You can also add fur around her cheeks and bouncy hair as well.

A rabbit's tail isn't very long nor is it perfectly round. Draw the tip a little sharp to make her tail more realistic.

Light

The light source is shining from the left-hand side. Therefore the right shoulder is covered in the shadow cast by her head. The shadow also helps express the depth of the other side of her body.

Step 4: Final touches

Add in shadows. You can indicate depth and dimension by shading in the undersides of the hair, insides of the sleeves and part of the right arm. Shade in the waist and the inside parts of the skirt to bring out the character's dynamics.

🐾 **Tip**

Using shadows to contour the face

When expressing the jawline (in this illustration it's covered by her hair) you can use the shadow cast by the face to express the contour for a softer outline.

Mouse

Pose 🐾 **Looking up**

Illustrator: Kishibe

A perky little mouse has something to say. Since the character is being seen from a high angle, think about perspective and viewpoint as you bring the pose to life.

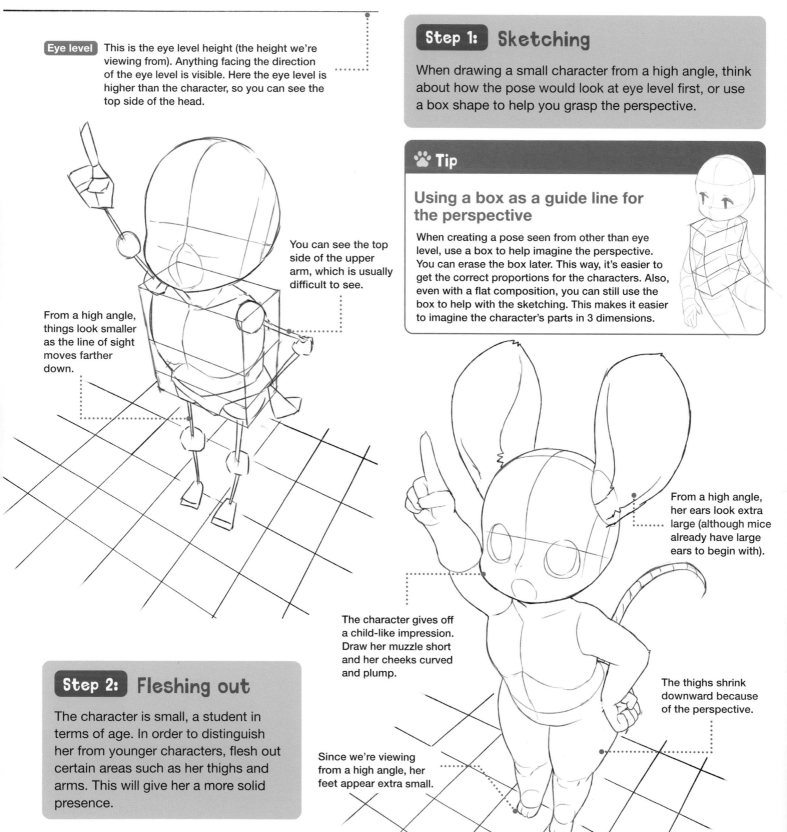

Eye level This is the eye level height (the height we're viewing from). Anything facing the direction of the eye level is visible. Here the eye level is higher than the character, so you can see the top side of the head.

From a high angle, things look smaller as the line of sight moves farther down.

You can see the top side of the upper arm, which is usually difficult to see.

Step 1: Sketching

When drawing a small character from a high angle, think about how the pose would look at eye level first, or use a box shape to help you grasp the perspective.

🐾 Tip

Using a box as a guide line for the perspective

When creating a pose seen from other than eye level, use a box to help imagine the perspective. You can erase the box later. This way, it's easier to get the correct proportions for the characters. Also, even with a flat composition, you can still use the box to help with the sketching. This makes it easier to imagine the character's parts in 3 dimensions.

From a high angle, her ears look extra large (although mice already have large ears to begin with).

The character gives off a child-like impression. Draw her muzzle short and her cheeks curved and plump.

The thighs shrink downward because of the perspective.

Step 2: Fleshing out

The character is small, a student in terms of age. In order to distinguish her from younger characters, flesh out certain areas such as her thighs and arms. This will give her a more solid presence.

Since we're viewing from a high angle, her feet appear extra small.

Her hair is thick, therefore, the hairline is drawn a little above the head outline.

Step 3: Rough draft

Draw her clothes and hair while paying attention to the perspective. Add a little fur on her arm that's visible.

Draw some fur sticking out on the outline of the joints.

The light source is directly above, so add shine to her bangs.

Draw her chest bulging a little.

Mice are characterized by the flesh color in their ears.

Put shoes on her feet. Mice already have small feet to begin with, but now that we're viewing her from a high angle, her feet look especially small.

The underside of the arm is shaded.

Since the breasts are angled slightly upward, add in a little shadow.

Step 4: Final touches

Add wrinkles and shadows to her clothes. Since the illustration is viewed from a high angle, the shaded areas are limited when the light source is shining from above. Be careful not to add in too much shadow.

Add a large shadow under the skirt.

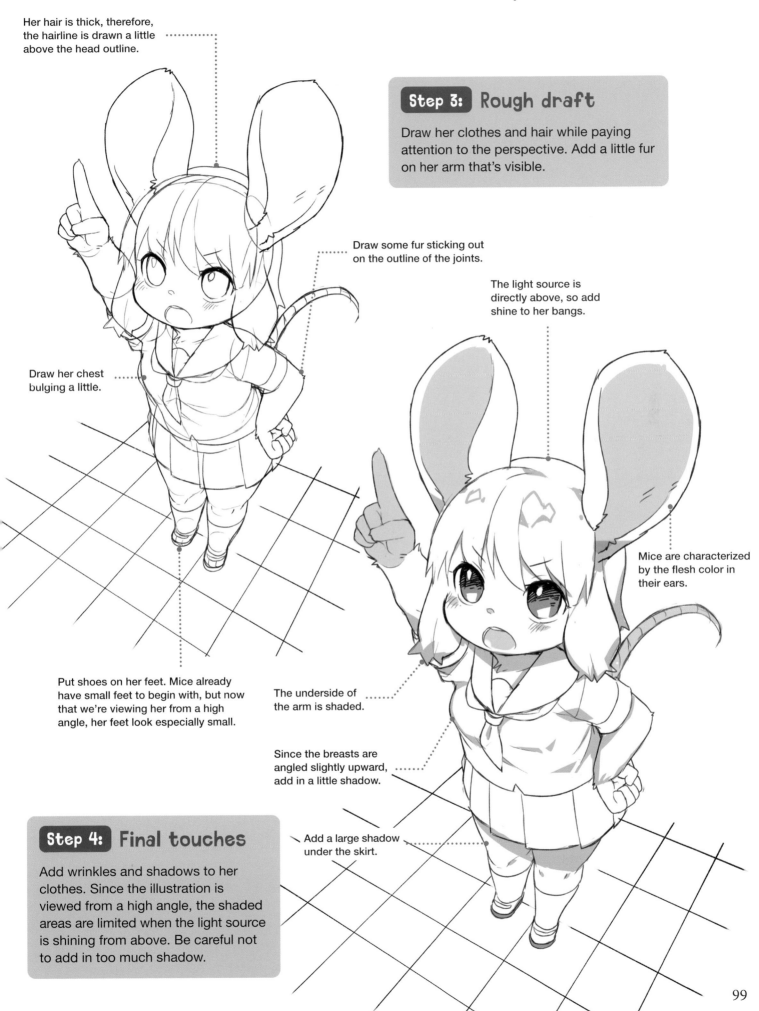

Mountain Goat

Pose 🐾 **Looking down**

Illustrator: Kishibe

With a firm physique, goat furries allow for a unique human-creature fusion. Give this character the fun-loving vibe of a gentle, older sister.

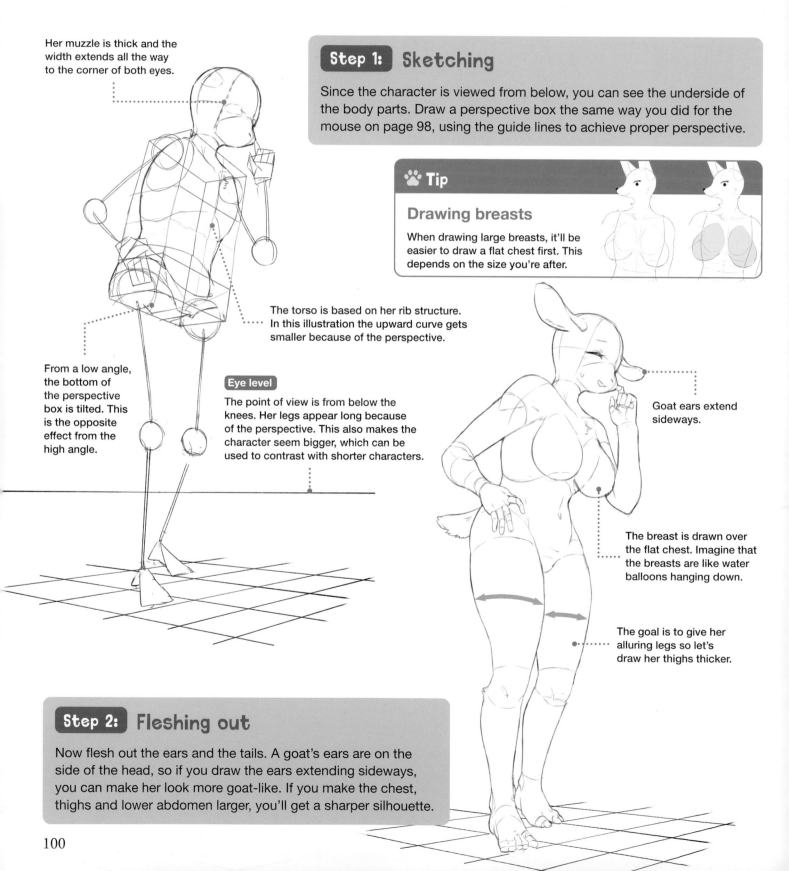

Her muzzle is thick and the width extends all the way to the corner of both eyes.

Step 1: Sketching

Since the character is viewed from below, you can see the underside of the body parts. Draw a perspective box the same way you did for the mouse on page 98, using the guide lines to achieve proper perspective.

🐾 **Tip**

Drawing breasts

When drawing large breasts, it'll be easier to draw a flat chest first. This depends on the size you're after.

The torso is based on her rib structure. In this illustration the upward curve gets smaller because of the perspective.

Eye level

The point of view is from below the knees. Her legs appear long because of the perspective. This also makes the character seem bigger, which can be used to contrast with shorter characters.

From a low angle, the bottom of the perspective box is tilted. This is the opposite effect from the high angle.

Goat ears extend sideways.

The breast is drawn over the flat chest. Imagine that the breasts are like water balloons hanging down.

The goal is to give her alluring legs so let's draw her thighs thicker.

Step 2: Fleshing out

Now flesh out the ears and the tails. A goat's ears are on the side of the head, so if you draw the ears extending sideways, you can make her look more goat-like. If you make the chest, thighs and lower abdomen larger, you'll get a sharper silhouette.

The hair falls gently over the shoulders. The hair around the neck falls straight down and doesn't follow the outline of the head.

Step 3: Rough draft

Draw her hair and clothing. For her outfit, give her a T-shirt and jeans. The area under the chest doesn't entirely follow the curve of the breasts, the cloth is pulled straight toward the abdomen.

Add shadows to the inner side of the hair and the back side of the face. This way you can express the depth of the hair and face.

The shirt doesn't follow the outline below the chest. Draw wrinkles that pull the shirt toward the belt.

Add shadows to her fingers. This helps show that the ring finger and the pinkie are bending and clearly touching her hips. Doing this brings out the fingers' dimensions.

Lightly shade in the lower part of her knees to show that they're slightly bent.

Step 4: Final touches

Apply shadows to the wrinkles of her clothes and around the face. The wrinkles on the clothes should flow from the chest to the belt. Also add in fine shadows. For the face area, shade in the back hair and the neck to bring out the 3D effect.

Retriever

Pose 🐾 **Brushing teeth**

Illustrator: Morikita Sasana

Here, a drowsy golden retriever brushes her teeth. With her small muzzle and fluffy coat, you can devise a perfectly charming dog furry in a more relaxed mode.

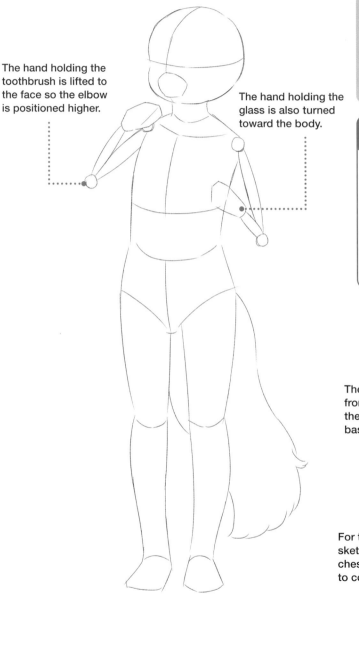

The hand holding the toothbrush is lifted to the face so the elbow is positioned higher.

The hand holding the glass is also turned toward the body.

Step 1: Sketching

Pay attention to how the hand holding the toothbrush and cup looks. Adjust the angle for the left and right hand to match the action of holding the items.

🐾 Tip

Fingers gripping objects

In this illustration, the character is holding a toothbrush in one hand, and a cup in the other. Sketch the outline while imagining what the pose would look like. Up to the first finger joints on the hand holding the toothbrush are visible. Also be aware of the difference in the elbow positions.

The ears hang down from where they meet the head. The ears are basically triangular.

For the upper body outline, sketch in a slight bump at the chest. Adjust the center line to compensate for this bump.

Step 2: Fleshing out

Now flesh out the details on the hands. The hands are roughly divided into 3 main sections, the back of the hand, the four fingers and the joints of the thumb. Also add in the character's large ears.

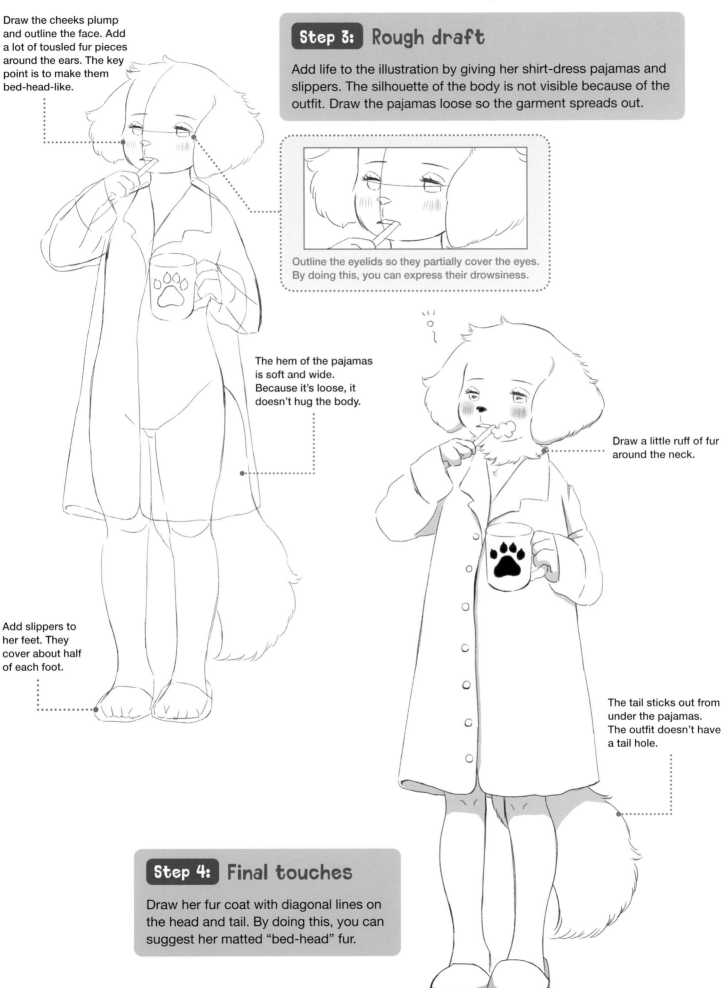

Draw the cheeks plump and outline the face. Add a lot of tousled fur pieces around the ears. The key point is to make them bed-head-like.

Step 3: Rough draft

Add life to the illustration by giving her shirt-dress pajamas and slippers. The silhouette of the body is not visible because of the outfit. Draw the pajamas loose so the garment spreads out.

Outline the eyelids so they partially cover the eyes. By doing this, you can express their drowsiness.

The hem of the pajamas is soft and wide. Because it's loose, it doesn't hug the body.

Draw a little ruff of fur around the neck.

Add slippers to her feet. They cover about half of each foot.

The tail sticks out from under the pajamas. The outfit doesn't have a tail hole.

Step 4: Final touches

Draw her fur coat with diagonal lines on the head and tail. By doing this, you can suggest her matted "bed-head" fur.

Siamese Cat

Pose 🐾 Painting fingernails Illustrator: Morikita Sasana

Now it's time to tackle a Siamese cat with slender limbs, large ears and that signature fur pattern. Highlighting the breed's graceful silhouette, show her painting her nails.

Step 1: Sketching

In this pose, she's doing her nails while lying on her stomach. The line from the abdomen to the thigh touches the ground. She's supporting her upper body with her elbows and lifting her legs up from the knees.

The contrast between her elegantly applying nail polish and her upturned legs adds a sense of realism and charm.

Her chest line is a gentle S curve.

She's arching her back so give the spine an upward curve.

The angle of the knees and the tip of the toes for each leg are different from each other. This gives the legs a natural pose.

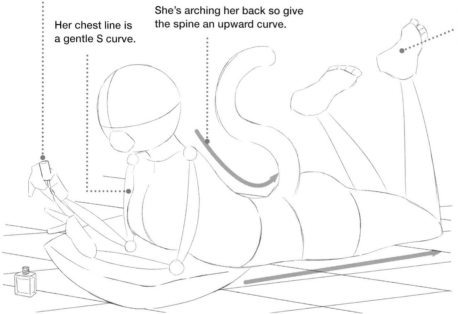

🐾 Tip

Think about the body parts

It's easier to grasp the depth of the body if you think about the surface of each section. The surface that's parallel to the floor runs from the back to the buttocks, and the sides curve down toward the floor.

Step 2: Fleshing out

Now outline the ears, limbs and body line. Angle her arms inward to soften the impression. For her right hand, add in the nail polish brush so that it fits in the hand naturally.

Make the ears large.

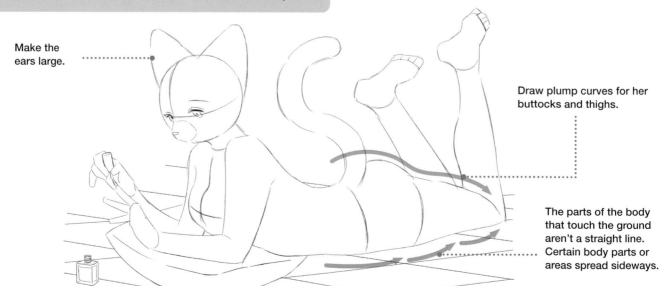

Draw plump curves for her buttocks and thighs.

The parts of the body that touch the ground aren't a straight line. Certain body parts or areas spread sideways.

Step 3: Rough draft

Since she's relaxing in her bedroom, give her a tube top and tight-fitting shorts so it's easier to show the body line. Pressed by the tail, the tube top wrinkles toward the back.

Using the face's horizontal line as reference, add some fur tufts. This will give her face look more of a rhomboid shape, which will be more like her animal counterparts' face.

Keep in mind that a Siamese cat has slender limbs.

The right hand is holding the brush and applying the nail to the left nails. Add some fine movement to the hands to make her pose more realistic.

Step 4: Final touches

The Siamese cat is known for its signature markings. This coat pattern is called chocolate point. The brown coat covers areas such as the face, ears and feet.

For slender characters, the lines of the joints and bones are much sharper. On the other hand, if you draw the muscles in a curve, you can show the contrasting silhouette.

The coat pattern varies with each cat, with the face color generally covering the forehead, eyes and muzzle. If you're working with digital painting, you can use the spray tool or a blur brush tool to give the coat pattern a soft texture.

Maine Coon Cat

Comic style · **Standard body** · **Furry**

Pose 🐾 **Putting on a hair accessory**

Illustrator: **Morikita Sasana**

The Maine coon cat is known for its large physique and long fluffy hair. Adding natural movements to the pose creates a study in casual feline furry elegance. It's good practice too!

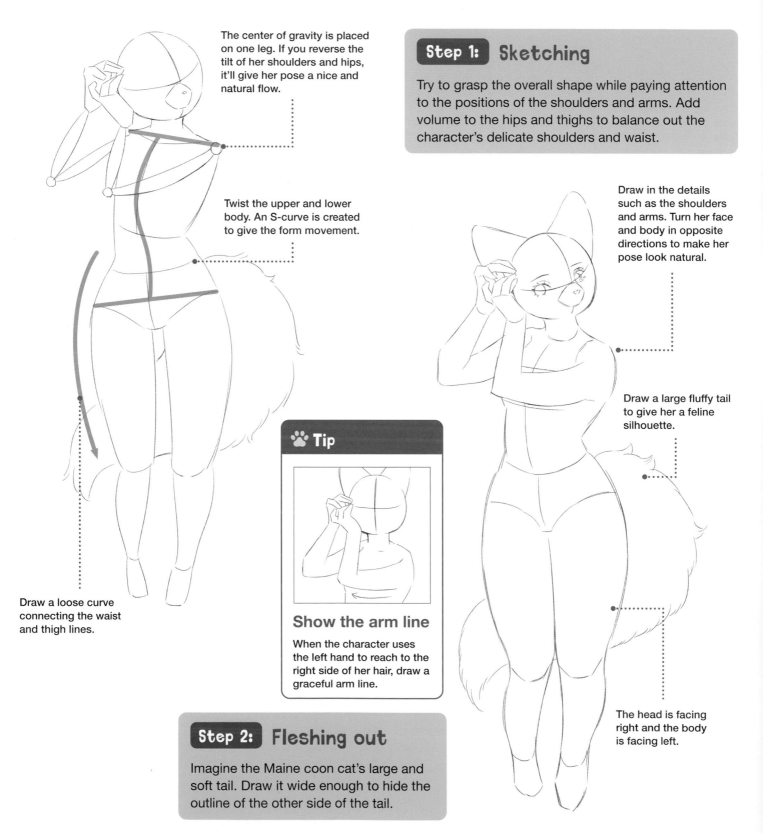

The center of gravity is placed on one leg. If you reverse the tilt of her shoulders and hips, it'll give her pose a nice and natural flow.

Step 1: Sketching

Try to grasp the overall shape while paying attention to the positions of the shoulders and arms. Add volume to the hips and thighs to balance out the character's delicate shoulders and waist.

Twist the upper and lower body. An S-curve is created to give the form movement.

Draw in the details such as the shoulders and arms. Turn her face and body in opposite directions to make her pose look natural.

Draw a large fluffy tail to give her a feline silhouette.

Draw a loose curve connecting the waist and thigh lines.

🐾 Tip

Show the arm line

When the character uses the left hand to reach to the right side of her hair, draw a graceful arm line.

The head is facing right and the body is facing left.

Step 2: Fleshing out

Imagine the Maine coon cat's large and soft tail. Draw it wide enough to hide the outline of the other side of the tail.

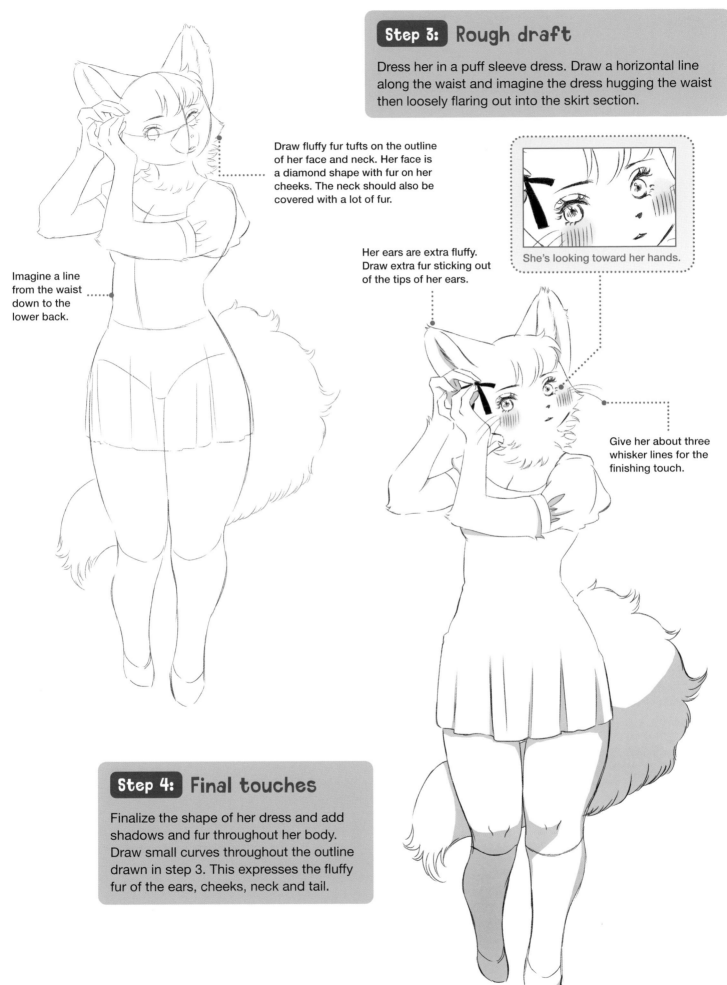

Step 3: Rough draft

Dress her in a puff sleeve dress. Draw a horizontal line along the waist and imagine the dress hugging the waist then loosely flaring out into the skirt section.

Draw fluffy fur tufts on the outline of her face and neck. Her face is a diamond shape with fur on her cheeks. The neck should also be covered with a lot of fur.

Imagine a line from the waist down to the lower back.

Her ears are extra fluffy. Draw extra fur sticking out of the tips of her ears.

She's looking toward her hands.

Give her about three whisker lines for the finishing touch.

Step 4: Final touches

Finalize the shape of her dress and add shadows and fur throughout her body. Draw small curves throughout the outline drawn in step 3. This expresses the fluffy fur of the ears, cheeks, neck and tail.

Fennec Fox

Pose 🐾 **Choosing an outfit**

Illustrator: **Morikita Sasana**

A member of the canine family, fennec foxes are known for their large ears and sharply defined muzzles. This furry version is all casual charm, as we've caught her picking out an outfit.

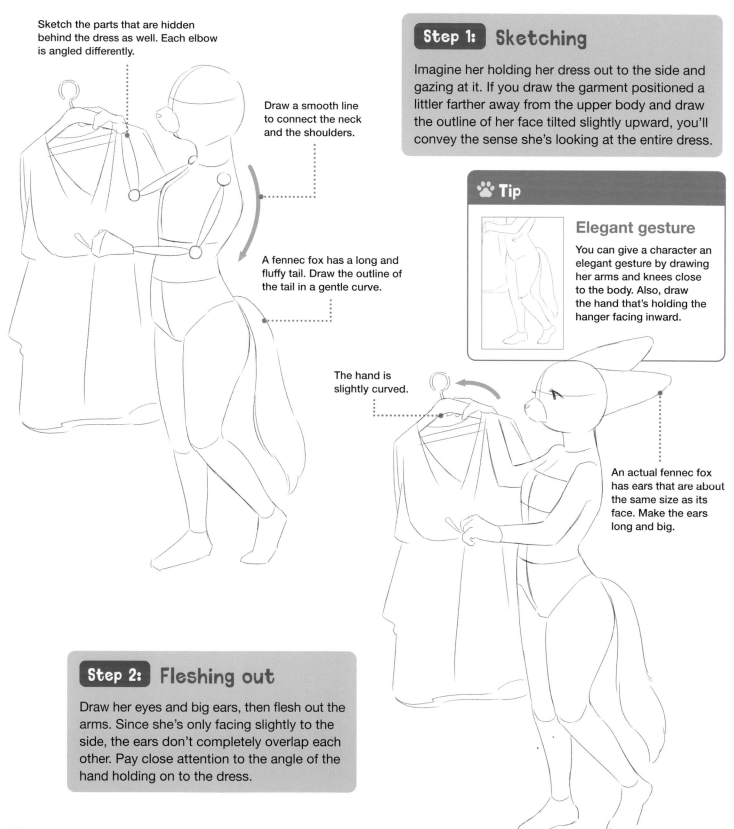

Sketch the parts that are hidden behind the dress as well. Each elbow is angled differently.

Draw a smooth line to connect the neck and the shoulders.

A fennec fox has a long and fluffy tail. Draw the outline of the tail in a gentle curve.

Step 1: Sketching

Imagine her holding her dress out to the side and gazing at it. If you draw the garment positioned a littler farther away from the upper body and draw the outline of her face tilted slightly upward, you'll convey the sense she's looking at the entire dress.

🐾 Tip

Elegant gesture

You can give a character an elegant gesture by drawing her arms and knees close to the body. Also, draw the hand that's holding the hanger facing inward.

The hand is slightly curved.

An actual fennec fox has ears that are about the same size as its face. Make the ears long and big.

Step 2: Fleshing out

Draw her eyes and big ears, then flesh out the arms. Since she's only facing slightly to the side, the ears don't completely overlap each other. Pay close attention to the angle of the hand holding on to the dress.

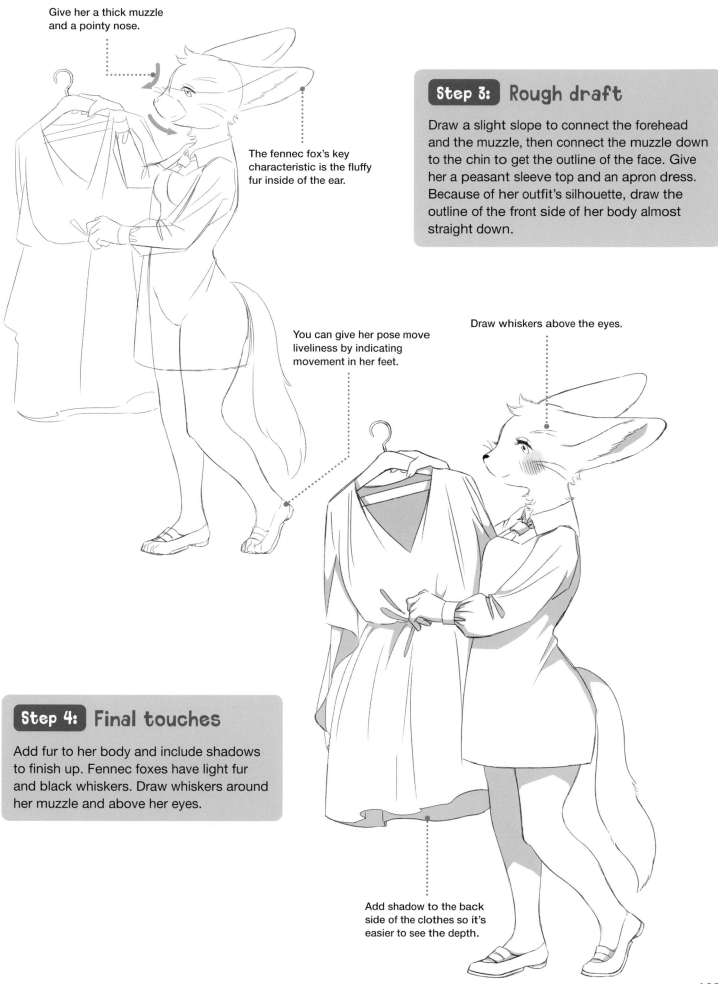

Give her a thick muzzle and a pointy nose.

The fennec fox's key characteristic is the fluffy fur inside of the ear.

Step 3: Rough draft

Draw a slight slope to connect the forehead and the muzzle, then connect the muzzle down to the chin to get the outline of the face. Give her a peasant sleeve top and an apron dress. Because of her outfit's silhouette, draw the outline of the front side of her body almost straight down.

You can give her pose move liveliness by indicating movement in her feet.

Draw whiskers above the eyes.

Step 4: Final touches

Add fur to her body and include shadows to finish up. Fennec foxes have light fur and black whiskers. Draw whiskers around her muzzle and above her eyes.

Add shadow to the back side of the clothes so it's easier to see the depth.

5 Another Look at Breasts and Chests

Thinking about the center of gravity

It's not that the chest doesn't have its own tension and weight throughout, but we have to take into consideration that the center of gravity is lower. Imagine a water balloon growing from a wall: this will make it easier to visualize the center of gravity. It's not just growing straight out, but there's a slight curve along the top, with the bulge of the breast suspended underneath.

If you want to make the breasts on your character bigger, think about how and where the breasts are growing from. First, draw a flat torso, then draw a silhouette of where the breasts are located on top of it.

If you want to draw a character that is a little plump or has less bulge in the silhouette, you can decide on the size of the chest at the sketching stage and round it out to give it a softer look.

Draw the size of the breasts at the preliminary stage.

The line for the underside of the chest is raised upward toward the "wall" to give the chest its shape.

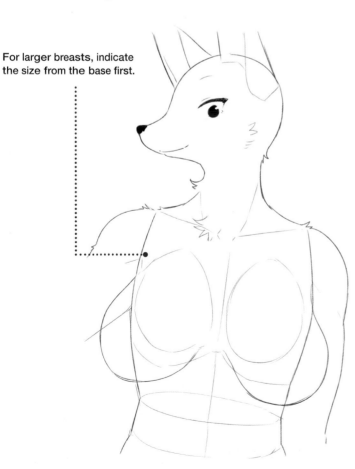

For larger breasts, indicate the size from the base first.

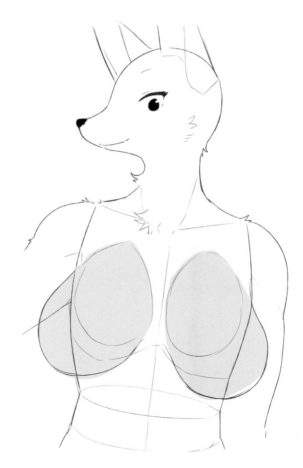

Chapter 3
Creating Chibi Furries

How to Draw Chibi Furries

We've all seen bobble-headed, pop-eyed chibis with their distended shapes and exaggerated features and expressions. Their comically distorted shapes are used for cartoonish or child-like effects or to create a charming symbolic mascot.

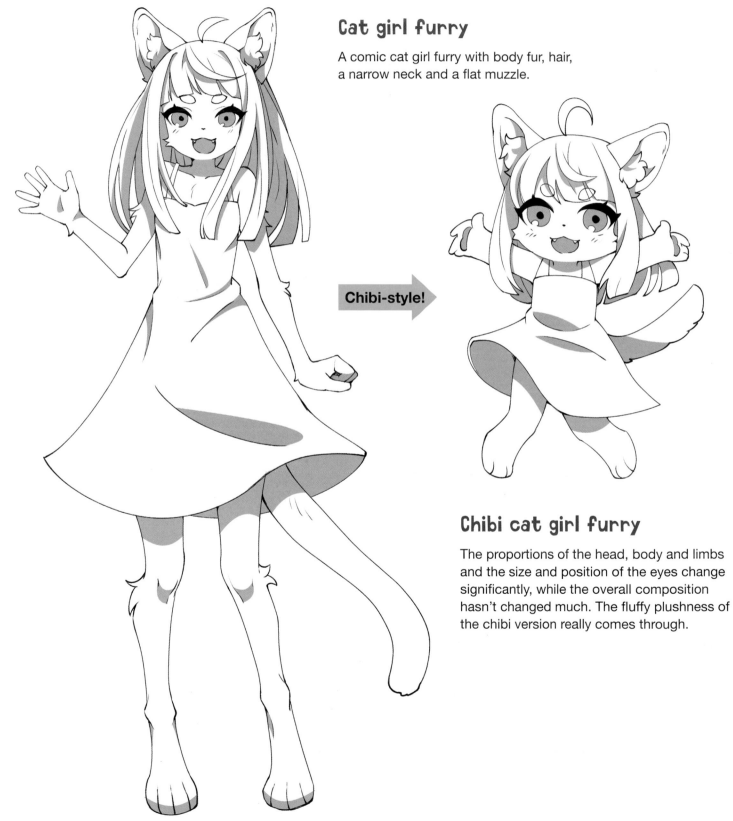

Cat girl furry

A comic cat girl furry with body fur, hair, a narrow neck and a flat muzzle.

Chibi-style!

Chibi cat girl furry

The proportions of the head, body and limbs and the size and position of the eyes change significantly, while the overall composition hasn't changed much. The fluffy plushness of the chibi version really comes through.

Chibi points
Chibi parts

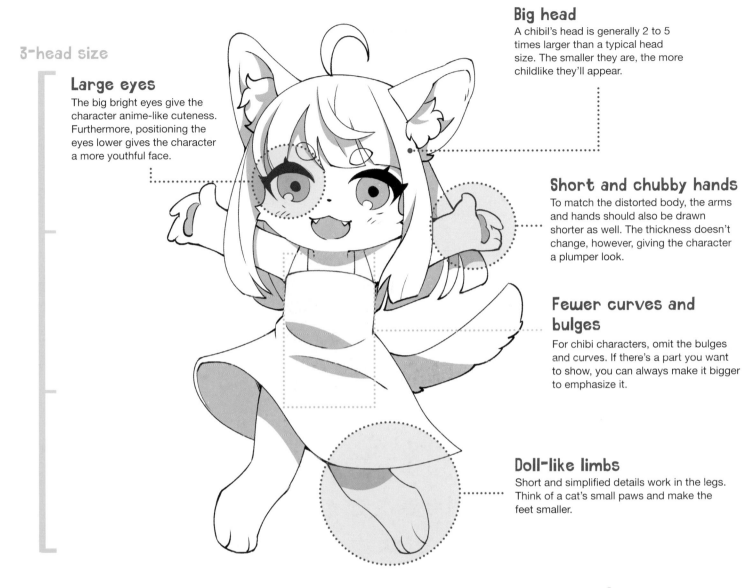

3-head size

Large eyes
The big bright eyes give the character anime-like cuteness. Furthermore, positioning the eyes lower gives the character a more youthful face.

Big head
A chibil's head is generally 2 to 5 times larger than a typical head size. The smaller they are, the more childlike they'll appear.

Short and chubby hands
To match the distorted body, the arms and hands should also be drawn shorter as well. The thickness doesn't change, however, giving the character a plumper look.

Fewer curves and bulges
For chibi characters, omit the bulges and curves. If there's a part you want to show, you can always make it bigger to emphasize it.

Doll-like limbs
Short and simplified details work in the legs. Think of a cat's small paws and make the feet smaller.

Stuffed Animals & Chibi Furries

When drawing chibi characters, adding stuffed-animal or plush-toy-like features is the right idea. The short limbs, round eyes and large head elevate its cuteness, charm and appeal.

When talking about stuffed animals, a teddy bear is generally the first thing that comes to mind. When bears stand upright on their back legs, their posture is surprisingly similar to humans.

The silhouette of a 3-heads-sized bear cub standing up on its two short legs is very similar to a human baby's. The adoration we have for teddy bears may be very much connected to the adoration we have for furries.

Degrees of Distortion

The degree of deformation and changes depending on the body-to-head ratio. The higher the ratio, the more realistic the character will appear. The lower the ratio, the more distorted the features become, intensifying the pop-eyed charm of your chibi furry.

4- to 5-head size

A tall body. At this size, the character will appear similar to a human child around 6–12 years old. Draw in as many details as much as possible. Furthermore, a real furry character would have a more horizontally elongated face (longer muzzle), however the chibi one has a rounder and almost vertically longer face.

3-head size

Highly distorted shapes. At this size, the character will appear similar to a human 0–5 years old. The head size is almost the same as the 4–5-head-sized character, but the body is shrunk to about ⅓.

2-head size

Mascot body shape. The ratio of head to body is 1:1. The details of the body are simplified and the joints resemble a stuffed animal's.

Selecting the key features

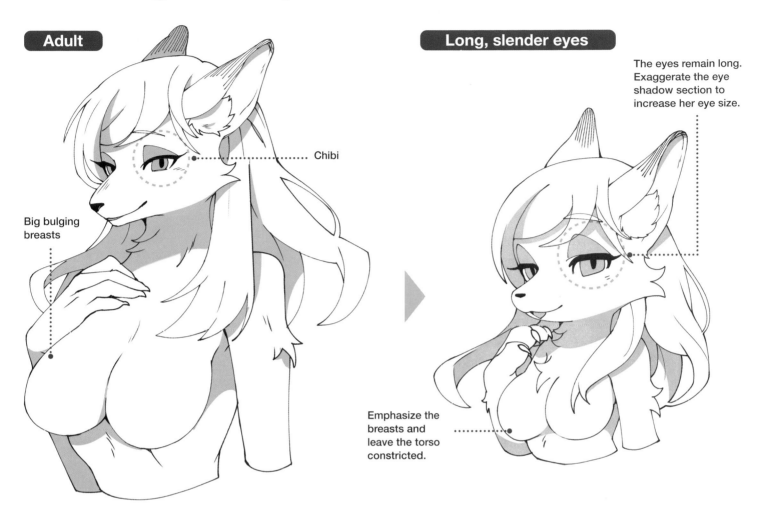

Adult

Chibi

Big bulging breasts

Long, slender eyes

The eyes remain long. Exaggerate the eye shadow section to increase her eye size.

Emphasize the breasts and leave the torso constricted.

Adult chibi

A character with a well-defined body shape. When you want to distort a character, you can use this diagram as an example. We wanted to keep the adult-like eyes and a glamorous body shape, so we designed the chibi by emphasizing the eye shadow and chest size while distorting the face ratio and making it rounder. Chibi-style distortion is not just about making it smaller and simpler. Design your chibis while thinking about the parts you want to emphasize.

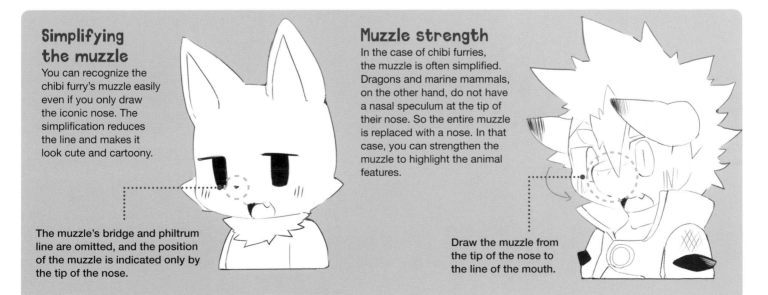

Simplifying the muzzle

You can recognize the chibi furry's muzzle easily even if you only draw the iconic nose. The simplification reduces the line and makes it look cute and cartoony.

The muzzle's bridge and philtrum line are omitted, and the position of the muzzle is indicated only by the tip of the nose.

Muzzle strength

In the case of chibi furries, the muzzle is often simplified. Dragons and marine mammals, on the other hand, do not have a nasal speculum at the tip of their nose. So the entire muzzle is replaced with a nose. In that case, you can strengthen the muzzle to highlight the animal features.

Draw the muzzle from the tip of the nose to the line of the mouth.

6 Tips on Drawing Chibi Characters

Searching for reference materials

Searching for reference materials can be tricky. It may be a good idea to take a look at children's books and fairy-tale picture books. At this point, you don't need to worry about how you want to draw.

Your initial sketch can just reference the stories and the worlds of the animals. You may want to incorporate simple animal features when you distort your characters. You don't have to worry too much about realism. Just understanding their basic features is very useful when creating characters.

Also, in fairy tales and picture books, there are often illustrations of simple and cute animals. These references may be new discoveries or tricks you can have up your sleeve.

Emphasis on the features

When drawing chibi furries, it's a good idea to think about which features you want to emphasize.

Animals have many characteristics that are different from humans, such as ears, tails, claws, paws and teeth. Which features of the animal do you find attractive?

If you want to distort the character more intensely, don't worry about the degree of distortion. The point is to bring out your favorite features in the character. This is also an easy way to have fun when drawing cute chibis.

Chibi Furries on the Go

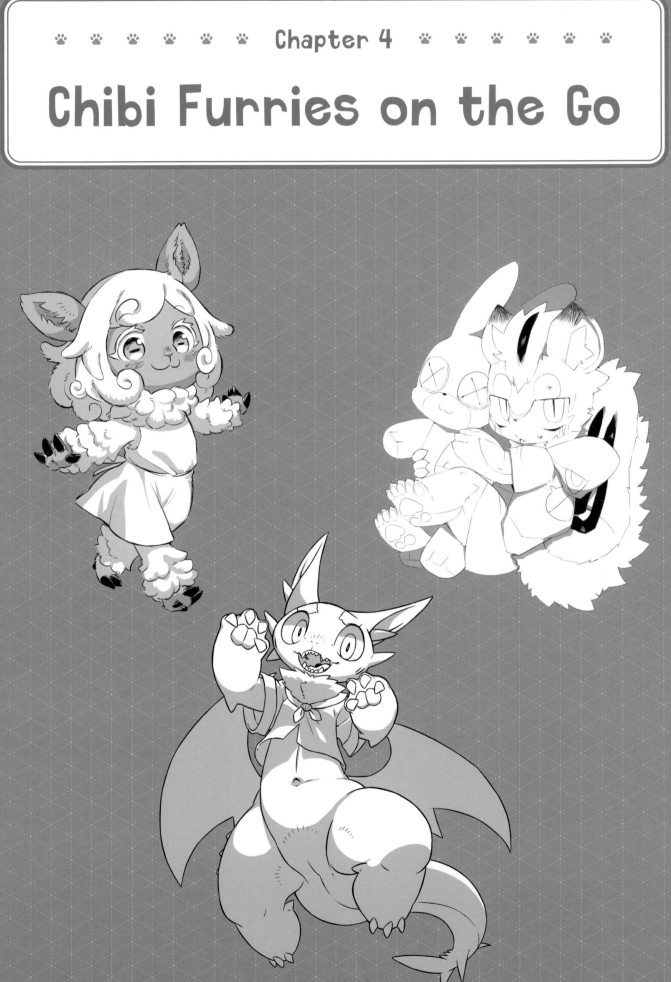

Calico Cat

Pose ❀ **Sitting on the floor**

Illustrator: Mabo

A young cat is plopped down in the perfect posture and pose to accentuate her chibi qualities. The position of the hips adds an immediacy and dynamism to the character.

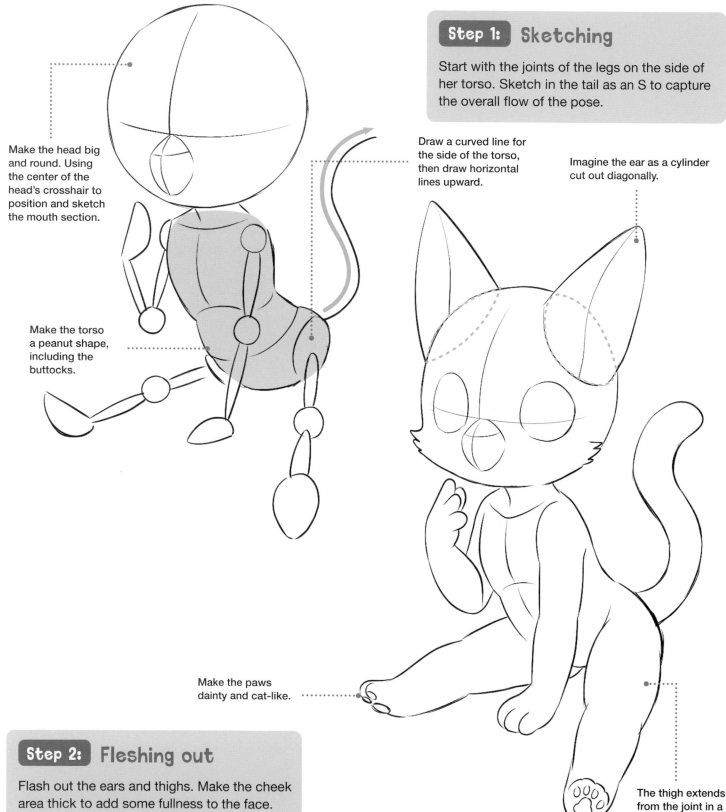

Step 1: Sketching

Start with the joints of the legs on the side of her torso. Sketch in the tail as an S to capture the overall flow of the pose.

Make the head big and round. Using the center of the head's crosshair to position and sketch the mouth section.

Make the torso a peanut shape, including the buttocks.

Draw a curved line for the side of the torso, then draw horizontal lines upward.

Imagine the ear as a cylinder cut out diagonally.

Make the paws dainty and cat-like.

Step 2: Fleshing out

Flash out the ears and thighs. Make the cheek area thick to add some fullness to the face.

The thigh extends from the joint in a cylindrical shape.

118

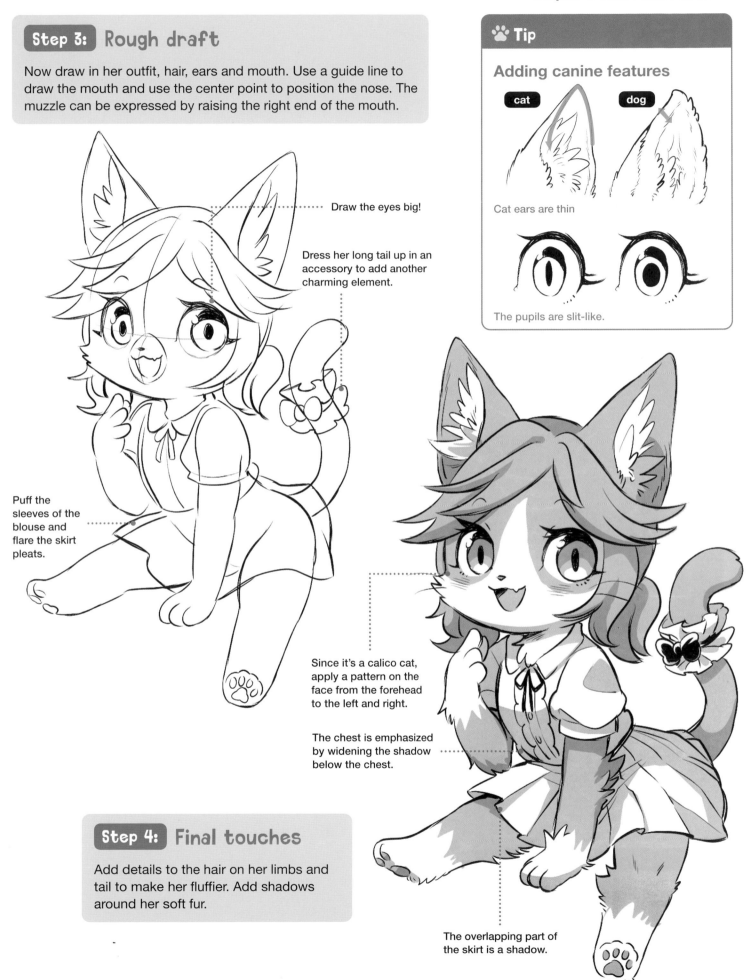

Step 3: Rough draft

Now draw in her outfit, hair, ears and mouth. Use a guide line to draw the mouth and use the center point to position the nose. The muzzle can be expressed by raising the right end of the mouth.

🐾 **Tip**

Adding canine features

cat　　　　dog

Cat ears are thin

The pupils are slit-like.

Draw the eyes big!

Dress her long tail up in an accessory to add another charming element.

Puff the sleeves of the blouse and flare the skirt pleats.

Since it's a calico cat, apply a pattern on the face from the forehead to the left and right.

The chest is emphasized by widening the shadow below the chest.

Step 4: Final touches

Add details to the hair on her limbs and tail to make her fluffier. Add shadows around her soft fur.

The overlapping part of the skirt is a shadow.

119

Husky

Pose 🐾 Waving both hands

Illustrator: Mabo

A husky combines coolness with charm, a true hybrid! For this pose, shrink the head, limbs and the position of the muzzle for extra cuteness and style points.

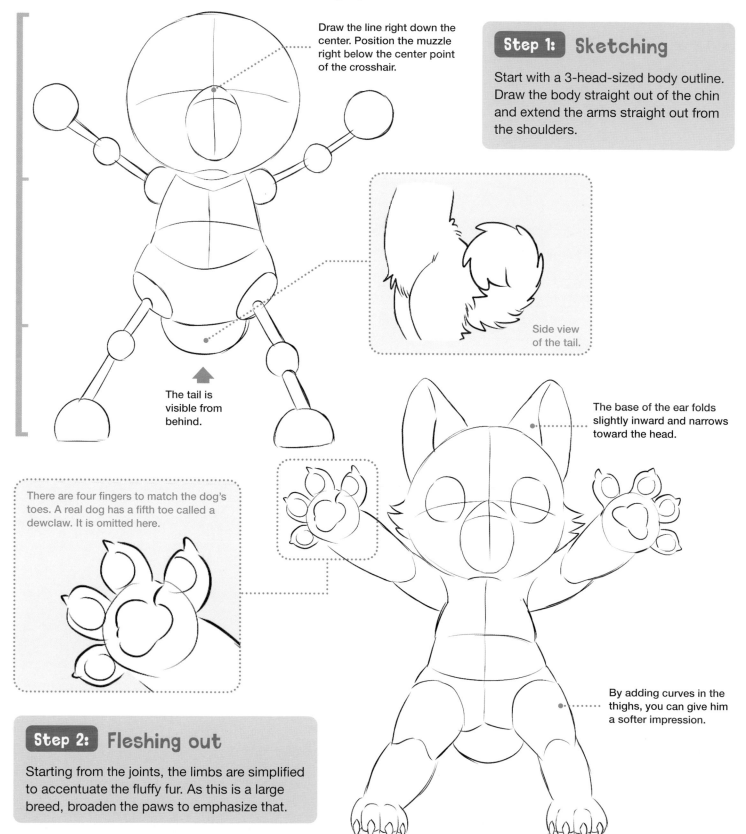

Draw the line right down the center. Position the muzzle right below the center point of the crosshair.

Step 1: Sketching

Start with a 3-head-sized body outline. Draw the body straight out of the chin and extend the arms straight out from the shoulders.

Side view of the tail.

The tail is visible from behind.

The base of the ear folds slightly inward and narrows toward the head.

There are four fingers to match the dog's toes. A real dog has a fifth toe called a dewclaw. It is omitted here.

By adding curves in the thighs, you can give him a softer impression.

Step 2: Fleshing out

Starting from the joints, the limbs are simplified to accentuate the fluffy fur. As this is a large breed, broaden the paws to emphasize that.

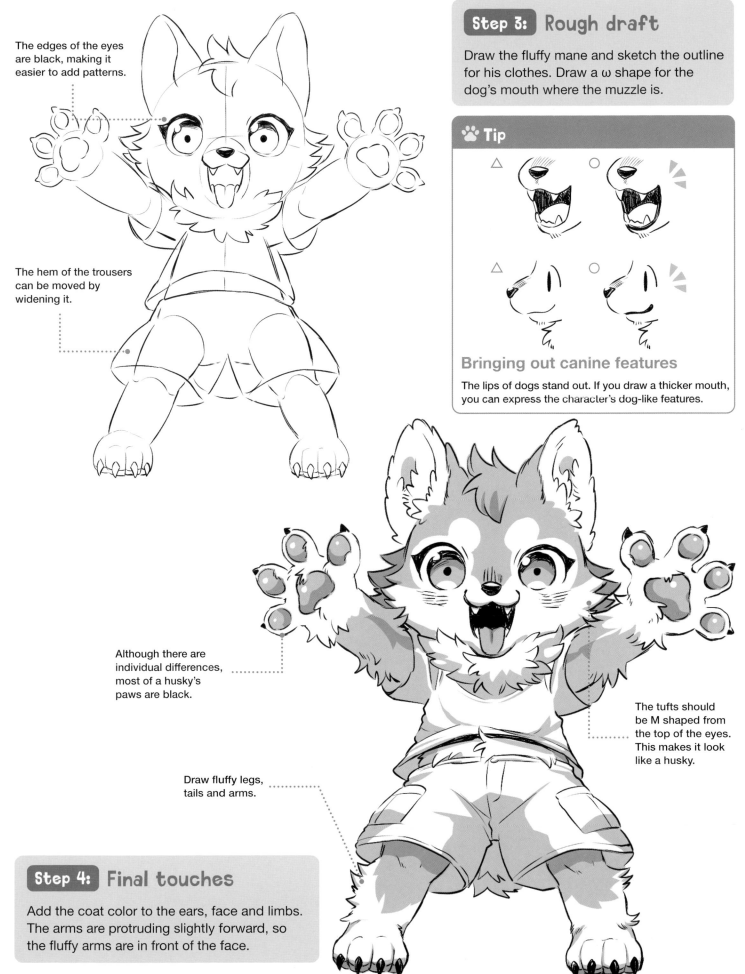

The edges of the eyes are black, making it easier to add patterns.

The hem of the trousers can be moved by widening it.

Step 3: Rough draft

Draw the fluffy mane and sketch the outline for his clothes. Draw a ω shape for the dog's mouth where the muzzle is.

🐾 Tip

△ ○

△ ○

Bringing out canine features

The lips of dogs stand out. If you draw a thicker mouth, you can express the character's dog-like features.

Although there are individual differences, most of a husky's paws are black.

The tufts should be M shaped from the top of the eyes. This makes it look like a husky.

Draw fluffy legs, tails and arms.

Step 4: Final touches

Add the coat color to the ears, face and limbs. The arms are protruding slightly forward, so the fluffy arms are in front of the face.

Sheep

Pose ❀ Walking

Illustrator: Mabo

A proud ewe with a spring in her step, her round chibi-style face is defined by its short muzzle. With this character, pay attention to the eyes, ears and limbs especially.

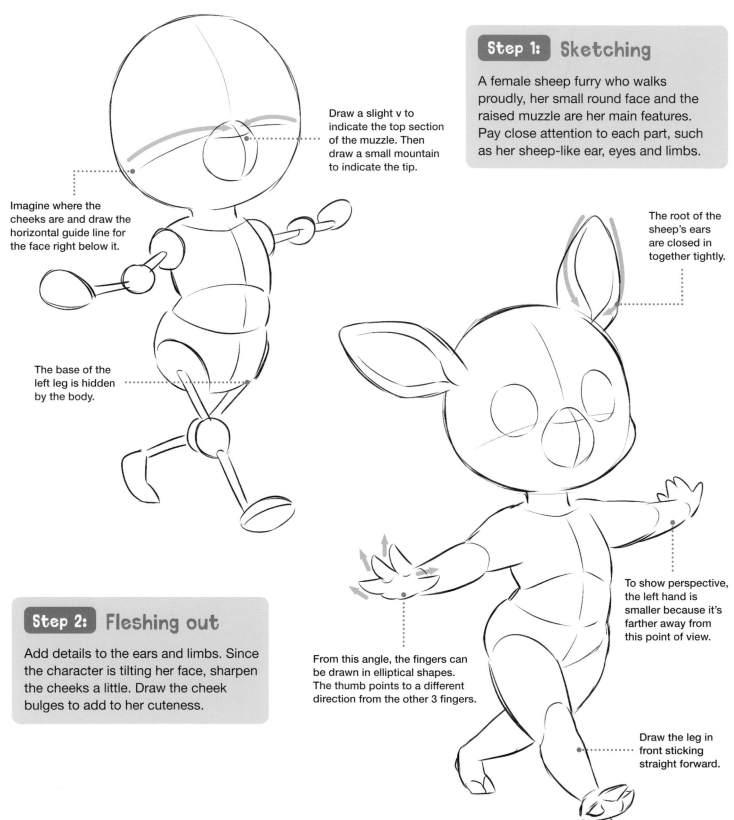

Draw a slight v to indicate the top section of the muzzle. Then draw a small mountain to indicate the tip.

Step 1: Sketching

A female sheep furry who walks proudly, her small round face and the raised muzzle are her main features. Pay close attention to each part, such as her sheep-like ear, eyes and limbs.

Imagine where the cheeks are and draw the horizontal guide line for the face right below it.

The root of the sheep's ears are closed in together tightly.

The base of the left leg is hidden by the body.

To show perspective, the left hand is smaller because it's farther away from this point of view.

Step 2: Fleshing out

Add details to the ears and limbs. Since the character is tilting her face, sharpen the cheeks a little. Draw the cheek bulges to add to her cuteness.

From this angle, the fingers can be drawn in elliptical shapes. The thumb points to a different direction from the other 3 fingers.

Draw the leg in front sticking straight forward.

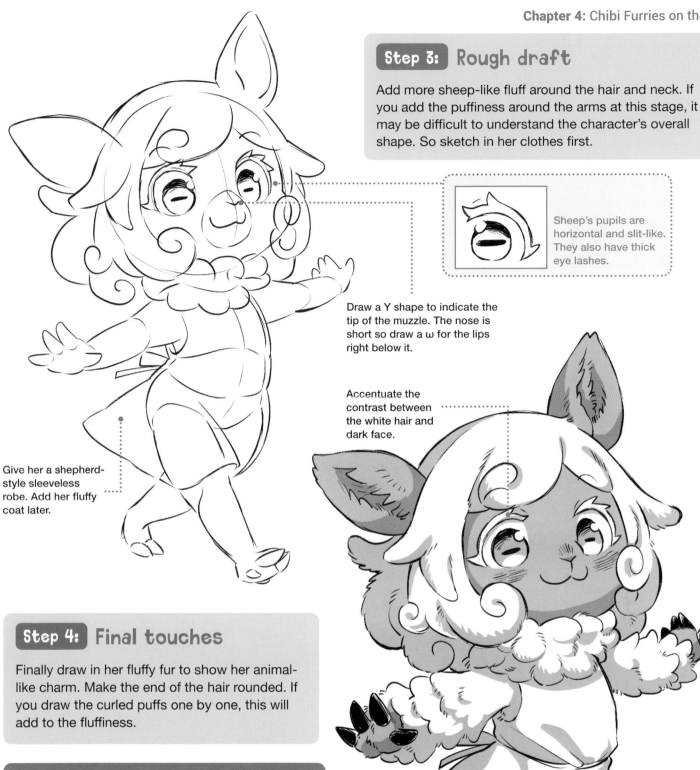

Step 3: Rough draft

Add more sheep-like fluff around the hair and neck. If you add the puffiness around the arms at this stage, it may be difficult to understand the character's overall shape. So sketch in her clothes first.

Sheep's pupils are horizontal and slit-like. They also have thick eye lashes.

Draw a Y shape to indicate the tip of the muzzle. The nose is short so draw a ω for the lips right below it.

Accentuate the contrast between the white hair and dark face.

Give her a shepherd-style sleeveless robe. Add her fluffy coat later.

Step 4: Final touches

Finally draw in her fluffy fur to show her animal-like charm. Make the end of the hair rounded. If you draw the curled puffs one by one, this will add to the fluffiness.

Tie the waist line with a string. Draw in the wrinkles and add in shadows.

🐾 Tip

Fingers as hoof	Shade in the fingers to indicate the hoof	Original animal hoof

Ways to portray a sheep hoof

Here, her hands were drawn in the "fingers as hoof" style and using an "original animal hoof" for her feet.

Reindeer

Pose 🐾 Running

Illustrator: Mabo

A strong young reindeer running in the cold. In this composition. Pay attention to the movement of the limbs and the reindeer's characteristics as well as his facial expression.

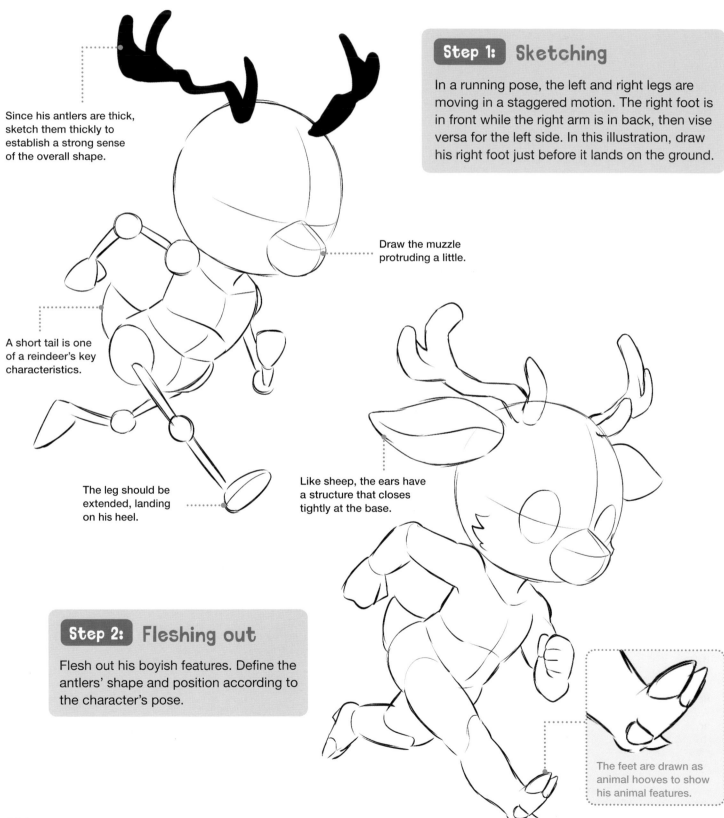

Since his antlers are thick, sketch them thickly to establish a strong sense of the overall shape.

A short tail is one of a reindeer's key characteristics.

The leg should be extended, landing on his heel.

Step 1: Sketching

In a running pose, the left and right legs are moving in a staggered motion. The right foot is in front while the right arm is in back, then vise versa for the left side. In this illustration, draw his right foot just before it lands on the ground.

Draw the muzzle protruding a little.

Like sheep, the ears have a structure that closes tightly at the base.

Step 2: Fleshing out

Flesh out his boyish features. Define the antlers' shape and position according to the character's pose.

The feet are drawn as animal hooves to show his animal features.

124

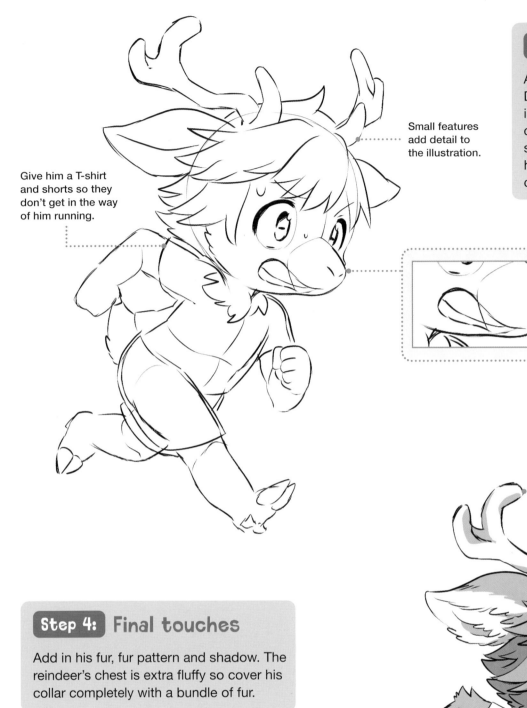

Small features add detail to the illustration.

Give him a T-shirt and shorts so they don't get in the way of him running.

Step 3: Rough draft

Add in his hair, clothes and face. Draw the tip of the nose like an inverted C shape. For his eyes, draw the white part and the pupils smaller to show that he's opening his eyes up wide. It adds to the character's sense of motion.

Draw his mouth wide open. Notice that the ends of the mouth are under the eyes. Don't draw the mouth to the tip of the muzzle's nose, but rather folded back toward the back of the face.

Add a shadow on the antlers. The shadow doesn't cover the antlers completely, but if you think about which parts are not exposed by light and shade it in, this will add to the antler's dimension.

Step 4: Final touches

Add in his fur, fur pattern and shadow. The reindeer's chest is extra fluffy so cover his collar completely with a bundle of fur.

🐾 Tip

Expressing emotions physically

By using the ears and tails, you can express the character's emotions more richly. To express happiness, you can draw their ears raised up, and for sadness you can droop the ears down. Depending on the situation, you can use the character's animal features to dynamically express emotions.

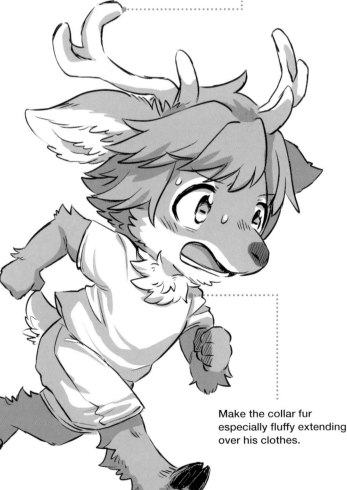

Make the collar fur especially fluffy extending over his clothes.

Cheetah

Male | Chibi | Furry

Pose 🐾 Kneeling

Illustrator: Dori

A male cheetah casts a backward glance while kneeling. Pay attention to the distorted legs and tail to capture the cheetah's lithe athleticism.

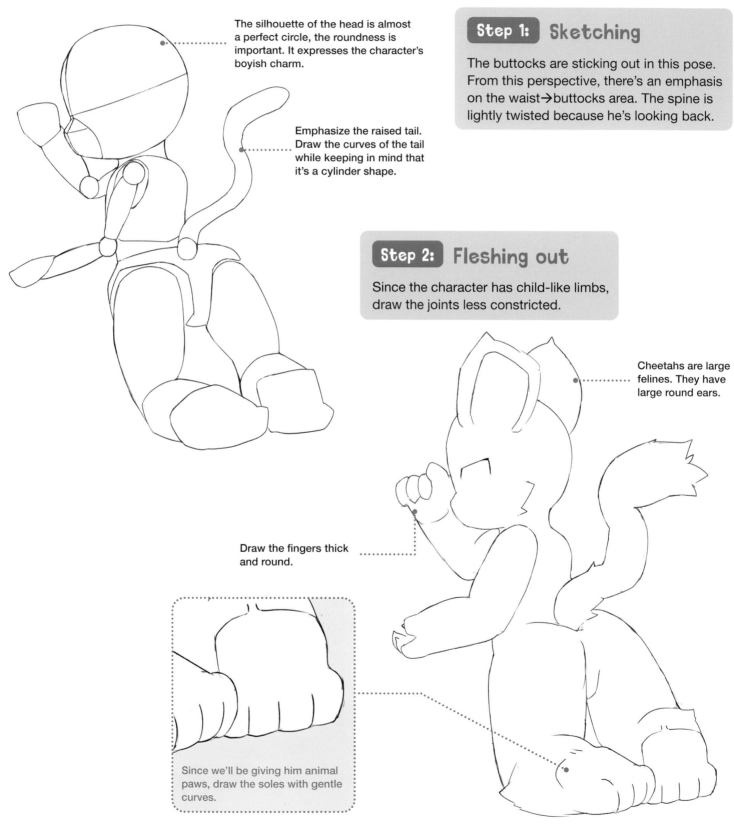

The silhouette of the head is almost a perfect circle, the roundness is important. It expresses the character's boyish charm.

Emphasize the raised tail. Draw the curves of the tail while keeping in mind that it's a cylinder shape.

Step 1: Sketching

The buttocks are sticking out in this pose. From this perspective, there's an emphasis on the waist→buttocks area. The spine is lightly twisted because he's looking back.

Step 2: Fleshing out

Since the character has child-like limbs, draw the joints less constricted.

Cheetahs are large felines. They have large round ears.

Draw the fingers thick and round.

Since we'll be giving him animal paws, draw the soles with gentle curves.

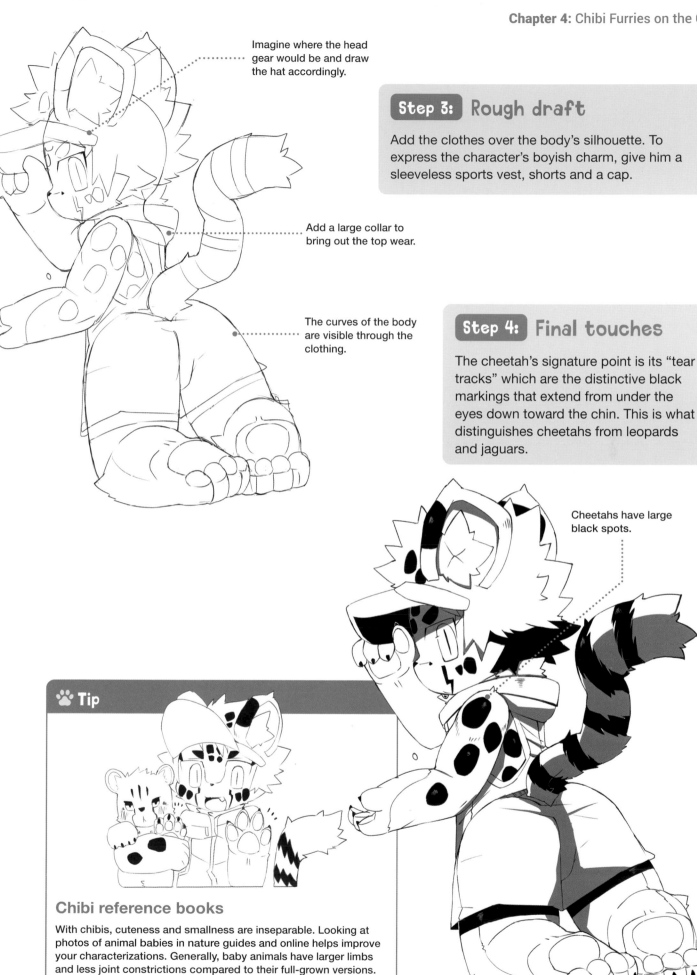

Imagine where the head gear would be and draw the hat accordingly.

Step 3: Rough draft

Add the clothes over the body's silhouette. To express the character's boyish charm, give him a sleeveless sports vest, shorts and a cap.

Add a large collar to bring out the top wear.

The curves of the body are visible through the clothing.

Step 4: Final touches

The cheetah's signature point is its "tear tracks" which are the distinctive black markings that extend from under the eyes down toward the chin. This is what distinguishes cheetahs from leopards and jaguars.

Cheetahs have large black spots.

🐾 Tip

Chibi reference books

With chibis, cuteness and smallness are inseparable. Looking at photos of animal babies in nature guides and online helps improve your characterizations. Generally, baby animals have larger limbs and less joint constrictions compared to their full-grown versions.

Squirrel

Pose 🐾 **Hugging a stuffed animal**

Illustrator: Dori

The soft doll will help accentuate the squirrel's similarly small body. The character's diminutive frame is sandwiched between the stuffed animal and his own large fluffy tail.

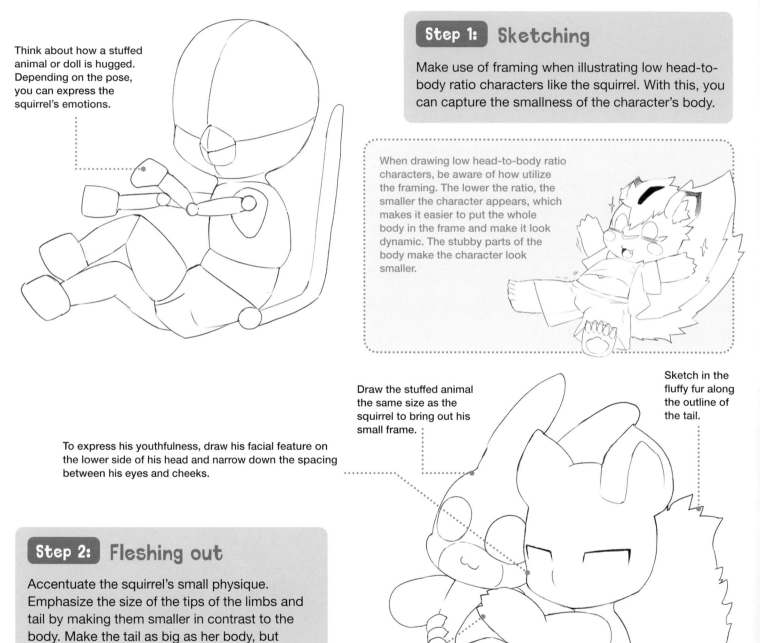

Think about how a stuffed animal or doll is hugged. Depending on the pose, you can express the squirrel's emotions.

Step 1: Sketching

Make use of framing when illustrating low head-to-body ratio characters like the squirrel. With this, you can capture the smallness of the character's body.

When drawing low head-to-body ratio characters, be aware of how utilize the framing. The lower the ratio, the smaller the character appears, which makes it easier to put the whole body in the frame and make it look dynamic. The stubby parts of the body make the character look smaller.

To express his youthfulness, draw his facial feature on the lower side of his head and narrow down the spacing between his eyes and cheeks.

Draw the stuffed animal the same size as the squirrel to bring out his small frame.

Sketch in the fluffy fur along the outline of the tail.

Step 2: Fleshing out

Accentuate the squirrel's small physique. Emphasize the size of the tips of the limbs and tail by making them smaller in contrast to the body. Make the tail as big as her body, but balancing with her body size.

Draw the limbs round and thick like a small animal.

Draw the doll's leg sticking out between the squirrel's legs. The stuffed animal's legs are slightly squished from being squeezed between the squirrel's legs.

A squirrel's fingers are slender, however if you make them too slender, they'll look too realistic, so add a bit of distortion.

Step 3: Rough draft

Draw in the fur and clothes covering the body outline. Add in a hoodie for his outfit. For the rabbit, give it a "pop horror" vibe.

🐾 **Tip**

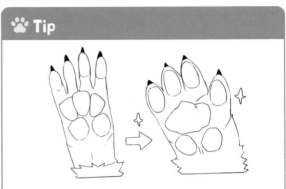

Squirrel paws, chibi-style

Squirrels actually have long fingers. But, it can look a little off-putting if you draw them too realistically. Instead, distort the paws while retaining their main defining characteristics.

Step 4: Final touches

Add shadows and wrinkles to the clothes. Also, draw in the details on the fur's pattern.

The striped back extends all the way to the front. The top of the head and under the eyes also have black stripes.

You can highlight the character's animal features by drawing the paws distinctly.

Cow

Pose 🐾 **Reading in bed**

Illustrator: Dori

Here, pay close attention to the character's line of sight. Make sure that he's looking at the book rather than at the viewer. Be aware of the direction of the head and the position of the neck.

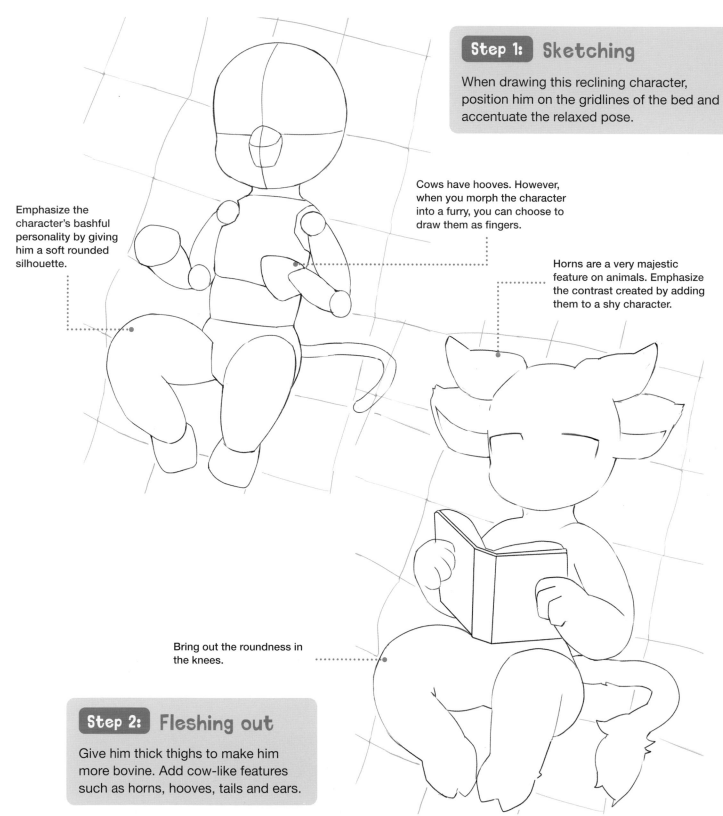

Step 1: Sketching

When drawing this reclining character, position him on the gridlines of the bed and accentuate the relaxed pose.

Cows have hooves. However, when you morph the character into a furry, you can choose to draw them as fingers.

Horns are a very majestic feature on animals. Emphasize the contrast created by adding them to a shy character.

Emphasize the character's bashful personality by giving him a soft rounded silhouette.

Bring out the roundness in the knees.

Step 2: Fleshing out

Give him thick thighs to make him more bovine. Add cow-like features such as horns, hooves, tails and ears.

130

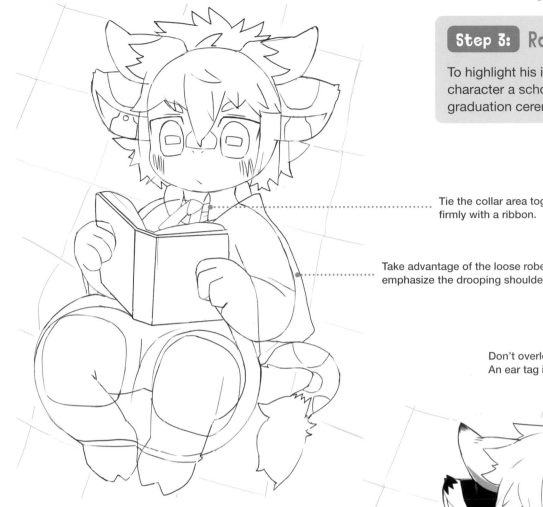

Step 3: Rough draft

To highlight his intellectual qualities, give the character a scholar's robe of the gown worn at graduation ceremonies.

Tie the collar area together firmly with a ribbon.

Take advantage of the loose robe to emphasize the drooping shoulders.

Don't overlook the details. An ear tag is a nice touch.

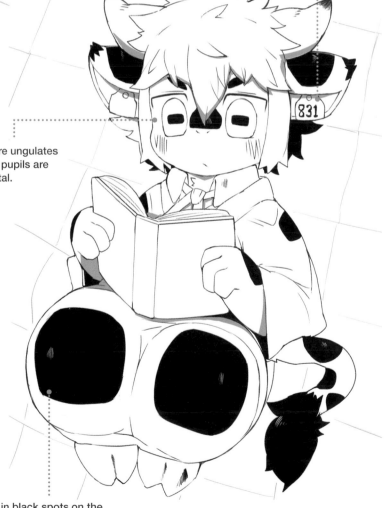

Cows are ungulates so their pupils are horizontal.

Step 4: Final touches

Add in the cow patterns and shadowing. Add patterns to each part of the body and a dark pattern to the back side of the hair. Also add black-and-white patterns to his gown as well.

🐾 **Tip**

Chibi-style hooves

A cow's hoof is drawn with a wide triangular silhouette at the bottom. If you keep this shape, you can suggest the bovine qualities even if you omit the individual sections.

Add in black spots on the lap to help emphasize the dimension of the knees.

131

Marine Dragon

Pose 🐾 **Lying on the floor** Illustrator: Dori

Aquatic dragon furries usually share features with dugongs and walruses: heavy bodies and tails. This pose highlights the playful side of chibi style while focusing on a fantasy creature that might be new to you.

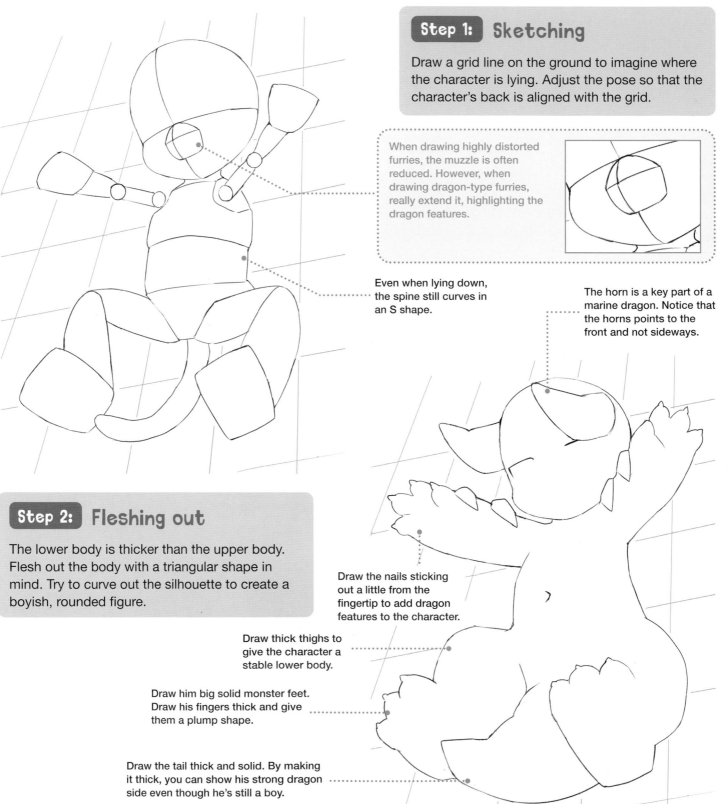

Step 1: Sketching

Draw a grid line on the ground to imagine where the character is lying. Adjust the pose so that the character's back is aligned with the grid.

When drawing highly distorted furries, the muzzle is often reduced. However, when drawing dragon-type furries, really extend it, highlighting the dragon features.

Even when lying down, the spine still curves in an S shape.

The horn is a key part of a marine dragon. Notice that the horns points to the front and not sideways.

Step 2: Fleshing out

The lower body is thicker than the upper body. Flesh out the body with a triangular shape in mind. Try to curve out the silhouette to create a boyish, rounded figure.

Draw the nails sticking out a little from the fingertip to add dragon features to the character.

Draw thick thighs to give the character a stable lower body.

Draw him big solid monster feet. Draw his fingers thick and give them a plump shape.

Draw the tail thick and solid. By making it thick, you can show his strong dragon side even though he's still a boy.

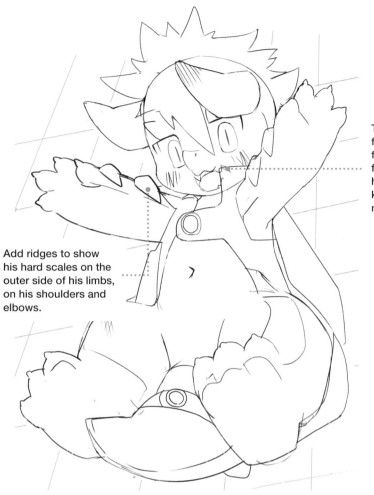

To add to his dragon features, draw small fangs sticking out from his mouth. Since he's a young dragon, keep the fangs a modest size.

Add ridges to show his hard scales on the outer side of his limbs, on his shoulders and elbows.

Step 3: Rough draft

Give him a cloak-shaped outfit to show off his round abdomen, which is one of the marine animal's notable feature. In order to express his boyish charm, the hair is also tousled and messy.

An example of the power of detail: The small nails add a level of specificity and refinement.

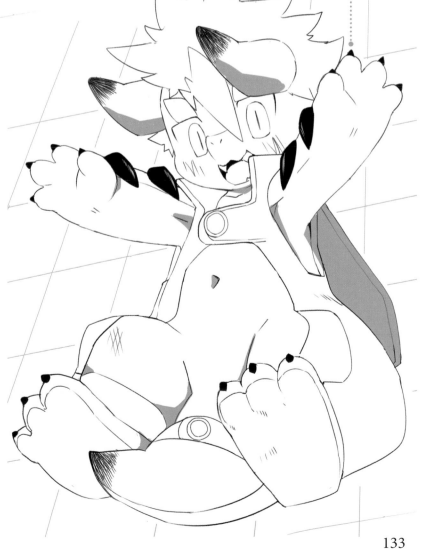

Step 4: Final touches

Add in shadows and details to complete the illustrations. The scales are the key point to express his dragon-like textured skin.

🐾 Tip

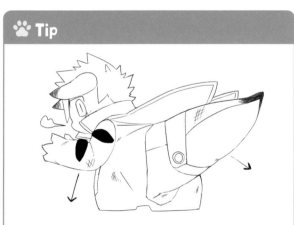

Skin texture

When drawing coarse skin or scales, if you draw it as is, it'll be too realistic. It's best to draw just the silhouette of it just to get the idea of the texture. Alternatively, you can simply draw lines on the parts that are exposed to light like the joints.

Bunny

Young boy Chibi Furry

Pose 🐾 Doing a one-armed handstand

Illustrator: Ishimura Reizi

Here, pay close attention to balancing the waist. You can play with the arm and head size and the positional relationship for a true action chibi.

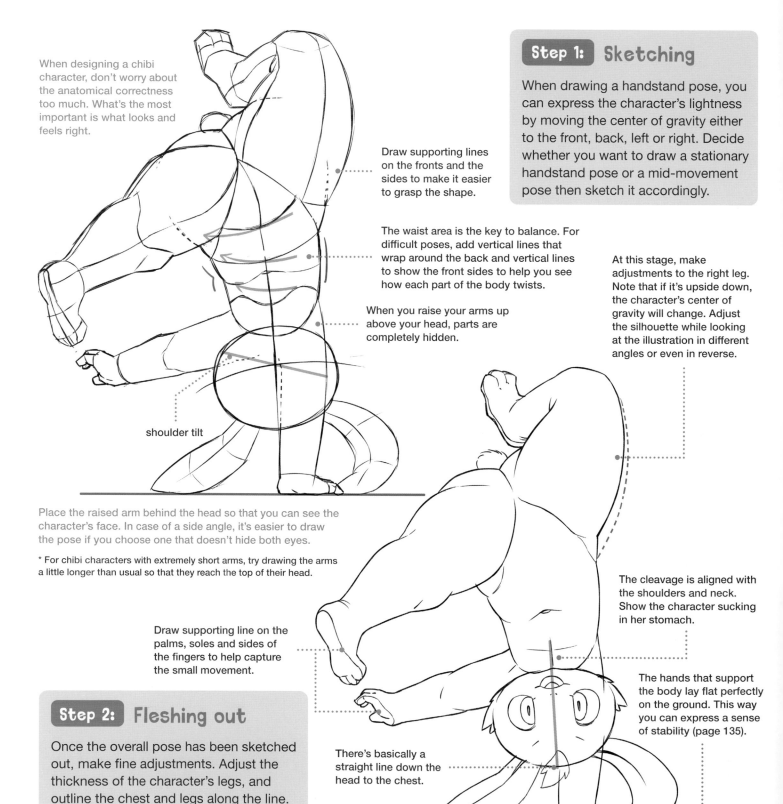

When designing a chibi character, don't worry about the anatomical correctness too much. What's the most important is what looks and feels right.

Draw supporting lines on the fronts and the sides to make it easier to grasp the shape.

The waist area is the key to balance. For difficult poses, add vertical lines that wrap around the back and vertical lines to show the front sides to help you see how each part of the body twists.

When you raise your arms up above your head, parts are completely hidden.

shoulder tilt

Step 1: Sketching

When drawing a handstand pose, you can express the character's lightness by moving the center of gravity either to the front, back, left or right. Decide whether you want to draw a stationary handstand pose or a mid-movement pose then sketch it accordingly.

At this stage, make adjustments to the right leg. Note that if it's upside down, the character's center of gravity will change. Adjust the silhouette while looking at the illustration in different angles or even in reverse.

Place the raised arm behind the head so that you can see the character's face. In case of a side angle, it's easier to draw the pose if you choose one that doesn't hide both eyes.

* For chibi characters with extremely short arms, try drawing the arms a little longer than usual so that they reach the top of their head.

Draw supporting line on the palms, soles and sides of the fingers to help capture the small movement.

The cleavage is aligned with the shoulders and neck. Show the character sucking in her stomach.

The hands that support the body lay flat perfectly on the ground. This way you can express a sense of stability (page 135).

Step 2: Fleshing out

Once the overall pose has been sketched out, make fine adjustments. Adjust the thickness of the character's legs, and outline the chest and legs along the line.

There's basically a straight line down the head to the chest.

134

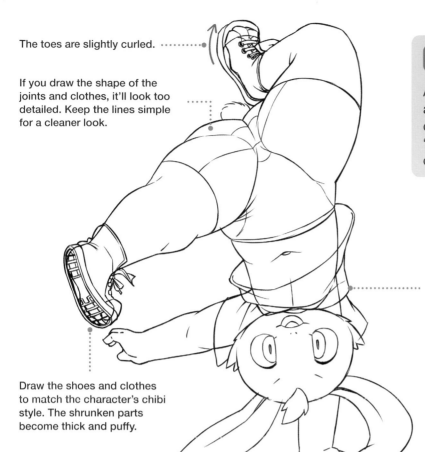

The toes are slightly curled.

If you draw the shape of the joints and clothes, it'll look too detailed. Keep the lines simple for a cleaner look.

Draw the shoes and clothes to match the character's chibi style. The shrunken parts become thick and puffy.

Step 3: Rough draft

Add in the clothes and the wrinkles on the clothes as well. Since it's a pose with a lot of movement, don't draw too many wrinkles and shadows. "Less is more" is often an important notion when drawing chibis.

If you draw too many wrinkles and shadows on the clothes, it'll become too detailed. Here you can see the fold in his stomach and the clothes falling over from the unusual and challenging pose.

Step 4: Final touches

Cast a shadow on the surface that wraps around toward the back of the character. It's effective to make the parts that protrude brighter and the parts in the back darker.

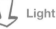

Light

The light is shining straight down.

🐾 Tip

Expressing the weight of the body

The way to express the character's lightness comes from how you draw the limbs and at which axes you position them. Depending on the pose, how much the legs/hands touch the ground will change.

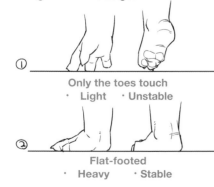

① **Only the toes touch**
· Light · Unstable

② **Flat-footed**
· Heavy · Stable

When drawing dancers or ballerinas, you might draw the character completely off the ground. When ignoring physics and you only want to show the character floating, avoid expressing any sense of weight.

The wrinkles on the clothes are drawn in a diamond shape. You can repeat this pattern on other areas of the body as well.

Try adding shadows to areas in the back side.

Housecat

Pose 🐾 **Flying kick** Illustrator: **Ishimura Reizi**

There's obviously a lot of movement and forward motion to this pose. The key is to accurately capture the depth and sense of perspective to do justice to this action cat.

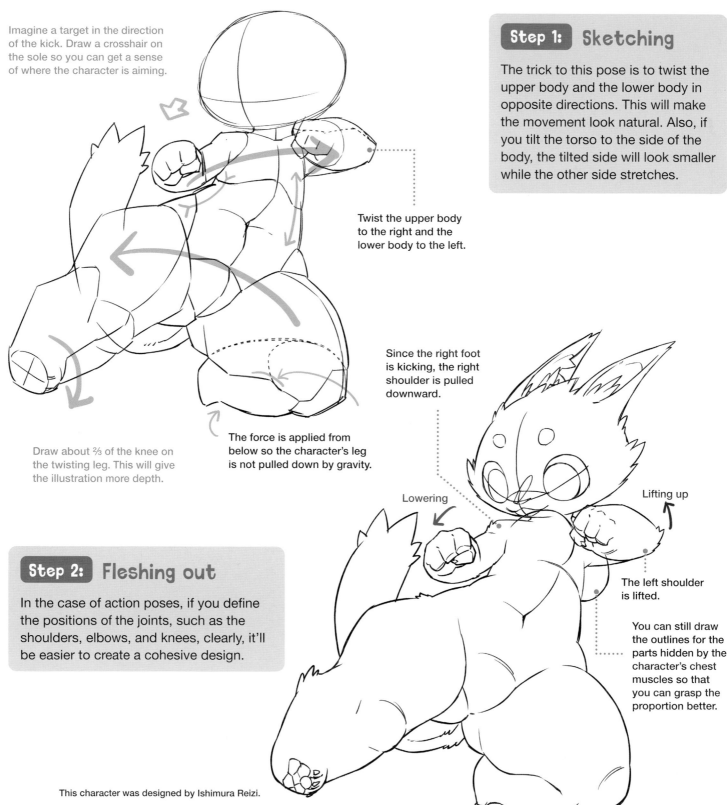

Imagine a target in the direction of the kick. Draw a crosshair on the sole so you can get a sense of where the character is aiming.

Step 1: Sketching

The trick to this pose is to twist the upper body and the lower body in opposite directions. This will make the movement look natural. Also, if you tilt the torso to the side of the body, the tilted side will look smaller while the other side stretches.

Twist the upper body to the right and the lower body to the left.

Since the right foot is kicking, the right shoulder is pulled downward.

Draw about ⅔ of the knee on the twisting leg. This will give the illustration more depth.

The force is applied from below so the character's leg is not pulled down by gravity.

Lowering

Lifting up

The left shoulder is lifted.

You can still draw the outlines for the parts hidden by the character's chest muscles so that you can grasp the proportion better.

Step 2: Fleshing out

In the case of action poses, if you define the positions of the joints, such as the shoulders, elbows, and knees, clearly, it'll be easier to create a cohesive design.

This character was designed by Ishimura Reizi.

Imagine where the target was originally positioned. Twisting the kick to the side can help suggest the force.

The force transferring through the clothes.

This is where the target originally was. The character kicked it here, so her legs are stretched out in that direction.

Step 3: Rough draft

The timeline in this action pose is immediately after kicking the target. The direction of the ears and nose expresses the force of the kick. The fur and clothes can also be used to suggest this movement.

The clothes are pulled along with the twisting of the body. It should be in the opposite direction of the jumping.

The right chest rises almost straight up and the left side shifts over. Therefore the clothes are caught in the cleavage.

Wrinkles on the clothes are pulled along with the body movement. Imagine a cloth being twisted.

🐾 Tip

Action movement

When you kick a target, the shoulder opposite to the kicking foot is raised up. If you follow this rule, you can draw a kicking pose that is strong and well balanced. Sometimes when you draw what is logically correct, it may somehow look strange. So we can intentionally draw a pose that is different from reality to make it look right in an illustration.

Raise the right shoulder and extend it slightly. The character's right-footed so that's the side kicking the ball.

Light ↗

The light source is placed where the face can be easily seen. Since the light source is located at the target, it creates an interesting dynamic with the shadows.

Light

The shadows are cast on areas that are not facing the target, such as where the chest and thigh wrap around.

Step 4: Final touches

The light source is where the target is, so shade the character accordingly. Pay attention to the shadow wrapping around the surface (opposite from the light source).

Polar Bear

Pose 🐾 **Sitting down eating**

Illustrator: **Ishimura Reizi**

When drawing chibis, the character's original proportions are altered and the joints are often omitted. Make use of both 3D and 2D expression to create increasingly compelling poses.

In order to emphasize the character's smallness, make the objects surrounding them large. On the other hand, you can draw the objects around the character smaller if you want to make them look bigger.

Draw them with the idea that there's no limit to their joints' range of motion.

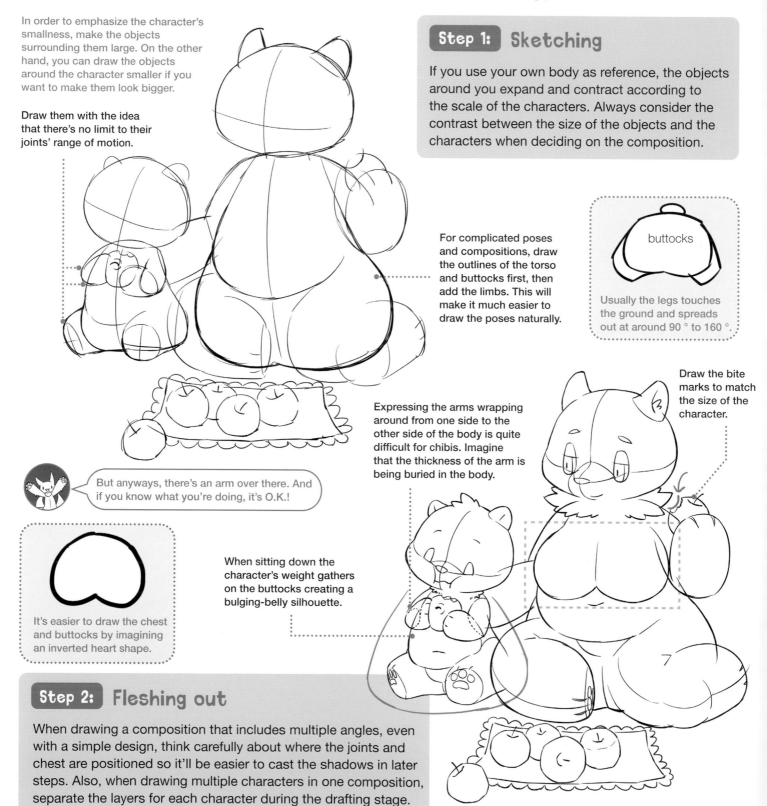

Step 1: Sketching

If you use your own body as reference, the objects around you expand and contract according to the scale of the characters. Always consider the contrast between the size of the objects and the characters when deciding on the composition.

For complicated poses and compositions, draw the outlines of the torso and buttocks first, then add the limbs. This will make it much easier to draw the poses naturally.

buttocks

Usually the legs touches the ground and spreads out at around 90 ° to 160 °.

Draw the bite marks to match the size of the character.

Expressing the arms wrapping around from one side to the other side of the body is quite difficult for chibis. Imagine that the thickness of the arm is being buried in the body.

But anyways, there's an arm over there. And if you know what you're doing, it's O.K.!

When sitting down the character's weight gathers on the buttocks creating a bulging-belly silhouette.

It's easier to draw the chest and buttocks by imagining an inverted heart shape.

Step 2: Fleshing out

When drawing a composition that includes multiple angles, even with a simple design, think carefully about where the joints and chest are positioned so it'll be easier to cast the shadows in later steps. Also, when drawing multiple characters in one composition, separate the layers for each character during the drafting stage.

Although their looks differ, make their movements similar so that you can show the similarity between family members.

slanted

It's cute when the way they're eating is a little messy.

slanted

Step 3: Rough draft

Draw in the eyes, clothes and hairstyle. For the mother polar bear, her eyes aren't fully open, you can see a portion of her eyelids. If you draw in the eyelid portions and make the lashes thicker, you can make her look more feminine. The apron is a tight fit, so it gets caught in between the folds of her skin.

The flesh of the chest is lifted a little with the apron and moves a little to the left due to the left arm's movement

The apron gets caught under the chest.

It's usually difficult to deal with the ears when you want to draw animals wearing a hood. Simply draw it as if the ears were growing out of the hood. Or you can simply draw hood over the ears.

Light

Shadows are an effective tool to emphasize the areas you want to stand out. Here, by shading in the neck, you can add contrast to make the face stand out.

Add shadows to parts that are in the back.

Tip

A polar silhouette

If you want to make the silhouette look more like a polar bear, image their overall shape to be similar to a bowling pin.

Step 4: Final touches

One method is to add blurry shadows mainly to the front part of the front side of the illustration. Draw large shadows and highlights on the eyes and apples for the final touch.

Shadow ● ● Light

In the case of this method, the shadow color will be cute if it is thin enough to be just above the background color.

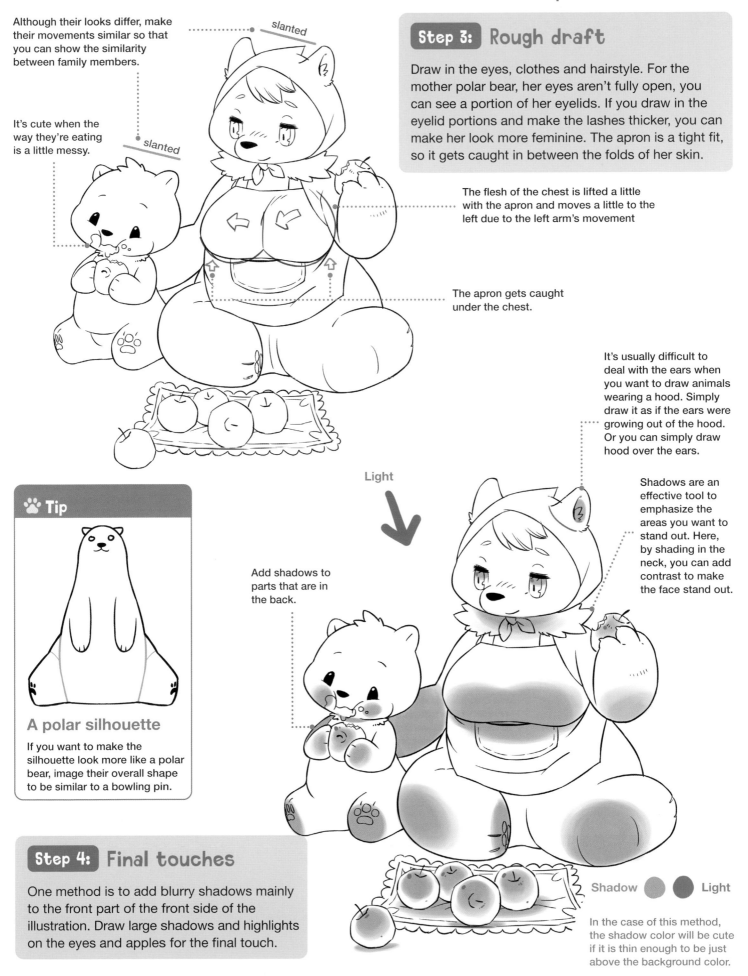

139

Black-Scaled Dragon

Young boy **Chibi** **Furry**

Pose 🐾 Jumping for joy

Illustrator: Ishimura Reizi

Dragons are true hybrids in terms of animal characteristics. This one assumes shark-like features. The expression and chibi embellishments add charm to what could be a menacing pose.

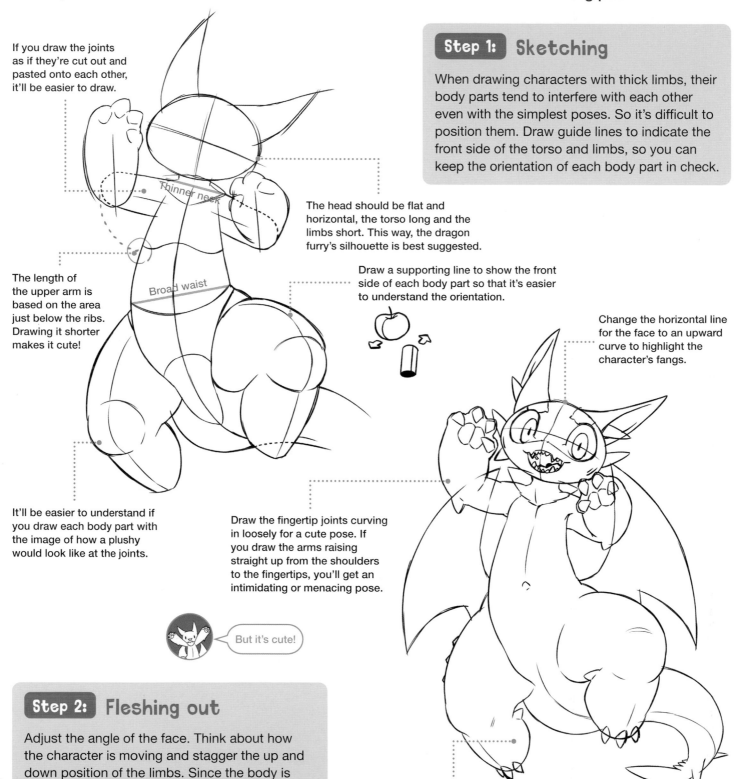

If you draw the joints as if they're cut out and pasted onto each other, it'll be easier to draw.

Thinner neck

The length of the upper arm is based on the area just below the ribs. Drawing it shorter makes it cute!

Broad waist

It'll be easier to understand if you draw each body part with the image of how a plushy would look like at the joints.

Draw the fingertip joints curving in loosely for a cute pose. If you draw the arms raising straight up from the shoulders to the fingertips, you'll get an intimidating or menacing pose.

But it's cute!

Step 1: Sketching

When drawing characters with thick limbs, their body parts tend to interfere with each other even with the simplest poses. So it's difficult to position them. Draw guide lines to indicate the front side of the torso and limbs, so you can keep the orientation of each body part in check.

The head should be flat and horizontal, the torso long and the limbs short. This way, the dragon furry's silhouette is best suggested.

Draw a supporting line to show the front side of each body part so that it's easier to understand the orientation.

Change the horizontal line for the face to an upward curve to highlight the character's fangs.

Step 2: Fleshing out

Adjust the angle of the face. Think about how the character is moving and stagger the up and down position of the limbs. Since the body is twisted, the torso on the twisted side shrinks and the other side stretches.

Since the right leg is pulled back away from the viewer, draw it slightly smaller than the left foot.

You can also show that the character is mid-movement by adding fluttering to the clothes and ribbon.

Let's keep the silhouette simple

Since the wings are stiff, try adding some movement to them. You can completely change the impression of the illustration with simple changes like this.

Step 3: Rough draft

Originally, this is a character that doesn't wear clothes. But give him a sailor suit for this illustration. Wearing a cropped top can help emphasize the thinness of the waist.

Since the silhouette is already well-defined, it'll look better if you don't add any clothing to the bottom half.

Draw in the details to accentuate the shape of the body. If you understand the shape of each body part it'll make it easier to add in the shadows.

Light source from directly above

Light

Shed light on the areas you want to bring out.

Step 4: Final touches

In this case, the underside of the muzzle casts a shadow. If you shade around the face, it'll look more realistic, like CG. Although there are various ways to shade it in, depending on how you want to express the illustration, here add a crescent-shaped shadow along the chin for a comic-style touch.

Draw a crease line at the stomach area.

🐾 Tip

"Rawr" pose

Drawing the pose asymmetrical will make it look more natural. No matter how simple the design is, it's rare to have a completely symmetrical pose for living things. Symmetrical design can make the character end up looking inorganic. You can use that when creating website icons or doll-like expressions.

Chibi-style limbs

For chibis, you can draw the limbs shorter or longer as needed. This is one of the reasons why people who understand anatomy may have a hard time drawing chibis. Sometimes you just have to ignore the accuracy of the anatomy to make chibi characters look right.

Shadows add dramatic and defining effects, right down to the very ends of its toes—I mean claws!

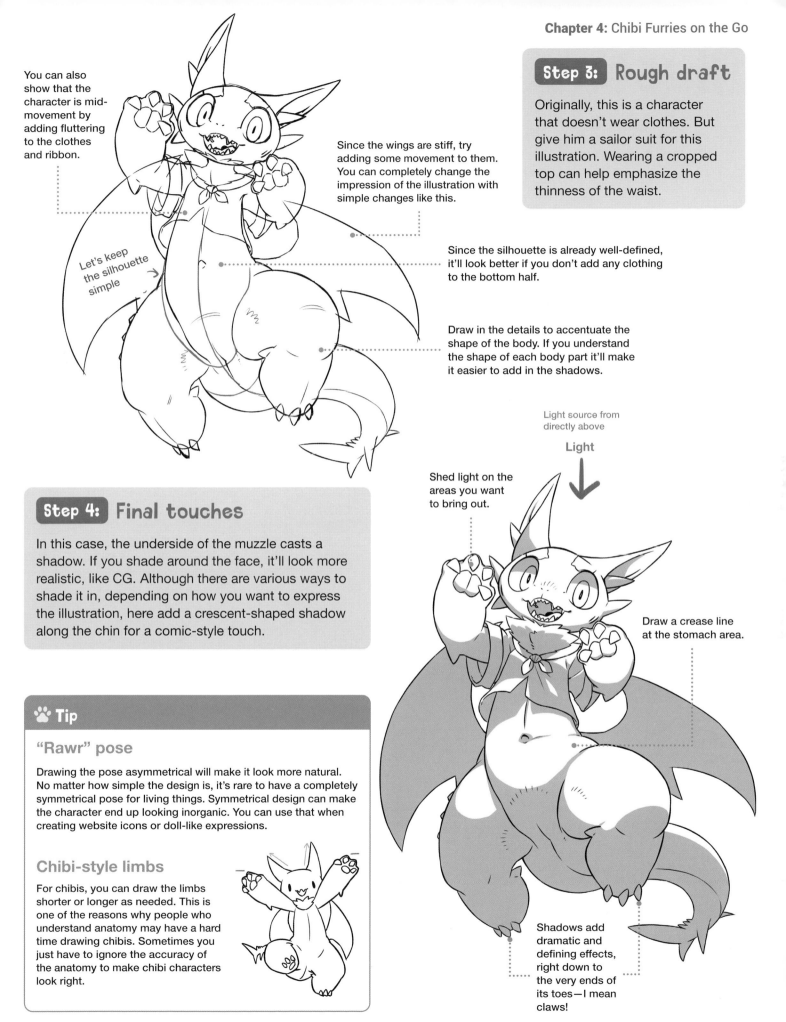

141

Illustrator Profiles

🐾 Yamayagi Yama

I'm an illustration who likes muscles, furries and girls. I especially like to explore different races, physiques and age groups. Regardless, I like to try bring out the charm of each creatures.

Illustrations: pages 26–33

HP https://arcadia-goat.tumblr.com
Twitter @singapura_ar

🐾 Muraki

A freelance artist, I mainly illustrate for books, game development and character design. I love drawing both humans and furries.

Illustrations: pages14–21; 112–115

HP https://iou783640.wixsite.com/muraki
Pixiv http://www.pixiv.net/users/10395965
Twitter @owantogohan

🐾 Suzumori

A 3D CG modeler and manga artist, I enjoy interactions between humans and furries whose faces and skeletons are similar to humans but whose spirits are similar to animals that don't particularly behave like humans. I hope you'll be interested in this as one way of expressing furry characters.

Illustrations: pages 34–41

Pixiv https://www.pixiv.net/users/22084595
Twitter @suzumori_521

🐾 Hitsujirobo

I illustrate manga that explores the world of furries! I'm in charge of the character designs! I'm looking forward to the second volume on furry design and creation! Thanks so much!

Illustrations: pages 42–49

Pixiv https://www.pixiv.net/users/793067
Twitter @hit_ton_ton

🐾 Itohiro

I specialize in drawing fantastic beasts and Japanese dragons. My ultimate goal right now is to continue to change and grow and create characters that will stick with someone for the rest of their lives, and create new opportunities in character design.

Illustrations: pages 60–67

Pixiv https://www.pixiv.net/users/1316534
Twitter @itohiro0305

🐾 Madakan

My hobby is drawing illustrations that focus on humanization. I am inspired by insects, deep-sea animals and orcas. The manga "Mörderwal," which is about an anthropomorphic orca, is now on sale.

Illustrations: pages 22–23; 50–57

HP https://morderwal.jimdofree.com/
Pixiv http://www.pixiv.net/users/13426936

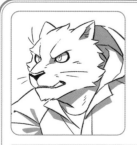

🐾 yow

I draw illustrations for manga both publicly and privately. I like both furries and people. It was a lot of fun to be able to draw multiple characters. Thank you very much!

Illustrations: pages 68–75

HP https://vish4ow.tumblr.com
Pixiv https://www.pixiv.net/users/60058
Twitter @vish4ow

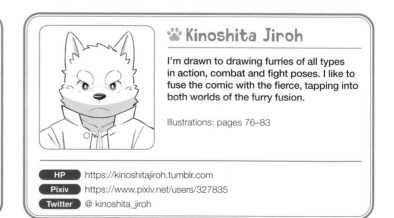

🐾 Kinoshita Jiroh

I'm drawn to drawing furries of all types in action, combat and fight poses. I like to fuse the comic with the fierce, tapping into both worlds of the furry fusion.

Illustrations: pages 76–83

HP https://kinoshitajiroh.tumblr.com
Pixiv https://www.pixiv.net/users/327835
Twitter @ kinoshita_jiroh

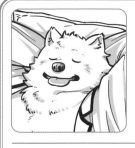 🐾 Yuzpoco

I'm active in several doujin genres such as originals, doujin parodies, furries and human-based. I also illustrate for TENGA, a Taiwanese company, and am active as a manga assistant.

Illustrations: pages 84–91

Pixiv https://www.pixiv.net/users/40376
Twitter @yuzpoco

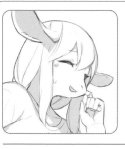 🐾 Kishibe

I'm an illustrator who enjoys drawing furries. I draw things other than furries too but drawing furries makes me happy. I like both mascots of small sizes and tall ones! I'm also into the plump dragons these days. And I do 3D modeling as a hobby these days.

Illustrations: pages 94–101

Pixiv https://www.pixiv.net/users/14518
Twitter @kishibe_

🐾 Morikita Sasana

I'm an illustrator who likes furries and girls. Being able to participate in creating this book was a very wonderful and valuable experience. The attractive furries, such as the body shape and soft coat, are so fun to see and draw. I hope to see you all again somewhere!

Illustrations: pages 102–109

HP https://sasanaco.tumblr.com
Pixiv https://www.pixiv.net/users/24829105
Twitter @sasanaco

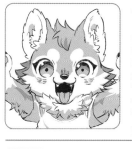 🐾 Mabo

I'm an illustrator and a manga artist who loves furries. Under the name "moffle," I also participate in doujinshi activities, mainly for furries. I've worked on "Sengoku Puzzle!! Animal Daizen," "Wolf + Kaleshi" and other program mascot characters.

Illustrations: pages 118–125

HP https://moffle69mb.tumblr.com/
Pixiv https://www.pixiv.net/users/9674
Twitter @shimabo

🐾 Dori

I'm a painter who enjoys drawing furries at my own pace. I also like cats and science fiction. I like buying the first editions of furry books and giving my impressions. When in doubt, my motto is to draw things a little larger and it'll be cute! Thank you for having me!

Illustrations: pages 126–133

Pixiv https://www.pixiv.net/users/12465683
Twitter @dinogaize

🐾 Ishimura Reizi

I'm a freelance character designer, sometimes a manga artist. I'm also active in designing character merchandise and directing game development.

Illustrations: pages 134–141

HP https://www.artstation.com/reizi666
Pixiv https://www.pixiv.net/users/60139
Twitter @zero_gravity666

References

- "How to Draw Manga Furries: The Complete Guide to Anthropomorphic Fantasy Characters," by Hitsujirobo, Madakan, Muraki, Yagiyama and Yow
- "Draw Amazing Manga Characters: A Drawing Exercise Book for Beginners / Learn the Secrets of Japanese Illustrators," by Akariko, Izumi, Ojyou, Onodo and To-ya.
- "Drawing Cute Manga Chibi: A Beginner's Guide to Drawing Super Cute Characters," by Ryusuke Hamamoto
- "Beginner's Guide to Drawing Manga Chibi Girls: Create Your Own Adorable Mini Characters," by Mosoko Miyatsuki and Tsubura Kadomura
- "The Ultimate Guide to Drawing Action Manga: A Step-by-Step Artist's Handbook" by shoco and Makoto Sawa
- "How to Create Manga: Drawing Action Scenes and Characters / The Ultimate Bible for Beginning Artists" by Shikata Shiyomi

"Books to Span the East and West"

Tuttle Publishing was founded in 1832 in the small New England town of Rutland, Vermont [USA]. Our core values remain as strong today as they were then—to publish best-in-class books which bring people together one page at a time. In 1948, we established a publishing office in Japan—and Tuttle is now a leader in publishing English-language books about the arts, languages and cultures of Asia. The world has become a much smaller place today and Asia's economic and cultural influence has grown. Yet the need for meaningful dialogue and information about this diverse region has never been greater. Over the past seven decades, Tuttle has published thousands of books on subjects ranging from martial arts and paper crafts to language learning and literature—and our talented authors, illustrators, designers and photographers have won many prestigious awards. We welcome you to explore the wealth of information available on Asia at **www.tuttlepublishing.com**.

Published by Tuttle Publishing, an imprint of Periplus Editions (HK) Ltd.

www.tuttlepublishing.com

ISBN 978-4-8053-1703-7
JUJIN POSE SHU
© 2020 Genkosha Co., Ltd
English translation rights arranged with Genkosha Co., Ltd through Japan UNI Agency, Inc., Tokyo

English Translation © 2022 Periplus Editions (HK) Ltd

All rights reserved. No part of this publication may be reproduced or utilized in any form or by any means, electronic or mechanical, including photocopying, recording, or by any information storage and retrieval system, without prior written permission from the publisher.

Distributed by

North America, Latin America & Europe
Tuttle Publishing
364 Innovation Drive
North Clarendon, VT 05759-9436 U.S.A.
Tel: 1 (802) 773-8930; Fax: 1 (802) 773-6993
info@tuttlepublishing.com
www.tuttlepublishing.com

Japan
Tuttle Publishing
Yaekari Building 3rd Floor
5-4-12 Osaki
Shinagawa-ku
Tokyo 141-0032
Tel: (81) 3 5437-0171; Fax: (81) 3 5437-0755
sales@tuttle.co.jp
www.tuttle.co.jp

Asia Pacific
Berkeley Books Pte. Ltd.
3 Kallang Sector #04-01
Singapore 349278
Tel: (65) 6741-2178; Fax: (65) 6741-2179
inquiries@periplus.com.sg
www.tuttlepublishing.com

25 24 23 22 10 9 8 7 6 5 4 3 2 1

Printed in China 2205EP

TUTTLE PUBLISHING® is a registered trademark of Tuttle Publishing, a division of Periplus Editions (HK) Ltd.

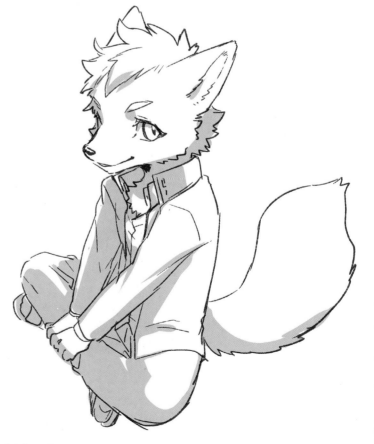